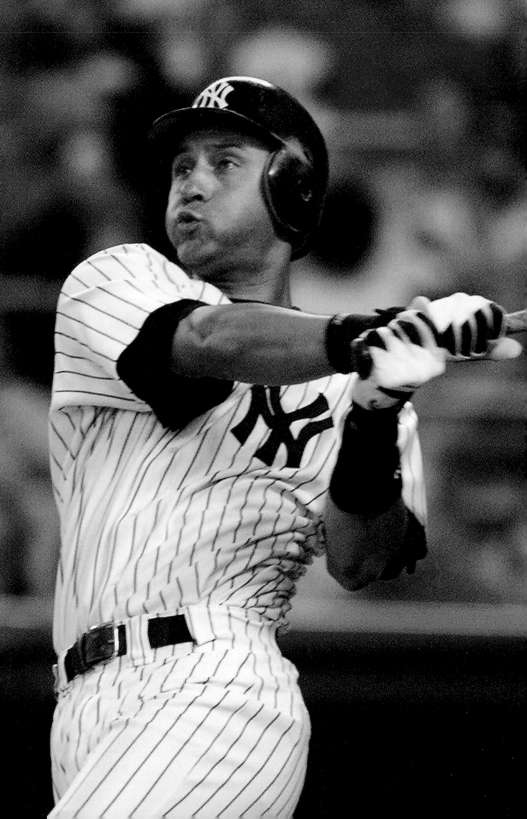

DAILY NEWS

100 YEARS
in Pinstripes

The New York
Yankees in
Photographs

TRIUMPH
BOOKS

Library of Congress Publication-in-Catalog Data available upon request

This book is available in quantity at special discounts for your group or organization.
For further information, contact:

Triumph Books LLC
814 North Franklin Street
Chicago, Illinois 60610
Phone: (312) 337-0747
www.triumphbooks.com

Printed in U.S.A.
ISBN: 978-1-62937-795-7

Interior design and editorial production by Alex Lubertozzi

Photos courtesy of The New York Daily News unless otherwise indicated

Photos on p. i (title page), 58, 88 (bottom right), 97, 101, 113, 114 (top left), 129, 131, 133, 134 (top left), 137, 141–42, 145–46, 159–60, 175, 180 (bottom left), 184, 190–91, 192 (top), 201 (top) by Keith Torrie; p. iii (contents), 134 (bottom right), 135 (bottom left), 138–39, 143–44, 148–49, 150 (bottom row), 152, 156–58, 161, 163–67, 169–70, 172, 173 (right), 174, 176, 180 (bottom center, bottom right), 182–83, 187, 189 (top left), 193 (left), 198, 205 (top right) by Linda Cataffo; p. 2 (top right), 18 (top left), 29, by Joe Costa; p. 3 (top left), 8, 37, 48, 78 by Hank Olen; p. 3 (bottom right) by Ed Jackson; p. 12 by Larry Froeber; p. 31, 46, 51–52 by Tom Watson; p. 32, 37 (top right), 39–40, 50, 53, 54 (top center), 61, 64, 71, 72 (bottom right), 75, 81, 83 by Charles Hoff; p. 38 by Levine; p. 42 by Leroy Jakob; p. 44 by Bob Seelig; p. 63, 67, 78 (inset) by Frank Hurley; p. 54–55 (background) by Al Pucci; p. 57 (top row) by Charles Payne; p. 57 (bottom left), 88 (bottom left) by Ed Clarity; p. 57 (bottom right) by Fred Morgan; p. 59 by Walter Kelleher; p. 65 by Ed Peters; p. 72 (top center), 77 by Jim Mooney; p. 73 (bottom), 74, 79 by John Duprey; p. 74 (inset) by Phil Greitzer; p. 80 by John Campbell; p. 84–85, 91–92, 106, 107 (left column), 109, 122–23, 128 by Dan Farrell; p. 87, 89 (bottom left), 96, 98, 99 (bottom), 119, 136 by Vincent Riehl; p. 88 (top left), 94 (top right), 95, 107 (right) by Anthony Casale; p. 88 (top right), 94 (top left) by Paul DeMaria; p. 93 by Bill Stahl Jr.; p. 94 (bottom left) by Tom Cunningham; p. 94 (bottom right) by Jim Hughes; p. 99 (top row), 102 by Gene Kappock; p. 103, 105 by Dick Lewis; p. 108 (top right) by Roy Morsch; p. 108 (bottom right) by Anthony Pescatore; p. 140, 147, 153, 154 by Gerald Herbert; p. 121 by Harry Hamburg; p. 126 by Nicole Bengiveno; p. 130 by Dan Cronin; p. 134 (bottom left) by Bill Turnbull; p. 150 (top left, middle left), 151 (left) by Susan Watts; p. 150 (top right), 162, 178, 186, 189 (bottom row), 193 (right), 195, 196, 208 (left, top right), 216 by Howard Earl Simmons; p. 151 (right), 173 (left) by Jon Naso; p. 155 by Misha Erwit; p. 171, 179, 210 (top left), 188, 189 (top right), 201 (bottom), 205 (top left, bottom), 208 (middle right, bottom right), 210 (bottom center), 213–15, 217 by Corey Sipkin; p. 177 by Mike Albans; p. 180 (top right) by David Handschuh; p. 181 (top right, bottom center), 212 by Andrew Theodorakis; p. 185, 192 (bottom), 199, 202 by Andrew Savulich; p. 197, 204, 207 by James Kelvom; p. 200, 203 by Ron Antonelli; p. 206 by Robert Sabo; and p. 210 (top right) by Anthony DelMundo.

CONTENTS

100
YEARS
in Pinstripes

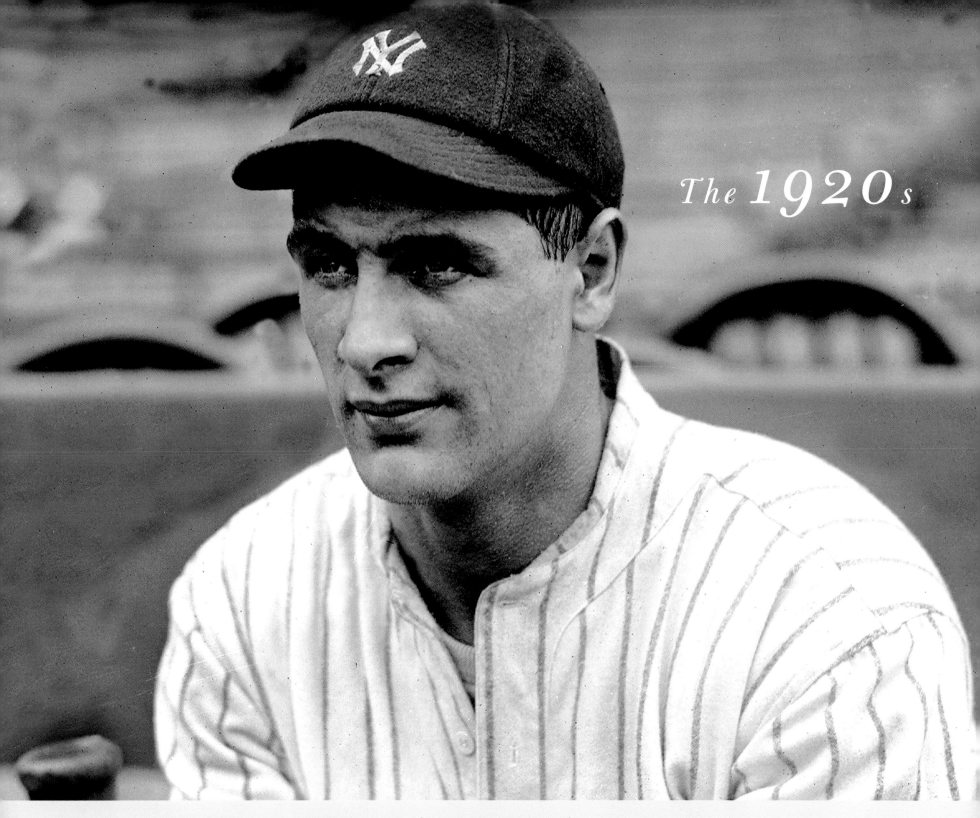

The 1920s

Lou Gehrig in 1923, his rookie year

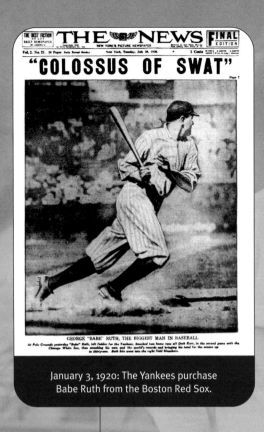

"COLOSSUS OF SWAT"

GEORGE "BABE" RUTH, THE BIGGEST MAN IN BASEBALL.

January 3, 1920: The Yankees purchase
Babe Ruth from the Boston Red Sox.

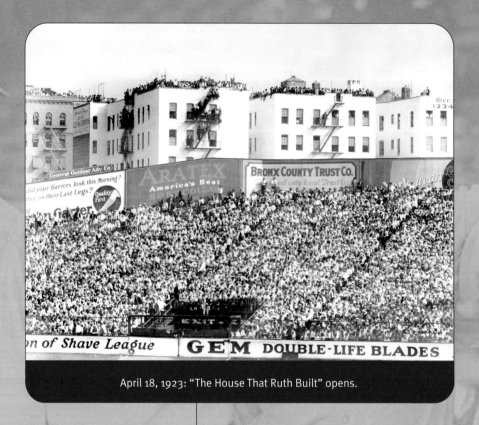

April 18, 1923: "The House That Ruth Built" opens.

1920 *1921* *1922* *1923* *1924*

September 1921: The Yankees
clinch their first AL pennant.

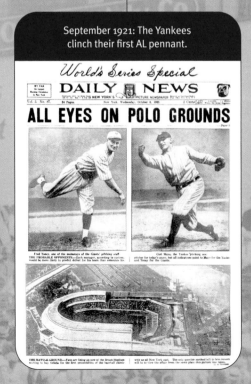

World's Series Special

ALL EYES ON POLO GROUNDS

October 15, 1923: Yankees win
their first World Series.

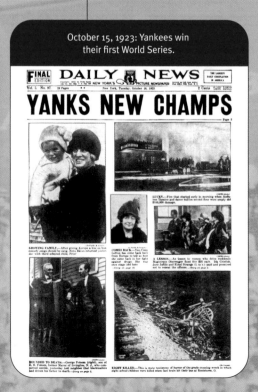

YANKS NEW CHAMPS

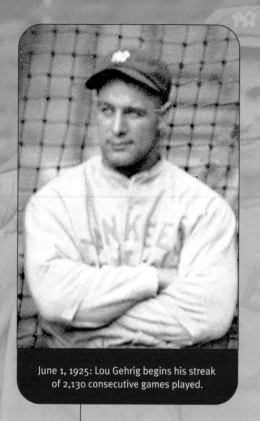

June 1, 1925: Lou Gehrig begins his streak of 2,130 consecutive games played.

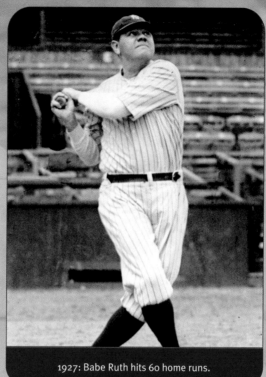

1927: Babe Ruth hits 60 home runs.

April 16, 1929: Yankees become the first team with permanent uniform numbers (which became standard for all teams by 1932).

1925 1926 1927 1928 1929

1927: The "Murderers' Row" Yankees go 110–44 and sweep the Pittsburgh Pirates to win the World Series.

September 25, 1929: Miller Huggins, the manager who led the Yankees to their first six AL pennants and their first three World Series titles, dies.

1928: The Yankees win the 1928 championship, sweeping the World Series for the second year in a row.

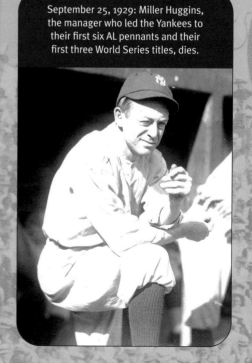

New York, Tuesday, January 6, 1920

$150,000 AMOUNT YANKEES PAID TO FRAZEE, IS REPORT

Southpaw Brings Three Times as Much as Speaker; Ruth Now in West

Babe Ruth, the home-run king, now a holdout for $20,000 a season, had been sold by the Boston Americans to the New York Yankees, it was announced here tonight by Col. Jacob Ruppert, one of the Yankee owners.

Although the price was not made public it is said to be in the neighborhood of $150,000.

Refusing to state the price paid Harry Frazee for Ruth's release, the Yankee magnate did say that his club offered $100,000 for Ruth some time ago and was turned down. The sale price was by many thousands the largest ever paid for one player, Ruppert said.

Ruth, who knocked twenty-nine homers last season, is now in Los Angeles, whence he sends out periodic reiterations of his demand for $20,000 a year, although his three-year contract with the Boston club, at $10,000 a season, still has two years to run.

Miller Huggins, manager of the Yankees, also is said to be in Los Angeles, trying to achieve a compromise dicker with Ruth.

Ruth probably will play right field for the Yankees. The price supposed to have been paid for Ruth is three times the sum paid for Tris Speaker or Eddie Collins, who were sold for $50,000 each. Col. Ruppert says the purchase is in line with the policy to give New York a pennant-winning team in the American League and as evidence of the faith the Yankee owners have in the future of baseball. ⬚

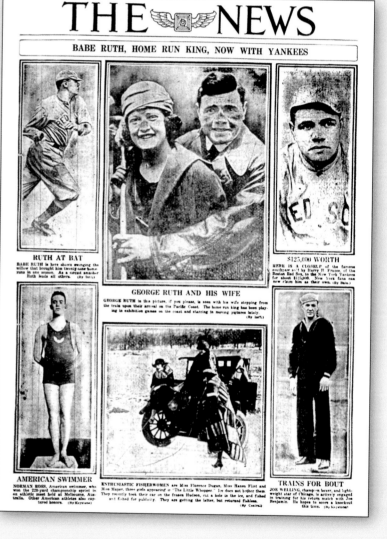

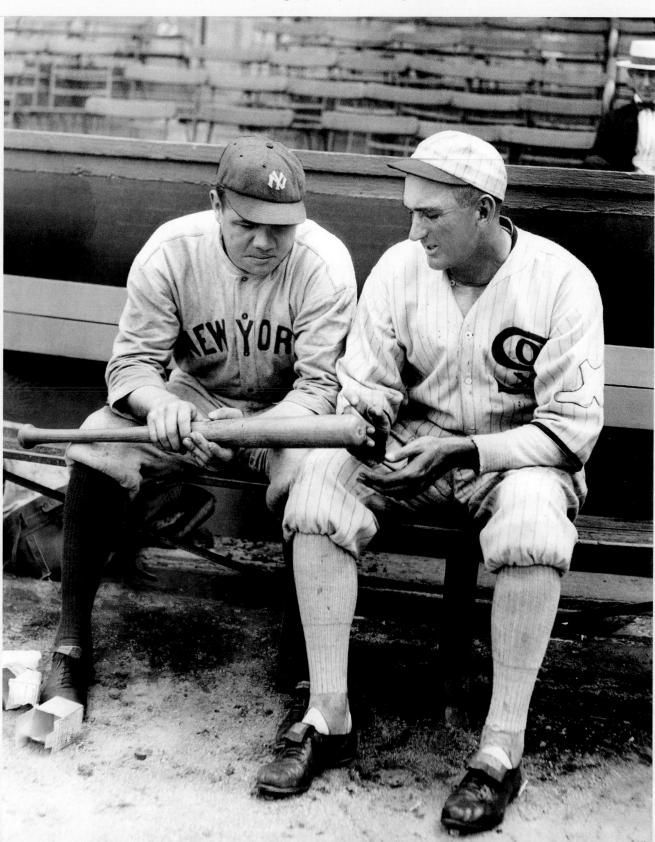

The New York Yankees' new slugger Babe Ruth and Shoeless Joe Jackson of the Chicago White Sox look at one of Babe's home-run bats.

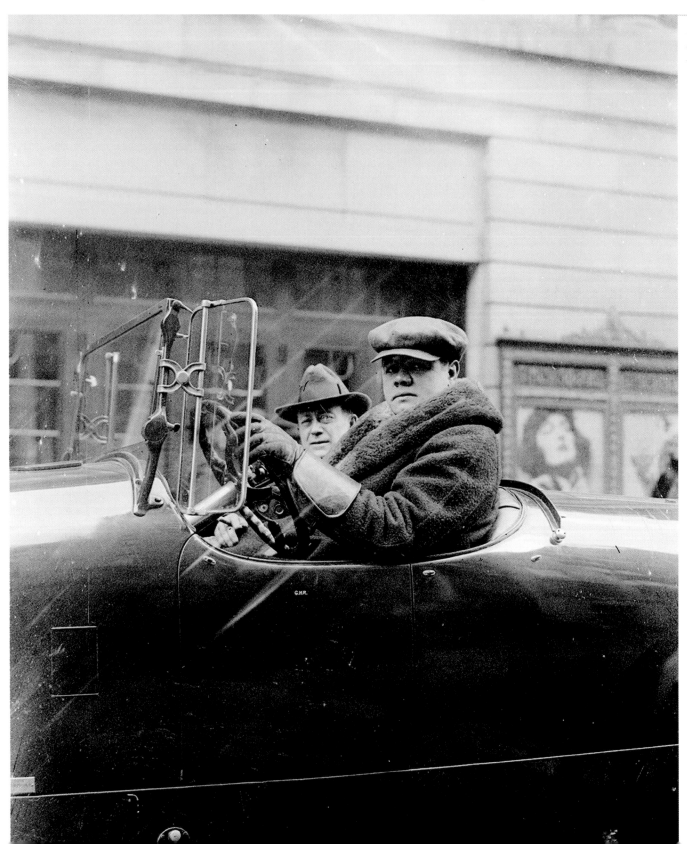

Babe Ruth with Yankees' manager Miller Huggins in February 1921.

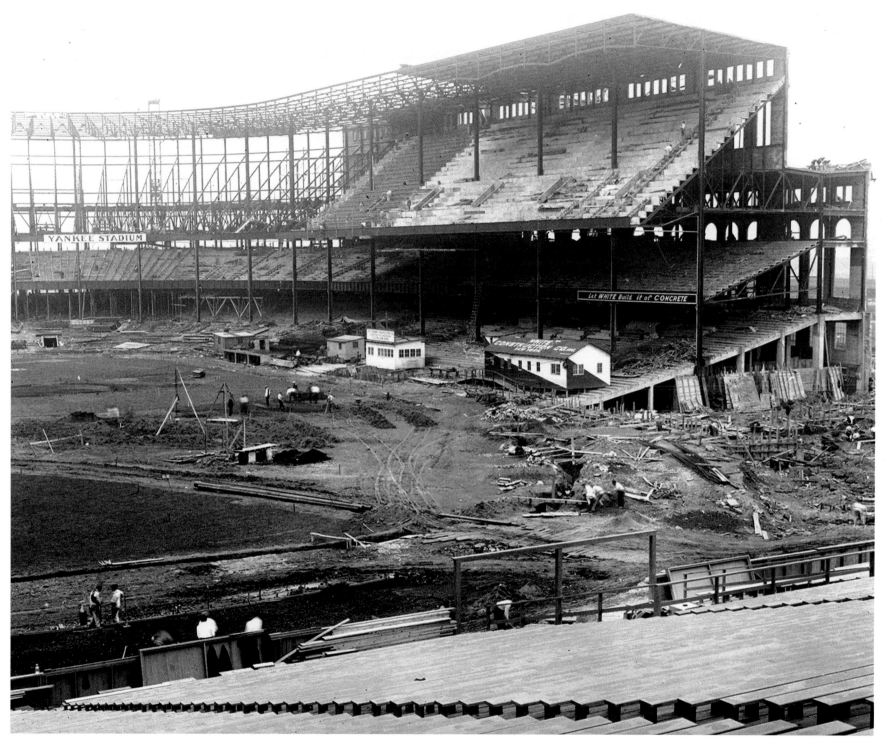

October 16, 1922: The House That Ruth Built rapidly nears completion, with part of the grandstands (upper right) already finished. The new stadium will be able to seat 75,000 fans.

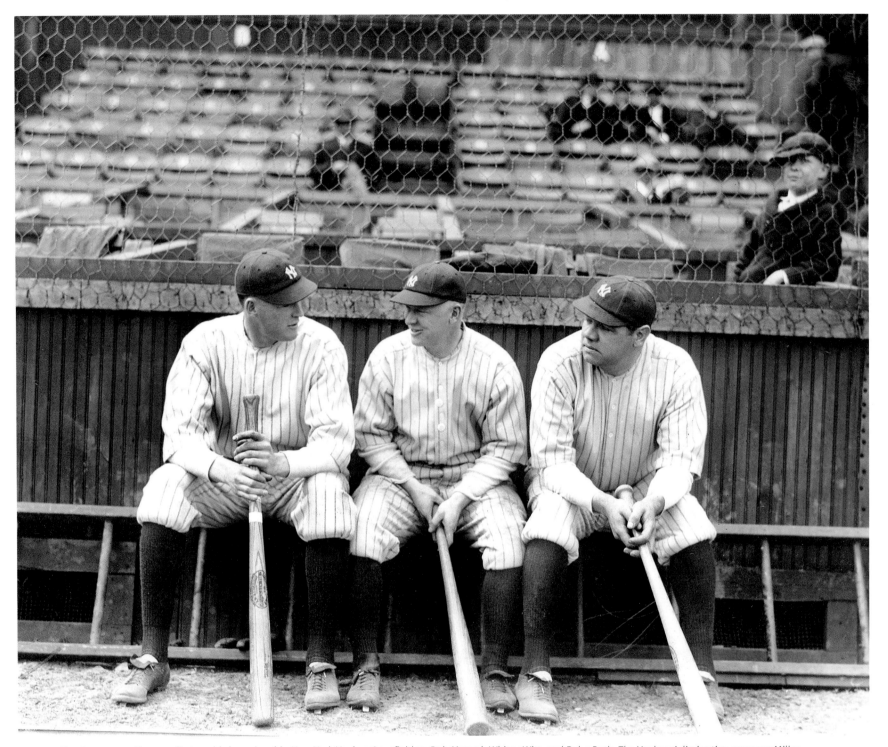

March 25, 1924. The very first world championship New York Yankees' outfielders Bob Meusel, Whitey Witt, and Babe Ruth. The Yankees' diminutive manager Miller Huggins (facing page) demonstrates his technique for coaching base runners at third.

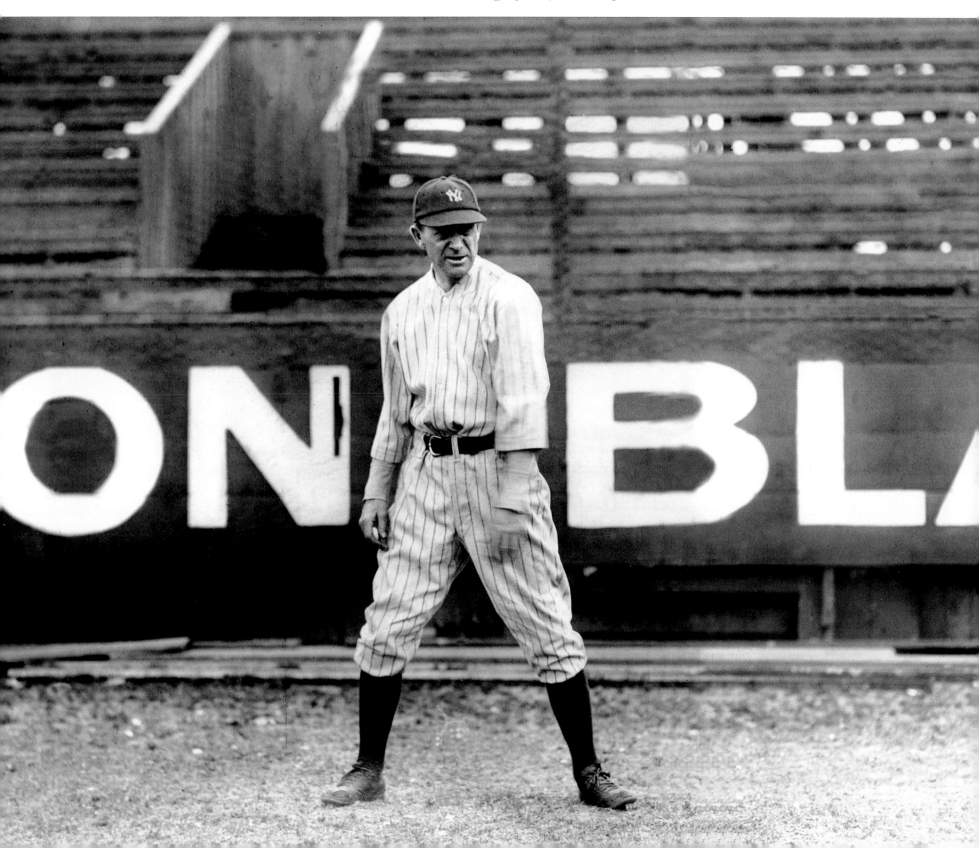

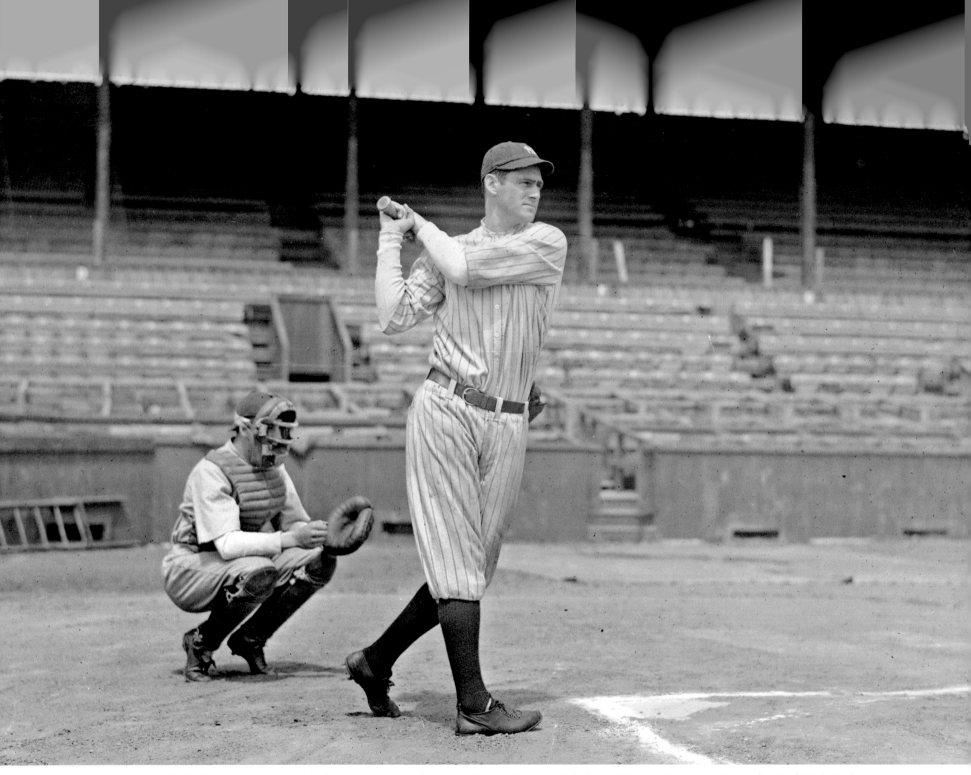

Earle Combs, the Yankees regular center fielder from 1925 to 1933, takes a practice swing in 1926. Combs had a career .325 batting average and was inducted into the Hall of Fame in 1970. Babe Ruth (facing page) bats during the 1926 season.

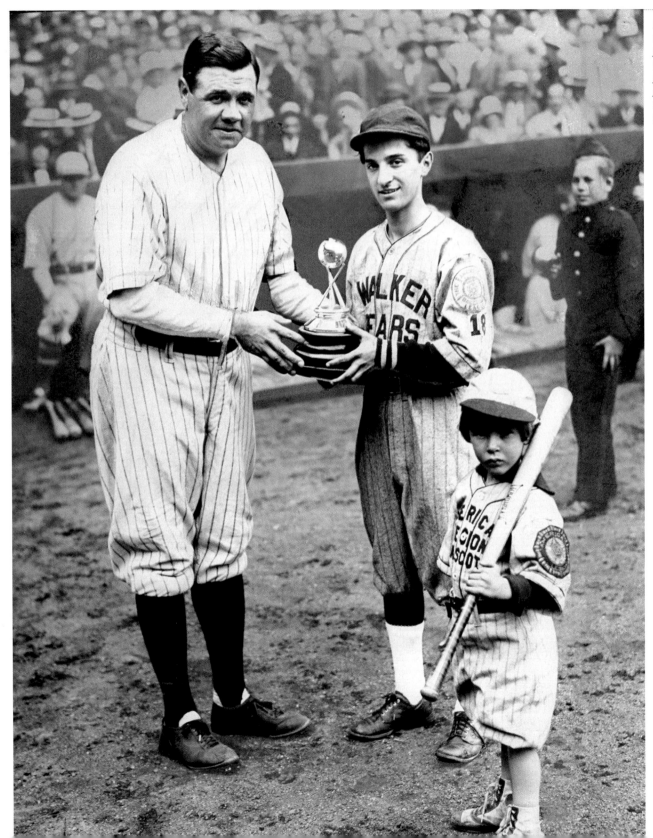

Babe Ruth hands Al Calistro, manager of Jimmy Walker's Bears, the trophy for the Bears' Junior Championship on June 20, 1928. Mascot Fred Garland, holding the bat, looks on.

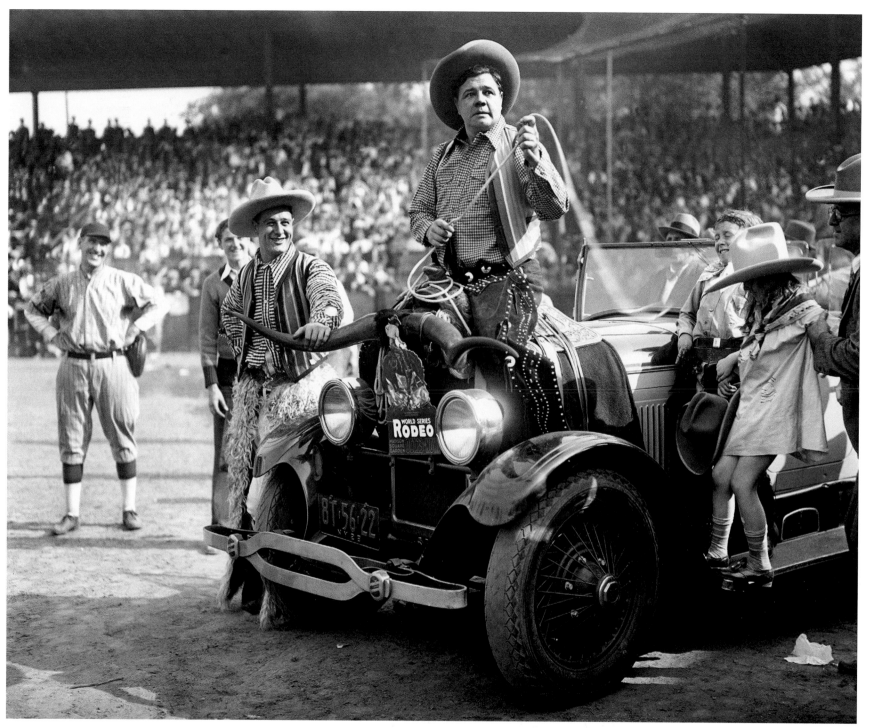

With Lou Gehrig riding shotgun, Babe Ruth and the Yankees lassoed big crowds wherever they went. Fresh off a four-game sweep of the St. Louis Cardinals in the 1928 World Series, Ruth and Gehrig give rodeo a try.

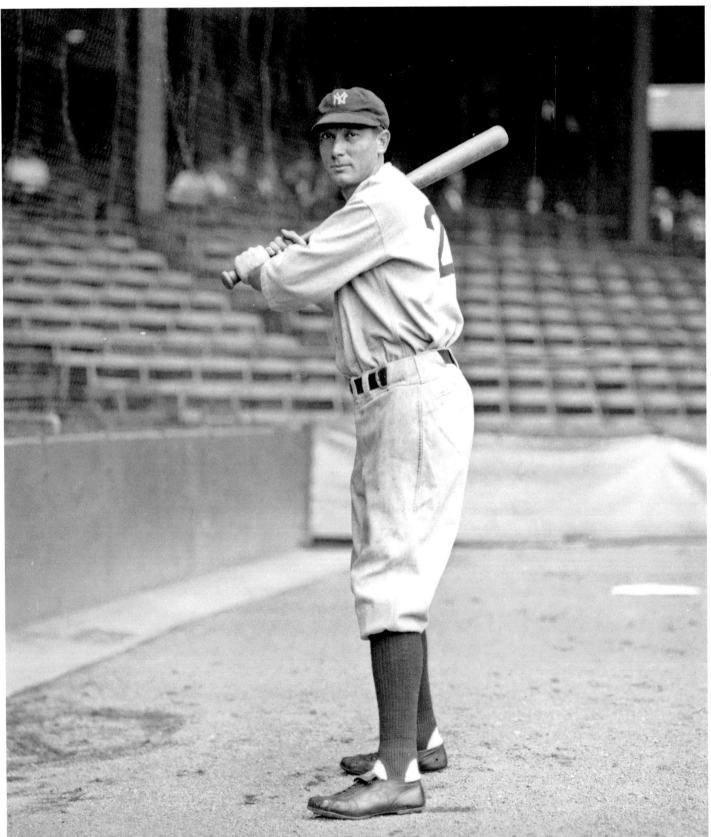

Yankees second baseman Tony Lazzeri began his Hall of Fame career in 1926 and would go on to win five World Series titles over 12 full seasons with the team.

When officers of the Japanese Fleet (facing page) visited Yankee Stadium on September 29, 1927, Babe Ruth, who equaled his home-run record of 59 on the occasion of their visit with two homers, drew one of the short swords from the sheath of one of the officers and proceeded to test the sharpness of the blade by attempting to use it as a razor.

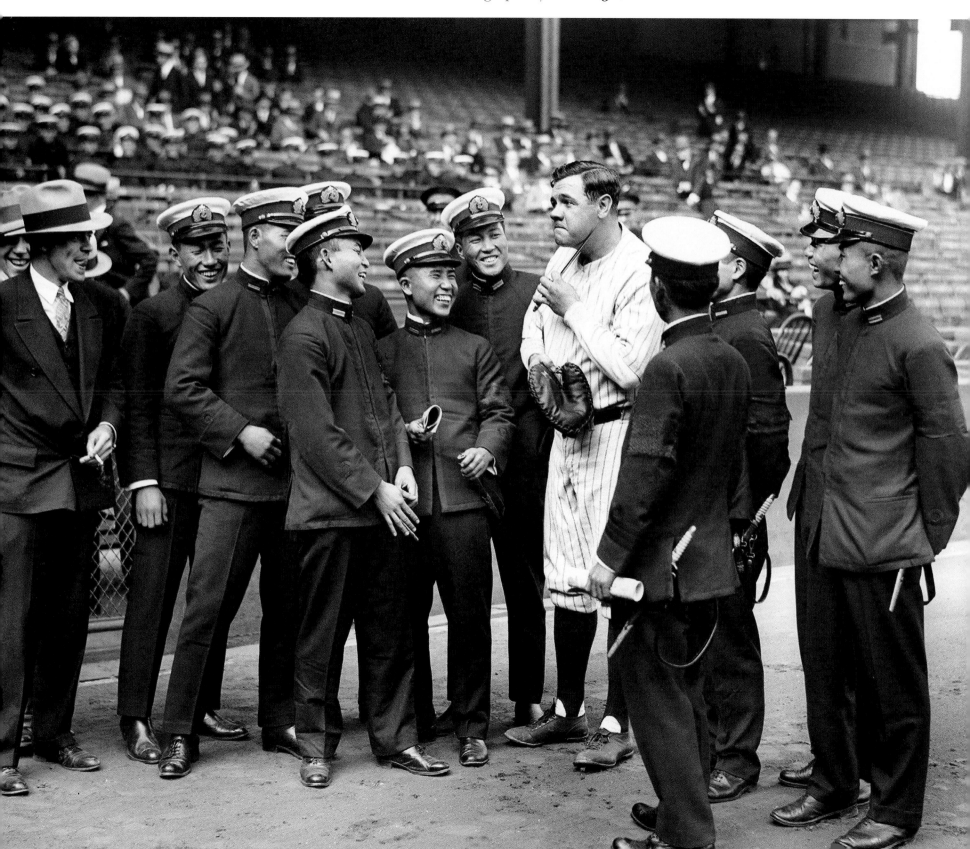

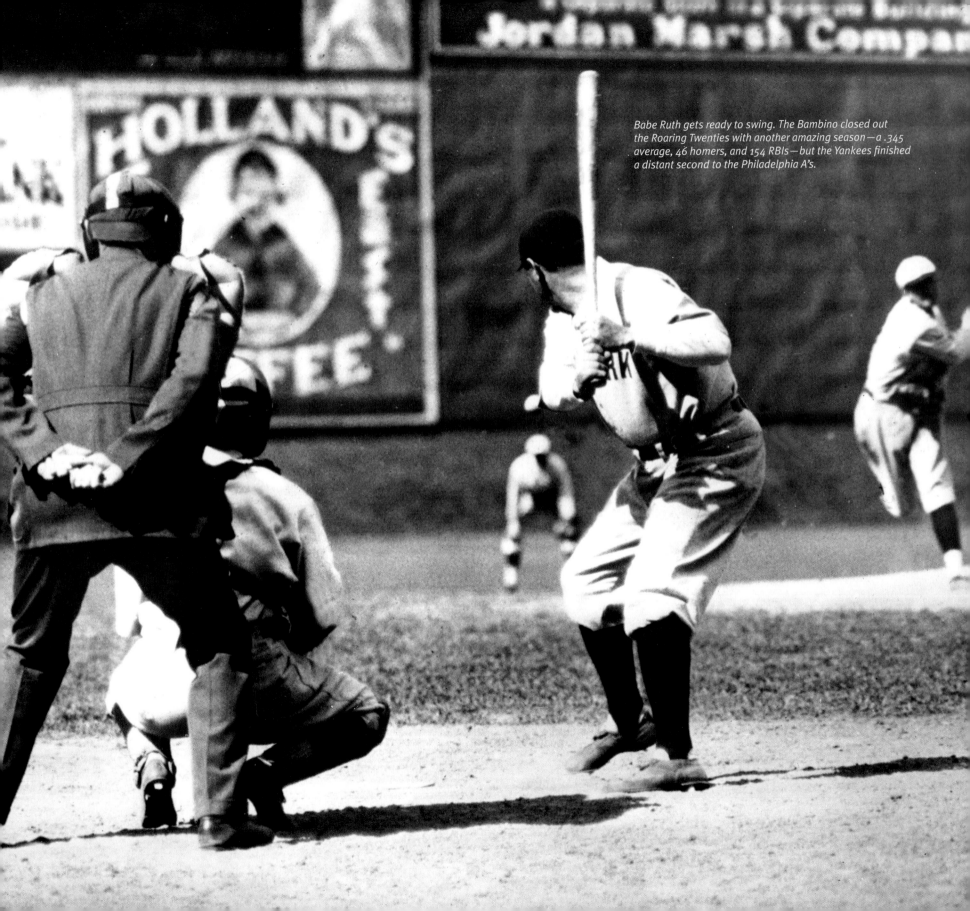

Babe Ruth gets ready to swing. The Bambino closed out the Roaring Twenties with another amazing season—a .345 average, 46 homers, and 154 RBIs—but the Yankees finished a distant second to the Philadelphia A's.

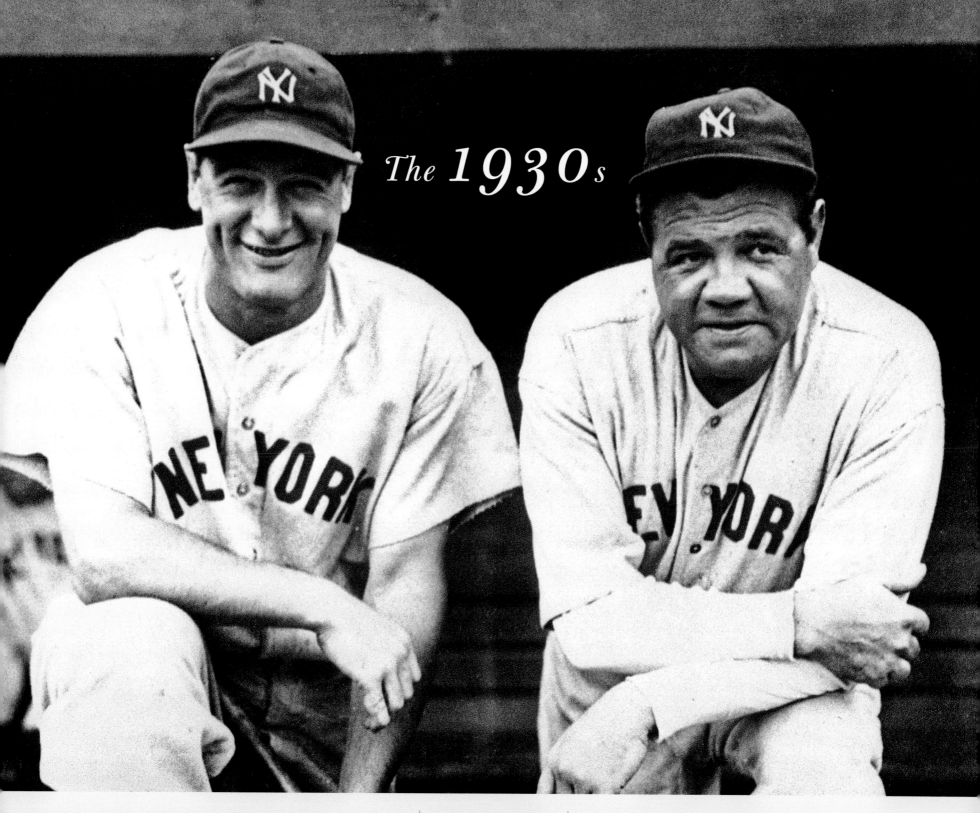

The 1930s

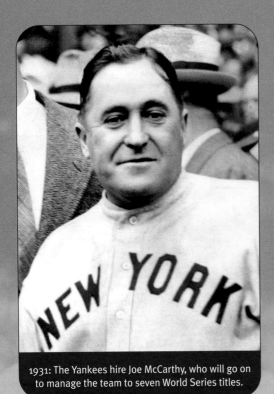

1931: The Yankees hire Joe McCarthy, who will go on to manage the team to seven World Series titles.

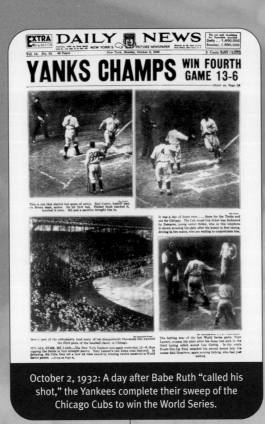

October 2, 1932: A day after Babe Ruth "called his shot," the Yankees complete their sweep of the Chicago Cubs to win the World Series.

November 21, 1934: The Yankees purchase Joe DiMaggio from the San Francisco Seals of the Pacific Coast League for $50,000.

1930 1931 1932 1933 1934

July 14, 1934: Babe Ruth hits the 700th home run of his career.

1934: Lou Gehrig wins the Triple Crown.

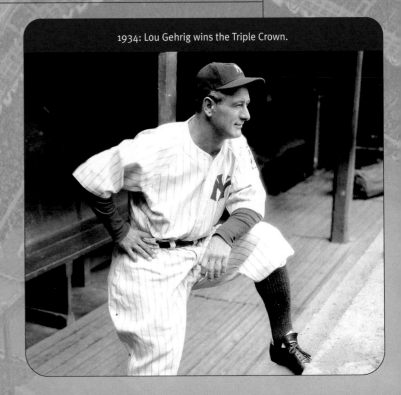

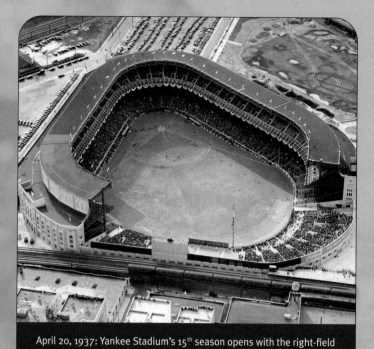

April 20, 1937: Yankee Stadium's 15th season opens with the right-field stands enlarged to three decks, wooden bleachers replaced by a concrete structure, and the center-field distance dropping from 490 to 461 feet.

1936: The Yankees win the World Series, four games to two, over the New York Giants.

1937: The Yankees win the World Series, four games to one, over the New York Giants for the second year in a row.

1938: The Yankees sweep the Chicago Cubs to win their third straight World Series title.

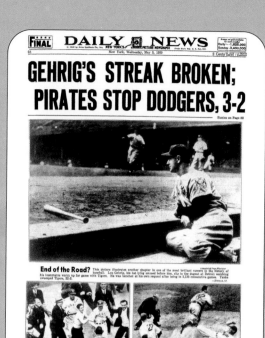

GEHRIG'S STREAK BROKEN; PIRATES STOP DODGERS, 3-2

May 2, 1939: Lou Gehrig's playing streak of 2,130 consecutive games ends.

1935 1936 1937 1938 1939

July 4, 1939: Lou Gehrig Appreciation Day: Gehrig's No. 4 is retired (the first in MLB history) and Gehrig makes his famous "Today I consider myself the luckiest man on the face of the Earth" speech.

1939: The Yankees sweep the Cincinnati Reds to win their fourth consecutive World Series.

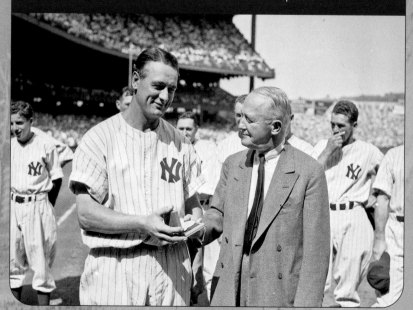

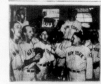
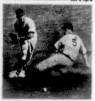
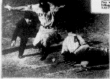

YANKS WIN SERIES FOR 4TH STRAIGHT

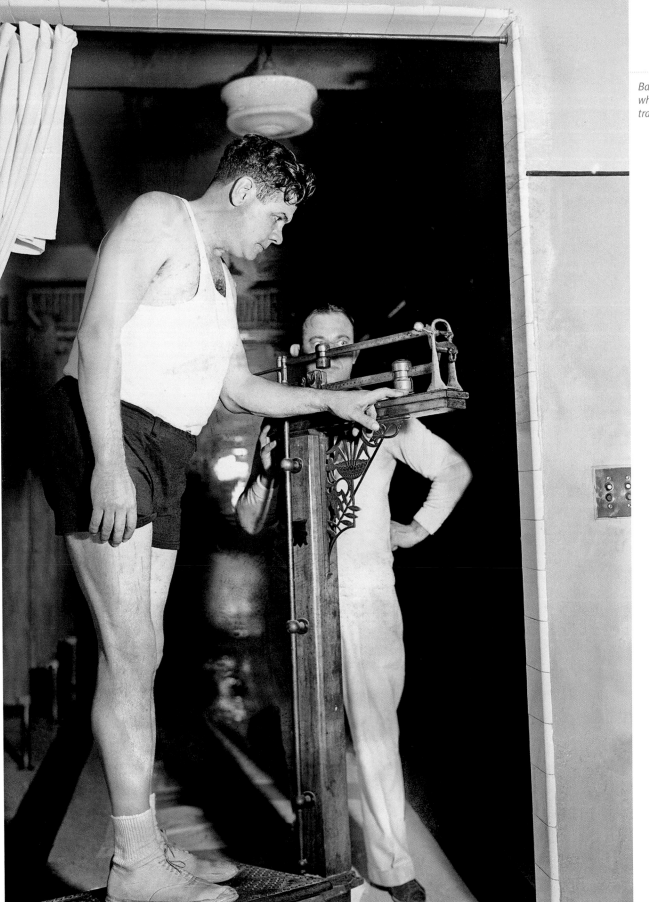

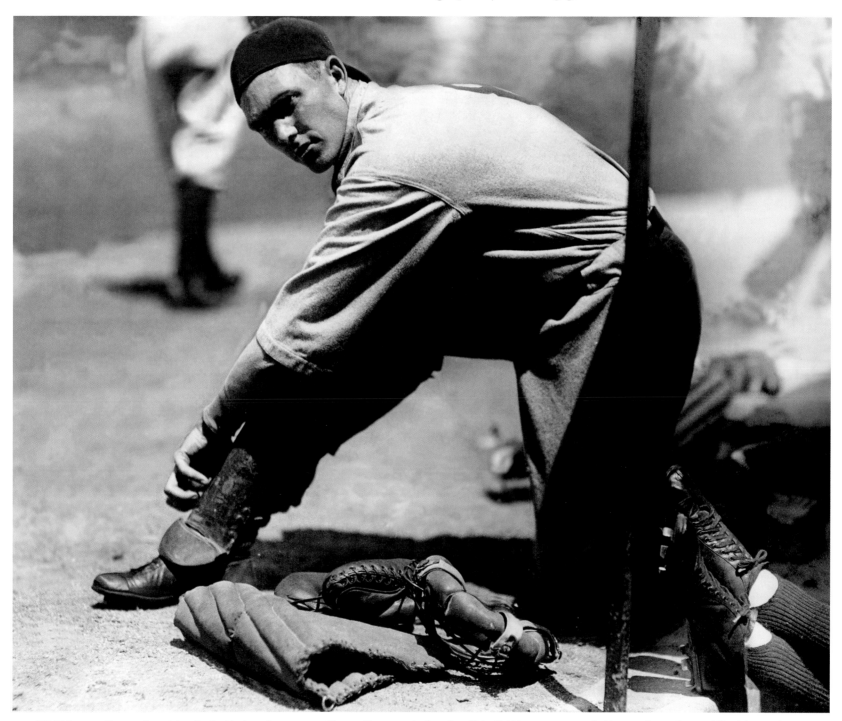

Bill Dickey was the regular catcher for the Yankees from 1929 until 1941. He was typically quiet off the field but was suspended in 1932 for 30 days and fined $1,000 for punching Carl Reynolds in the mouth after Reynolds, a Washington Senators outfielder, crashed into Dickey while scoring on a squeeze play that tied the game. A lifetime .313 hitter with more than 200 homers and 1,200 RBIs, he was elected to the Hall of Fame in 1954.

New York, Sunday, October 2, 1932

THIRD IN ROW FOR YANKS, 7–5

Babe, Lou Get Two Homers Each as Cubs Are Beaten

By Paul Gallico

Wrigley Field, Chicago, October 1—The show is on—the World Series has finally clicked. In a tense, dramatic ballgame full of thrills and chills and terrific cannonading, the Yankees defeated the Cubs here this afternoon for the third successive time in the current series by the score of 7–5. It was the 11th straight World Series game the Yankees have won. One more and they will have set a record that probably would stand for all time.

Babe Ruth hit two home runs, one of them the longest ever, a smash that dropped over the wire screen into the farthermost corner of the right-center-field bleachers. Lou Gehrig hit two home runs into the right-field stands. In the fifth inning, Babe and Lou smashed them in succession, breaking a tie and winning the ballgame with a display of brutal hitting power that let all of the pep and courage out of the Cubs the way sawdust seeps out of a broken doll.

And for the final thrill, Herb Pennock, veteran pitcher who has never lost a World Series game, walked out to the mound in the ninth inning when Pipgras faltered and the Cubs rallied, and with the excited screams of 50,000 partisan fans rattling about his ears, calmly pitched the Chicago batters into subjection and saved the game.

Just Like That

The way the Cubs can get into trouble opening a ballgame is simply amazing. Combs, up first, hit an easy grounder to Jurges who had all the time in the world to throw to Grimm. The Cub shortstop fired the ball right into the Yankee dugout.

Little Sewell came to bat, crouched low over the plate and teased Charley Root, upon whom the Cubs were relying to stop the Yankees, into giving him a base on balls.

Thus, Combs on second, Sewell on first. Babe Ruth up. CRACK, that CRACK—that certain sound. Once you've heard it you never forget it. High into the center of the right-field stands.

Home run. Three runs over the plate. There you are, Mr. Pipgras. Go in and pitch!

Pipgras Not So Hot

Big George didn't start any too auspiciously either, for that matter. He passed Herman, got English on a long fly to Ruth, but Cuyler hit a whistling double to right and Herman scored. Crosetti threw out Stephenson, Moore walked, but Grimm grounded to Crosetti, ending the inning.

The Yanks lay low in the next inning, although there was one pregnant smack that might have been. After Pipgras fanned and Combs flied out to center, Sewell teased another walk out of Root, annoying him no end, and who was at bat again? You know.

The Babe swung, Cuyler got the imprint off the right-field fence on the seat of his pants for a moment, came forward a few feet and caught the ball. Ten feet more and it would have been a home run.

The Cubs' second frame was distinguished only by Jurges who hit a single and stole second, but nothing came of it. Pipgras was nicely in control of the the situation. Lou Gehrig, who had grounded out in the first, opened the third inning for the Yankees. He took his bat off his shoulder, met one of Root's specials coming in collar-bone high and whipped it into the right-field stands for his first home run of the game, making the score 4–1 in favor of the Yankees.

Now we note a Cub uprising in the last half of the third. With one out, Kiki Cuyler dumped the ball into the middle of the right-field stands for a home run, his second consecutive hit. Stephenson singled. Moore forced him at second, but Charley Grimm hit a lashing double that Chapman, playing in right field (Ruth was in left because of the sun) misjudged off the fence, and by the time he had located the ball and picked it up, Moore had scored from first, making the score 4–3, with the Yankees but one run out in front.

(Continued on p. 24)

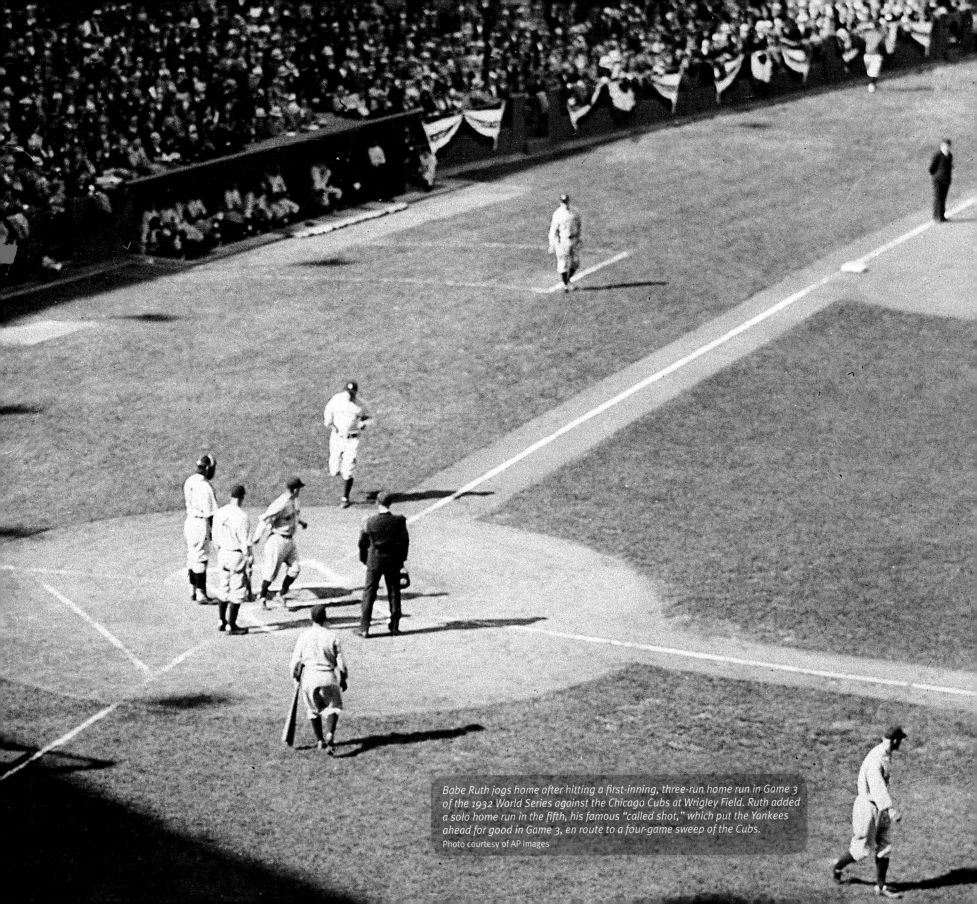

Babe Ruth jogs home after hitting a first-inning, three-run home run in Game 3 of the 1932 World Series against the Chicago Cubs at Wrigley Field. Ruth added a solo home run in the fifth, his famous "called shot," which put the Yankees ahead for good in Game 3, en route to a four-game sweep of the Cubs.
Photo courtesy of AP Images

Cubs Tie It

The New Yorkers perished in an orderly manner, one—two—three, to start the fourth inning, but the Cubs sent the 49,986 addicts into hysteria when they tied the score on a long double by Jurges and an odoriferous error by Master Lazzeri at second base.

Jurges pasted the ball out to Ruth who came in like a charging bull in an attempt to take it off his shoe tops. He missed but carried the ball along with him and finally wound up sitting on it, after sliding along a few yards on his face.

When he finally extracted it from beneath his person, Jurges was on second. English, next up, slapped a grounder to Lazzeri who fielded it, dropped it, kicked it, lost it, and finally stood there just being ashamed. Crosetti ran up behind him and made a wild throw to Dickey, pulling him so far from the plate that Jurges had no trouble scoring the tying run.

However, two were already out and when English tried to steal second, Dickey cut him down with a perfect throw to Lazzeri.

The Great Man Again

Well, we now come to the dessert—the crème-de-la-crème. This is what you have been waiting for. This is how the ballgame was won. Sewell grounded out to open the fifth and the Great Man came to bat again. Root wound up and pitched. Strike one, the crowd booed. Babe Ruth held up one finger to the Cub dugout to indicate that but one strike had passed.

Again Root threw. Ball one. Another windup. Another pitch. Strike two. The crowd roared, yelled, and cat-called. The Babe merely held up two fingers to the Cub dugout to show that there was still another pitch coming to him. He also did a little plain and fancy leering and then faced Root again with the bat clutched in the end of his fingers.

Windup. Pitch. Flash of ball! Crack! Goombye! The pellet sailed high, wide, and handsome straight out for the flagpole to the right of the scoreboard in center field, where it sank into the clutching hands of customers seated in the extreme left end of the right-field bleachers.

The Babe ran around the bases gesticulating at the Cub dugout, mocking them, teasing them, and holding up three fingers. Oh, my New York constituents, how your heart would have warmed had you seen the Ruth thus confounding his enemies, thus making his run.

The hubbub had not yet died away. The crowd had not yet settled down. The senses had not yet had time to digest the Great Man's latest miracle, when there came another sharp "crack" and Lou Gehrig, next up, had smashed his second home run of the day over the right-field fence but just inside the foul line.

It blew Root right out of the game. Two home-run balls in succession was too much.

They wouldn't let him chuck anymore. Pat Malone came in and promptly walked Lazzeri and Dickey. But Chapman could do nothing about it and grounded out. Malone walked Crosetti to get at Pipgras and struck him out. Score: Yankees 6, Cubs 4.

Is that fun or isn't it?

Three Cubs faced Pipgras in each of the fifth, sixth, seventh, and eighth innings. Three numb Cubs, dazed Cubs, puzzled Cubs, to an inning. No more no less.

One More for Yanks

The Yanks came up for the ninth inning. Gehrig popped up to the infield. Gabby Hartnett carted himself, trappings and all into the melee, galloped around in circles, bumped Jurges, bumped English, bumped Malone, Tinning. English finally managed to retain the ball.

Gabby retired, blushing. Lazzeri hit the same kind of ball high over the infield. Again Master Hartnett galloped onto the diamond. This time they all gave him plenty of room. He stuck out his big glove. The ball bounced in. Then it bounced out. The heat from Hartnett's blushes, this time, was felt up in the press box.

Dickey lifted a fly to Herman back of second. Herman dropped it. The invitation to score was too tempting. Chapman slashed a double inside third base and Lazzeri came in with the last Yankee run, as Crosetti and Pipgras were easy outs.

Lotsa Trepidation

But the Cubs have always been known as a strong ninth-inning club and when Gabby Hartnett atoned for his misdeeds by opening the ninth with a home run to the top of the left-field bleachers, there was trepidation. And when Jurges hit a single into left, his third hit of the day, there was more than trepidation: there was action!

Joe McCarthy came out of the dugout. Big George Pipgras looked in his direction and then marched off the field. And Herb

Pennock, who had been warming up along with Wiley Moore in the bullpen, heard the umpire calling him in to take up the desperate job of stopping a pinch-hitter and the top of the Cubs' batting order.

Yes, here was your World Series drama, your plot and your play. Veteran pitcher called in to save game. On the train hither-bound someone asked Pennock whether he thought he would get in the Series. He said: "I don't think so." But added wistfully, "But gee, I'd like to just once more."

And so there he was. Catcher Hemsley came in to pinch-hit. Pitching slowly and gracefully, Pennock struck him out. But that dangerous run was still on first and Herman and English coming up. A home run would tie the score. A batting rally would win the game.

Herman swung from his shoulder and sent a weak grounder to Pennock, who guided it tenderly over to Gehrig. English took a healthy slash at the ball. Lou Gehrig scuttled over to his right, came up with the ball, sprinted over first base and dug the ball deep into English's middle, with a follow-through that carried the Cub third baseman on nearly into the Yankee dugout.

That was game No. 3. There ended the drama. ▣

Temporary stands built beyond the left- and right-field walls of Wrigley Field accommodated thousands. The first row of extra bleacher seats stretched along the tops of the walls. The rear rows were as high as the ridge poles of houses across the streets....

This was the first World Series in which players of both teams wore numbers on their backs. Even Aunt Eliza from Peoria, attending her first baseball game, could tell who was batting, provided she had invested in a scorecard....

Ruth went over to the Cub dugout during batting practice and hollered something. When he returned to his own side of the field he shouted to the Cub rooters in the stands: "I was just telling 'em that was the last they'd see of the Yankee Stadium." A Cub rooter made a noise and another said: "Hit 'em to Ruth! Hit 'em to Ruth!" a reflection on the Babe's bobbles in right at the Stadium....

More about Ruth: He went into left field for practice and the charming characters infesting the bleachers there pelted him with apples and oranges. The Babe, grinning cheerfully, goaded them on and then threw them back.

Daily News coverage of the Yankees' clinching Game 4 victory against the Cubs in the 1932 World Series.

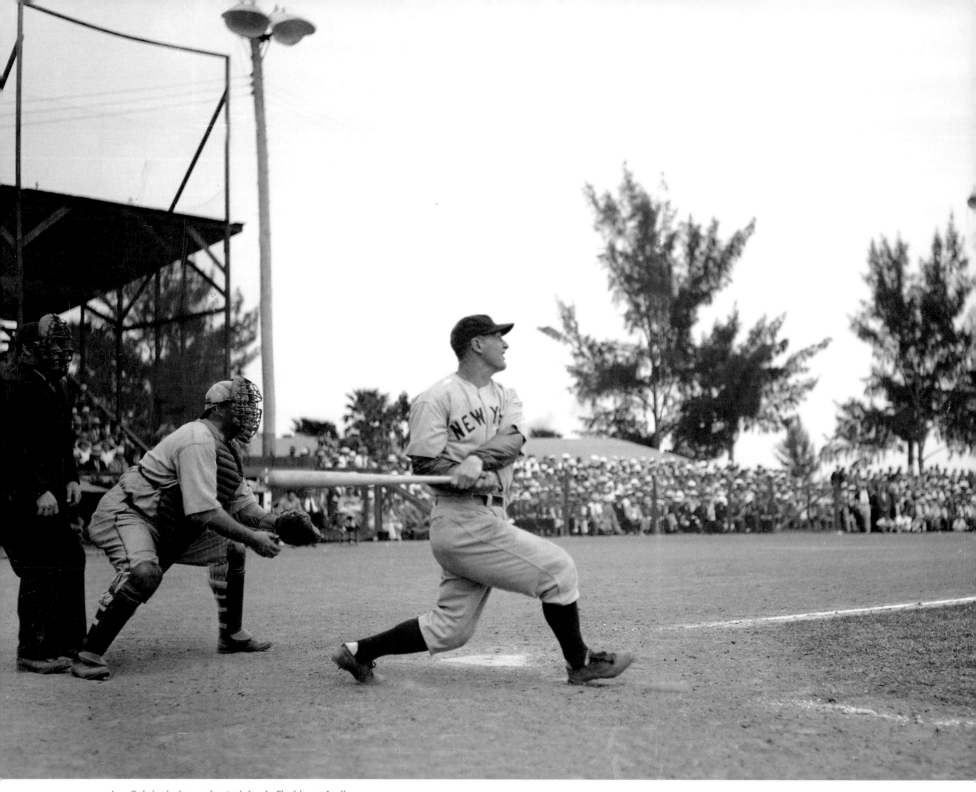

Lou Gehrig during spring training in Florida on April 1, 1934.

Babe Ruth holds an autographed bat for Prince and Princess Kaya of Japan at Yankee Stadium on August 15, 1934, where the Yankees went on to defeat the Detroit Tigers. Afterwards the royal pair went to a banquet held by the Japanese community at the Hotel Astor.

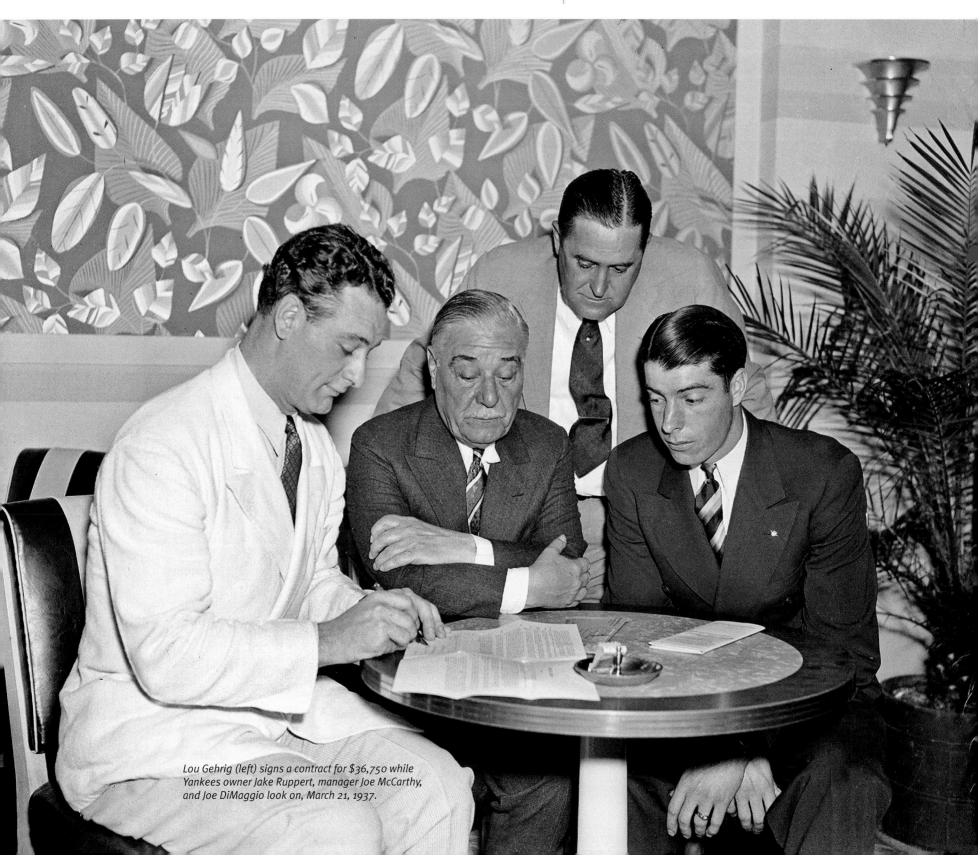

Lou Gehrig (left) signs a contract for $36,750 while Yankees owner Jake Ruppert, manager Joe McCarthy, and Joe DiMaggio look on, March 21, 1937.

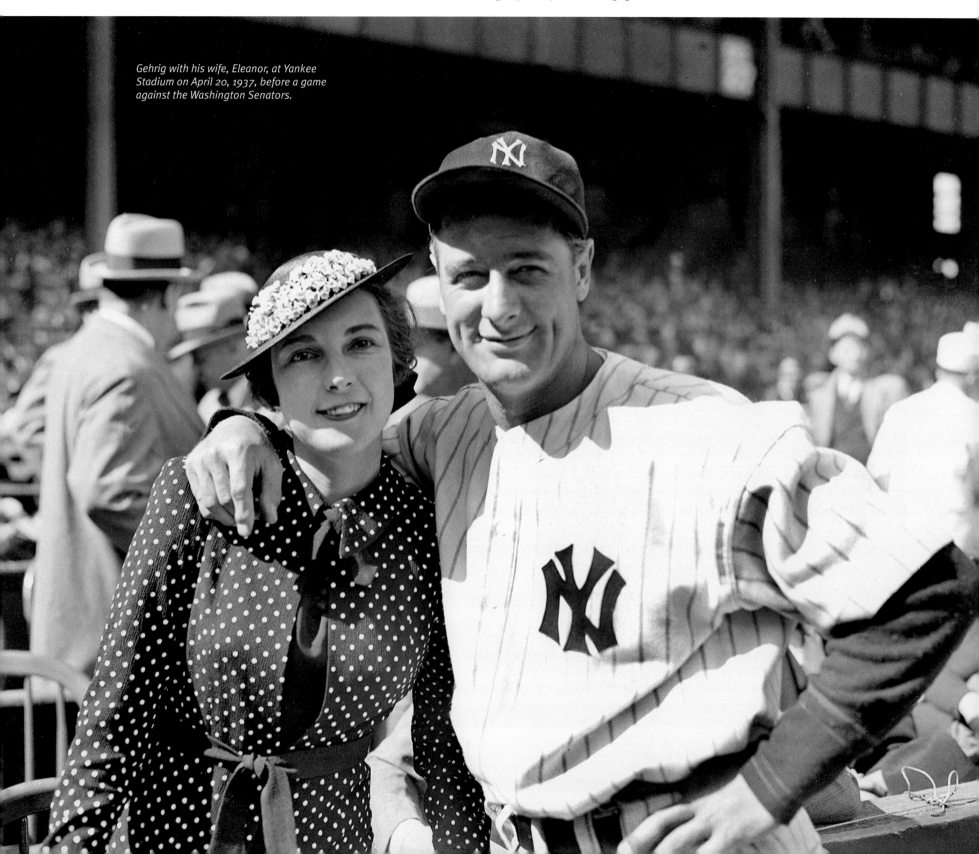

Gehrig with his wife, Eleanor, at Yankee Stadium on April 20, 1937, before a game against the Washington Senators.

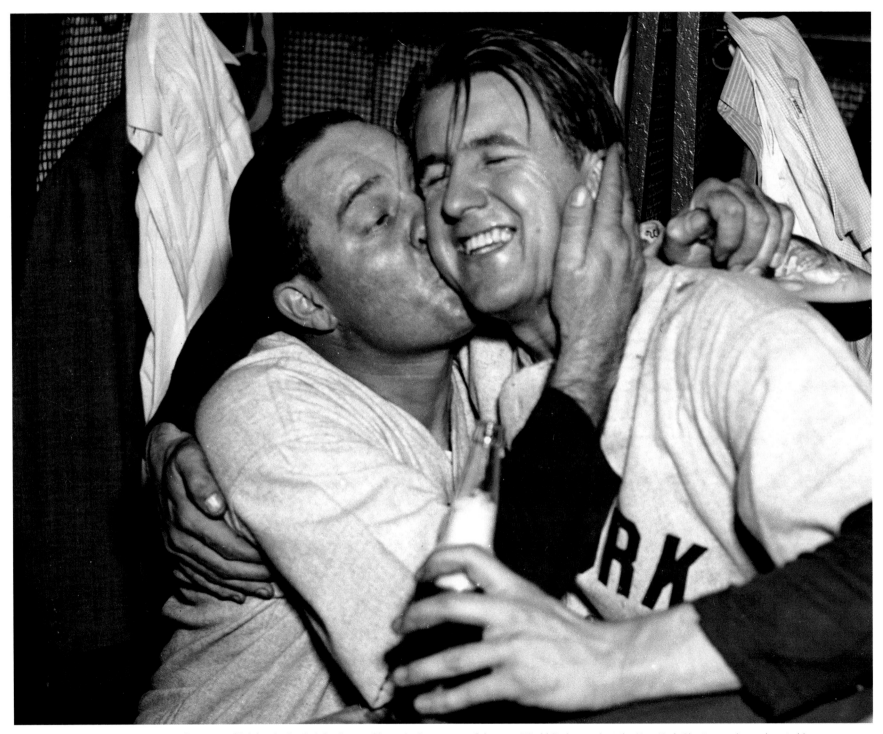

"I Kiss Your Face, Señor!" Lefty Gomez (right), who hurled the first and last winning games of the 1937 World Series against the New York Giants, receives a hearty kiss from his teammate, pitcher Pat Malone. With the 4–2 victory, the Yankees won the Series four games to one.

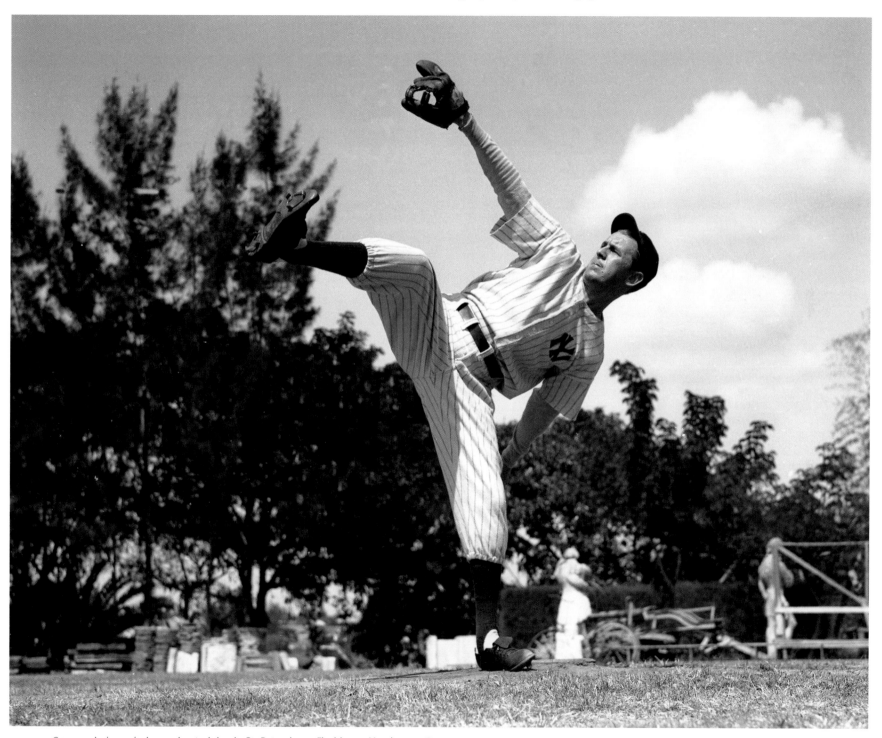

Gomez winds up during spring training in St. Petersburg, Florida, on March 7, 1938.

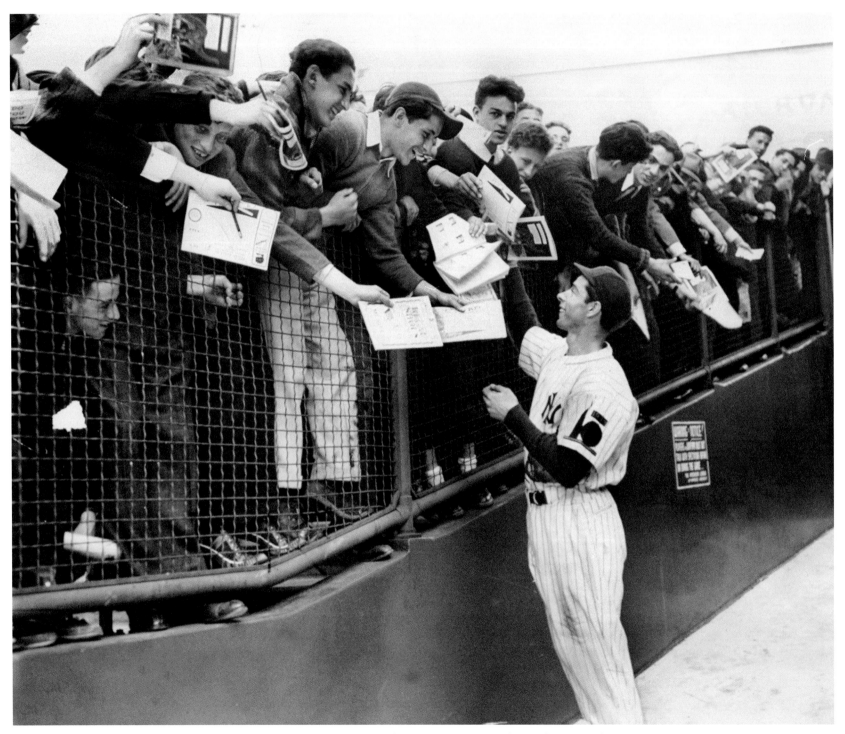

The Yankees' twenty-three-year-old center fielder Joe DiMaggio greets fans and signs autographs at Yankee Stadium on April 24, 1938.

New York, Wednesday, July 5, 1939

YANKS, 61,000 FANS HONOR LOU GEHRIG

"Ladies and gentlemen," apologized the master of ceremonies to the 61,808 at Yankee Stadium's Lou Gehrig Appreciation Day yesterday. "Lou has asked me to thank you all for him. He is too moved to speak." But the biggest baseball crowd of the year wouldn't stand for it. White-shirted waves roared for at least a few words.

And Gehrig came through again—this time with a great, heart-stirring speech instead of his accustomed baseball feats.

"Fans," Lou began, "for the past two weeks you have been reading about a bad break I got. Yet today I consider myself the luckiest man on the face of the Earth. I have been in ballparks 16 years, and have never received anything but kindness and encouragement from you fans."

Lou stopped to daub his eyes with a handkerchief as the stands delivered a throaty salute.

He continued: "Wouldn't you consider it an honor just to be with such great men even for one day?" He motioned to the Yanks of '39, baseball kings the past three seasons, lined up along with the Senators; from Lou at home plate to the band at the pitchers' box; and the Yanks of '27, greatest of all time, who had paraded earlier to the flag pole where their World Championship banner was raised.

Praises Former Bosses

Gehrig then paid tribute to the men he had been associated with in his 15-year career.

"Sure, I'm lucky! Who wouldn't consider it an honor to have known Jacob Ruppert, builder of baseball's greatest empire; to have spent six years with such a grand little fellow as Miller Huggins; to have spent the next nine years with that smart student of psychology—the best manager in baseball today, Joe McCarthy?

"Who wouldn't feel honored to room with such a grand guy as Bill Dickey?" Applause.

"When the New York Giants [boos], a team you would give your right arm to beat, and vice versa, sends a gift—that's something

[cheers]. When the groundskeepers and office staff and writers and old-timers and players and concessionaires all remember you with trophies—that's something.

"When you have a wonderful mother-in-law [boos], who takes sides with you in squabbles against her own daughter [cheers]—that's something. When you have a father and mother who work all their lives so that you can have an education and build your body—it's a blessing [cheers]. When you have a wife who has been a tower of strength, and shown more courage than you dreamed existed—that's the finest I know.

"So I close in saying that I might have had a tough break; but I have an awful lot to live for."

Tumultuous Cheers

Then followed the most tumultuous ovation the Stadium ever saw. Lou daubed handkerchief against nose and eyes as the fans screamed to the heavens, his friends patted his back, and the band played "Du, Du Liegst Mir im Herzen [You, You Are in My Heart]."

Among the baseball immortals come to pay honor to Lou were Mark Koenig, Wally Schang, Herb Pennock, Wally Pipp, Bob Shawkey, Benny Bengough, George Pipgras, Tony Lazzeri, Earle Combs, Joe Dugan, Waite Hoyt, Bob Meusel, Everett Scott, and Babe Ruth.

Mayor LaGuardia and Postmaster Farley saluted Gehrig in speech.

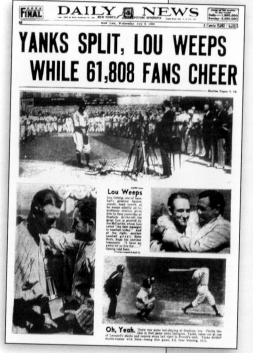

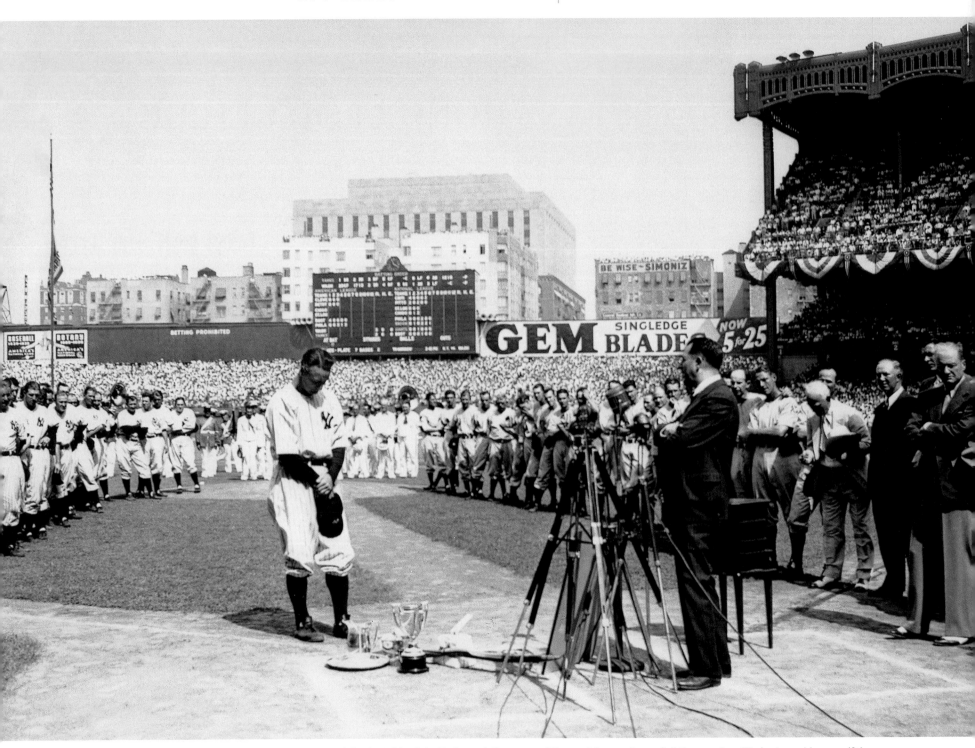

On July 4, 1939, "Lou Gehrig Appreciation Day," Gehrig, the Pride of the Yankees, delivers one of the most famous lines of all time, saying, "Today I consider myself the luckiest man on the face of the Earth." The Yankees first baseman, weakened by amyotrophic lateral sclerosis (ALS)—later known as Lou Gehrig's Disease—would never play again. The Yankees retired his No. 4 jersey, and he was inducted into the Hall of Fame by special election in 1939.

The 1940s

Joe DiMaggio in the 1947 World Series

DAILY NEWS

YANKS CHAMPS

Cochrane Outpoints Jenkins in 10

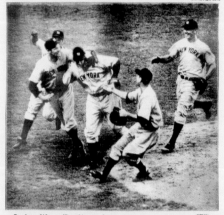

Bonham Was a 'Bon Homme.'

1941: The Yankees win their ninth World Series, defeating the Brooklyn Dodgers four games to one.

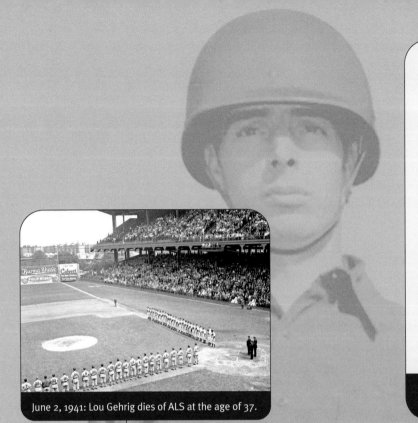

June 2, 1941: Lou Gehrig dies of ALS at the age of 37.

1943–1945: Yankees players fit for military duty leave the team to serve their country in World War II for part or all of three seasons, including future Hall of Famers Joe DiMaggio, Phil Rizzuto, Bill Dickey, Joe Gordon, and Red Ruffing, as well as Tommy Henrich, Charlie Keller, Spud Chandler, and Johnny Murphy.

1940 *1941* *1942* *1943* *1944*

1941: Joe DiMaggio hits safely in 56 consecutive games, a record never matched.

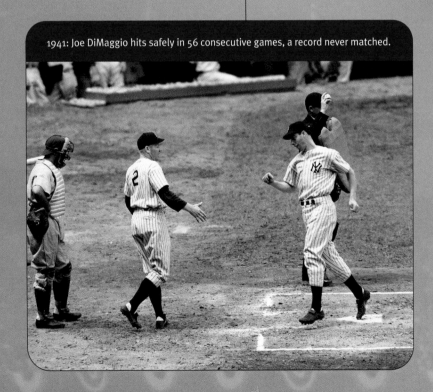

1943: The Yankees win the 1943 World Series 4–1 over the St. Louis Cardinals, manager Joe McCarthy's final championship.

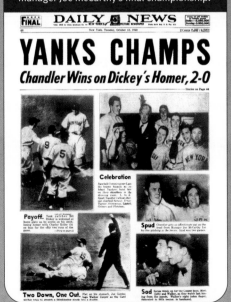

DAILY NEWS

YANKS CHAMPS

Chandler Wins on Dickey's Homer, 2-0

Celebration

Payoff.

Spud

Two Down, One Out.

Sad

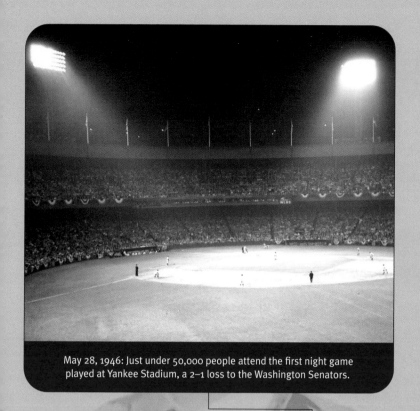

May 28, 1946: Just under 50,000 people attend the first night game played at Yankee Stadium, a 2–1 loss to the Washington Senators.

1947: The Yankees defeat the Brooklyn Dodgers in seven games to win the World Series.

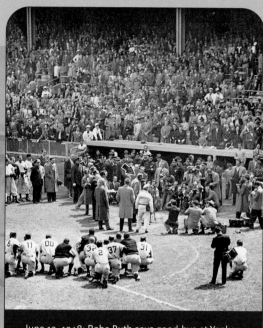

June 13, 1948: Babe Ruth says good-bye at Yankee Stadium in what will turn out to be his last public appearance as his No. 3 is retired. On August 16, Ruth dies of throat cancer in New York at 53 years old.

1945 1946 1947 1948 1949

October 12, 1948: Casey Stengel is hired as Yankees manager (and shares a moment with Yogi Berra).

1949: The Yankees once again defeat the Brooklyn Dodgers in the World Series, four games to one, securing their 12th title in team history, as well as their first of five consecutive championships.

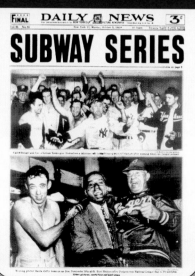

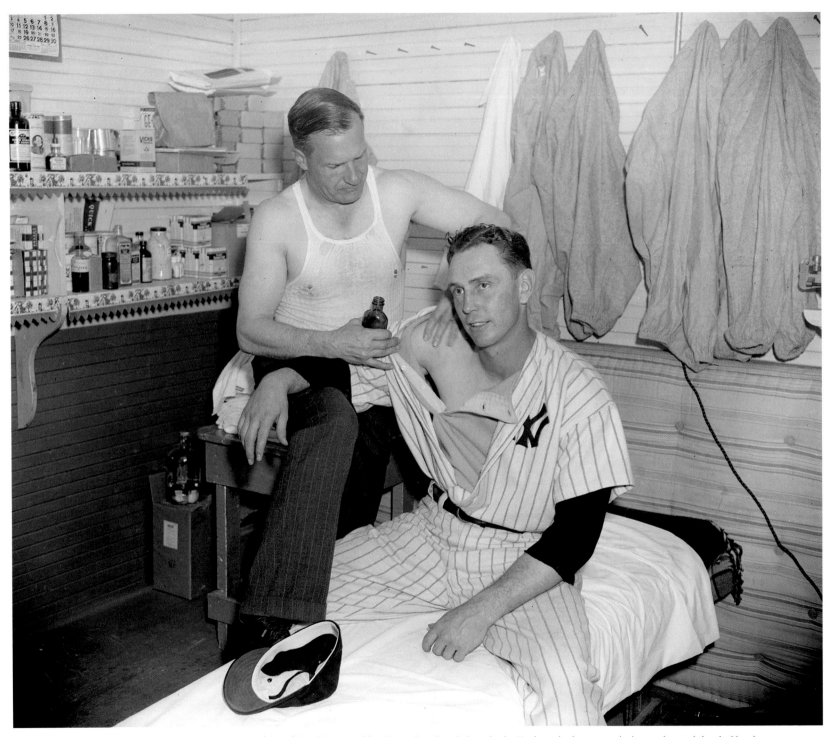

Yankees first baseman Ellsworth "Babe" Dahlgren (above) has his arm rubbed by trainer Doc Painter in the Yankees locker room during spring training in March 1940. Yankees manager Joe McCarthy (facing page) and Brooklyn Dodgers manager Leo Durocher at Ebbets Field for an exhibition game on April 14, 1940.

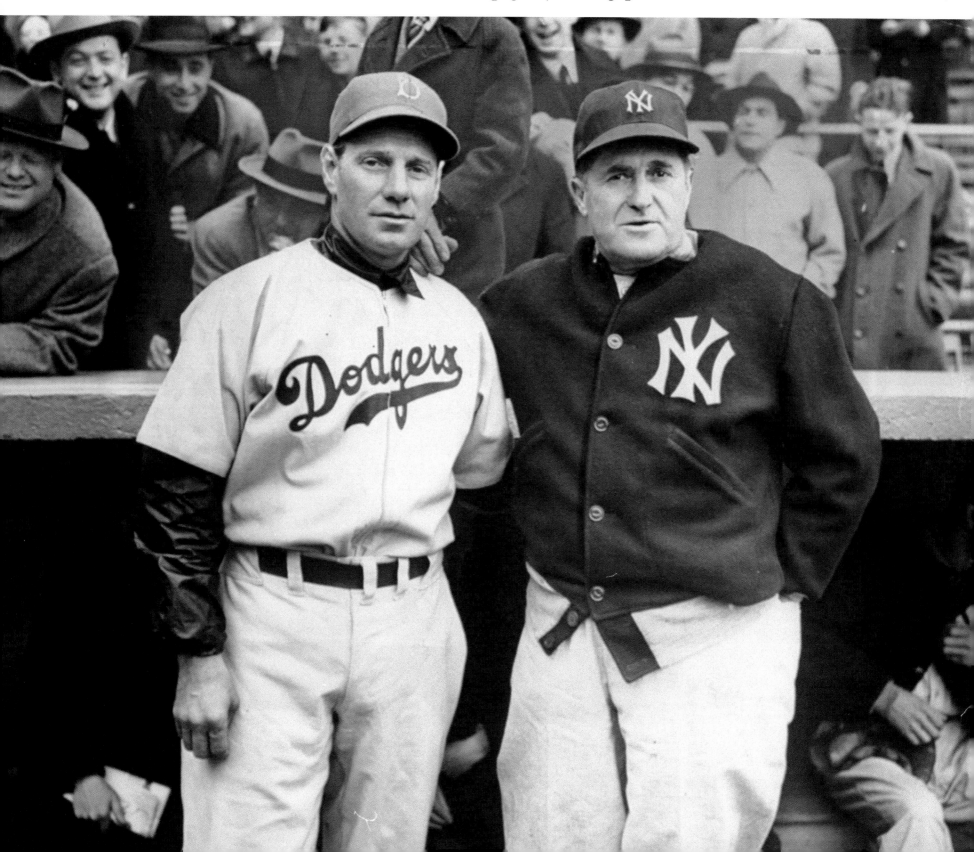

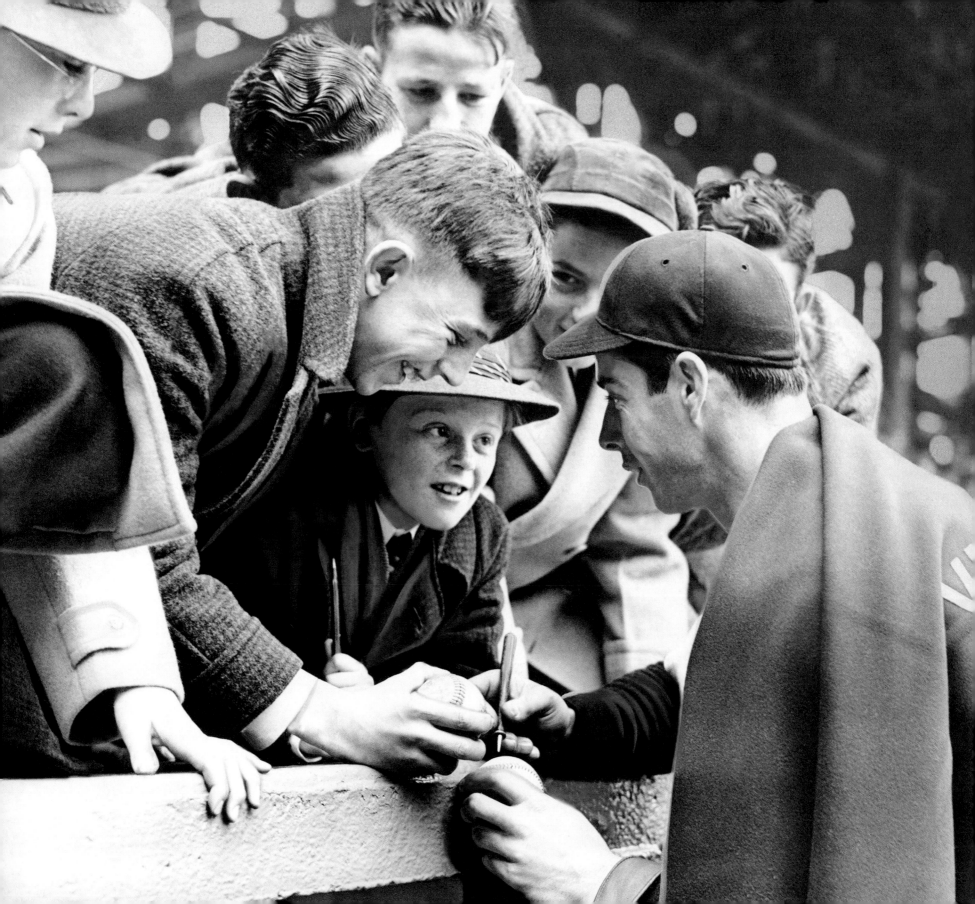

New York, Friday, July 18, 1941

DIMAG STREAK HALTED BY SMITH AND BAGBY AS YANKS COP, 4–3

by Jack Smith

Cleveland, July 17.—One of the greatest feats in the history of baseball—Joe DiMaggio's 56-game hitting streak—ended under the gleaming arclights of huge Municipal Stadium here tonight. The largest crowd ever to see a night game, 67,468 roaring fans, sat tensely through nine spectacular innings which ended with the Yanks beating the second-place Indians, 4–3. In four trips to the plate, the great Yankee outfielder failed to get the ball out of the infield, drawing one walk and slapping three infield grounders. It was the end of a streak that surpassed by 12 games the previous all-time high for the major leagues and which was the driving force in a Yank surge which carried them from fourth place into the seven-game lead they now hold.

Joe's streak started more than two months ago, on May 15, when he punched a single into right field off southpaw Ed Smith of the White Sox. During that time, he faced every team in the league at least once and teed off on every kind of hurling until the combined work of lefty Al Smith and right-hander Jim Bagby stopped him tonight.

Keltner Robs Joe

Only once before (June 15) during the streak has DiMag faced Al Smith, whose chief threat to any batter is control and pitching brains. He was robbed the first time up when he smashed a sizzling grounder toward third. Keltner speared it close to the foul line with a great backhand stab and threw him out at first by two steps.

Joe walked on a three-and-two pitch in the fourth and in the seventh whacked the first pitch back to Keltner again. Against Bagby he slapped an easy grounder to Boudreau for an inning-ending double play.

The game itself was dramatic enough without the added feature of DiMaggio. For six innings it was a blistering duel between Smith and Lefty Gomez. Rolfe's infield hit and a foul-line double by Henrich gave the Yanks a run in the first which the Indians didn't match until the fourth when Gee Walker clouted an inside-the-park homer that stopped rolling only when it hit the fence 463 feet away.

Gordon Hits Homer

Smith had allowed only two hits as he started the seventh. Henrich and DiMaggio were infield outs. The third out was not so easy and didn't come until after Joe Gordon wafted his 15th homer over Gee Walker's lunging hands and into the left-field stands 335 feet from the plate.

That should have been the tipoff that Smitty was tiring. He couldn't get past the eighth. Keller led off with a liner to center which Weatherly played into a triple. After Keltner threw out Rizzuto, Gomez lined a three-and-two pitch to left, scoring Keller. Sturm dropped a single in center and Rolfe banged a double to right, scoring Gomez. A walk to Henrich filled the bases, finished Smith and brought DiMag to the plate to face Bagby.

Gomez Tires, Too

It was not Joe's night. He sent an easy grounder to Boudreau who flipped to Mack, forcing Henrich. Mack pivoted and fired to Grimes for the double play.

(Continued on p. 42)

Joe DiMaggio (facing page) signs baseballs for some of the young fans at Ebbets Field in Brooklyn before a preseason game against the Dodgers on April 14, 1940.

The ninth was by far the most exciting frame of the night. Gomez also wearied after flipping eight innings of four-hit ball. Walker led off with a single through the middle. Grimes lined another single to left. Enough for Gomez. The game was left for Johnny Murphy to save. He almost didn't.

Larry Rosenthal, hitting for Mack, lined his first pitch between Henrich and DiMag for a triple. It was the same kind of a hit as Walker's homer and a faster man might have scored on it. What a spot! None out and the tying run on third base. What pitching! The run didn't score.

Pinch-hitter Trosky grounded out to Sturm, Rosenthal holding third. Then came the play that lost the game for the Indians.

Campbell batted for Bagby and smacked back to the box. Murphy juggled it, then recovered, and threw to the plate. Rosenthal was trapped. Campbell should have gone to second on the rundown, which cut off the score. But he didn't. He stayed on first which made Johnny Sturm play close to the bag on the foul line. Had Campbell been on second, Sturm would have been off the bag and Weatherly's foul-line grounder would have whizzed by for extra bases sending Campbell across with the tying run. 🔲

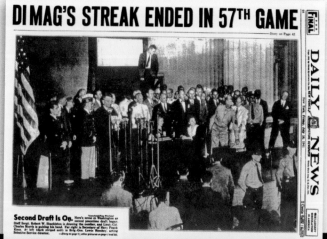

DI MAG'S STREAK ENDED IN 57TH GAME

The end of DiMaggio's 56-game hitting streak warranted a banner headline (left) in the July 18, 1941, edition of the Daily News.

DiMaggio (below) gives some batting tips to Daily News reporter Joe Mathias.

DiMaggio (facing page) slides into home with a fifth-inning run during a 9–0 victory over the St. Louis Browns at Yankee Stadium on August 1, 1941. This was game No. 12 of a 16-game hitting streak the Yankee Clipper started right after his 56-game run ended.

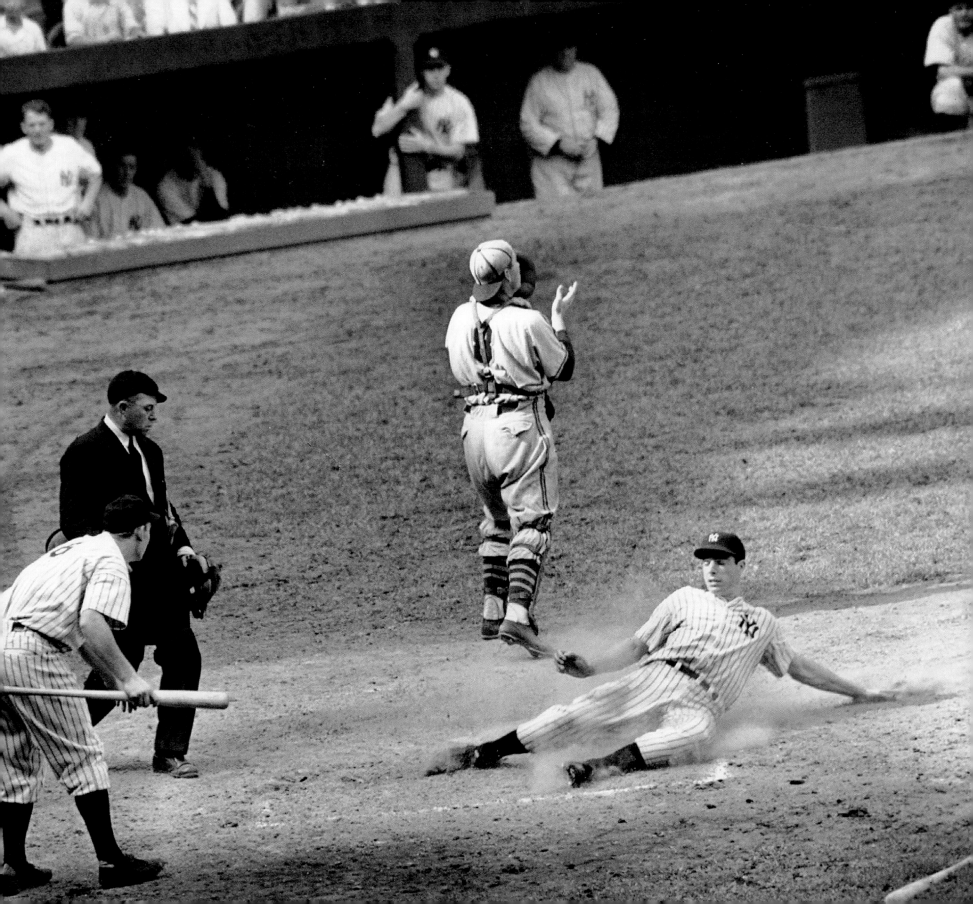

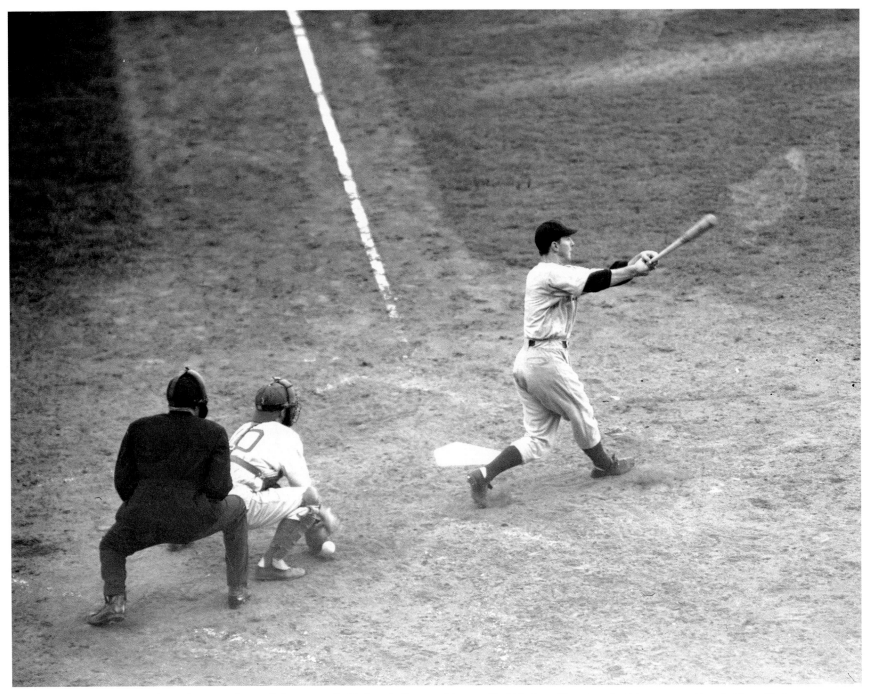

This play, which cost the Dodgers a well-earned victory over the Yankees in Game 4 of the 1941 World Series, will go down in history as one of baseball's costliest errors. As Tommy Henrich swings and misses for his third strike and what should have been the third out in the ninth, the ball gets away from catcher Mickey Owen. Umpire Larry Goetz's right hand was still raised for the out as Owen, tossing off his mask, started after the bounding ball. Henrich hot-foot it for first, which he reached safely. Before the Dodgers could get the side out, the Bombers had scored four times to take the game, 7–4, and a commanding 3–1 lead in the Series.

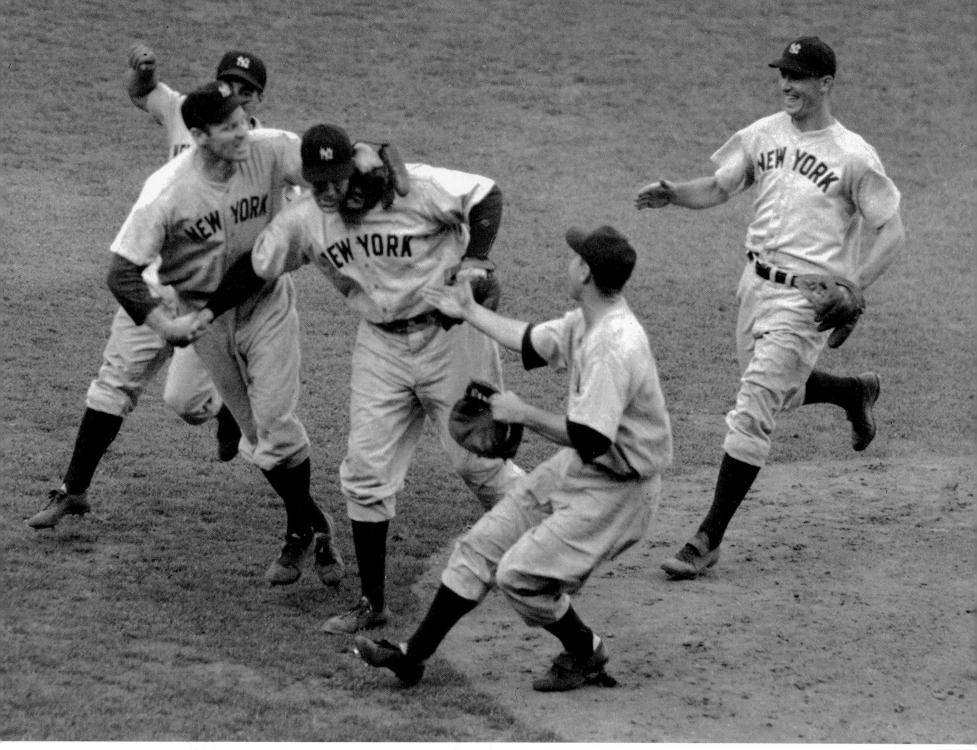

Out in center field, Joe DiMaggio has just made the last putout of the 1941 World Series, and here in the middle of the diamond the Yankees infield mobs pitcher Ernie "Tiny" Bonham, who hurled a sterling four-hitter to win 3–1 and clinch the Series for the Bronx Bombers in Game 5 at Ebbets Field. Left to right are: Phil Rizzuto (almost hidden), Red Rolfe, Bonham, Johnny Sturm, and Joe Gordon.

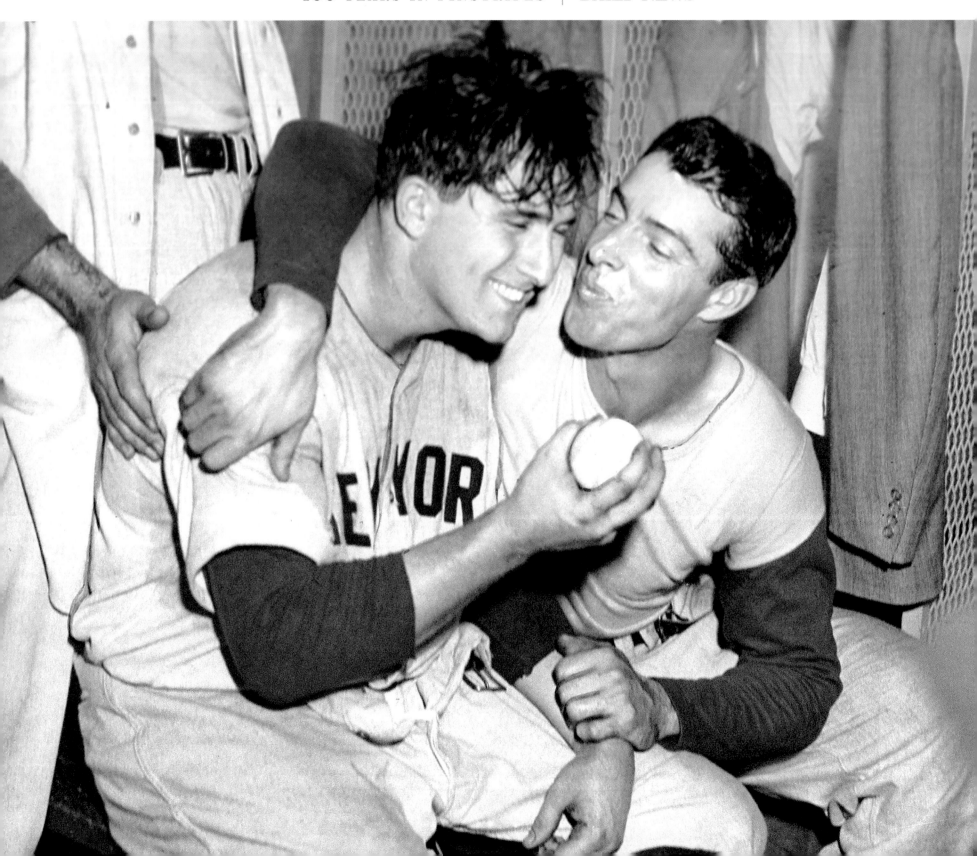

Joe DiMaggio (facing page) plants a kiss on winning pitcher Frank "Spec" Shea after the Yankees' victory over the Brooklyn Dodgers at Ebbets Field in Game 5 of the 1947 World Series, which put the Yankees up 3–2 in the Series.

Yogi Berra (right) became the starting catcher for the Yankees in 1947 and an All-Star in 1948. He would be named an All-Star for 15 straight seasons and win three MVP awards over his 18-year, Hall of Fame playing career with the Yankees.

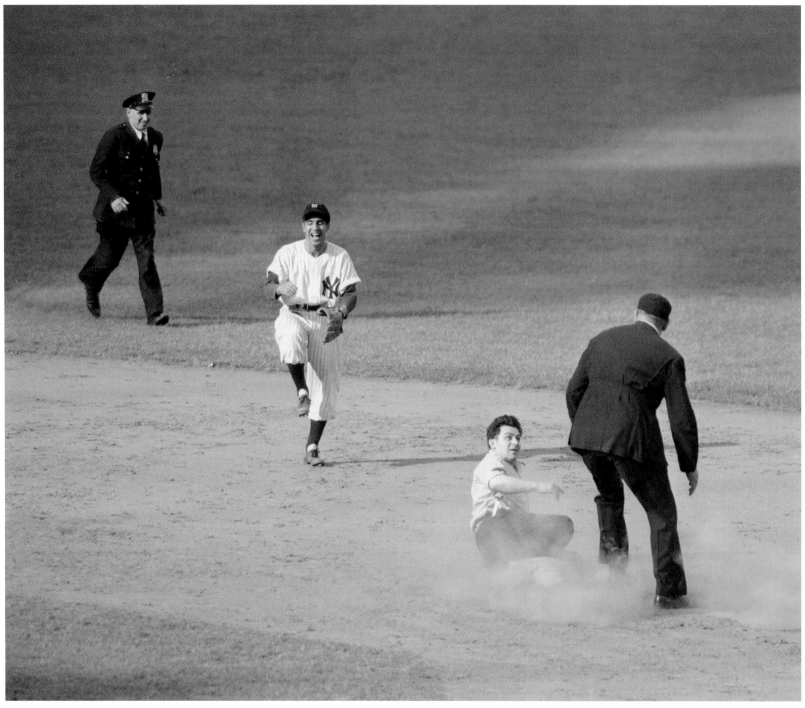

Yankees shortstop Phil Rizzuto slaps his knee and cracks up as a fan executes a beautiful slide into second base after scrambling from the stands at Yankee Stadium and outrunning a flock of police and umpire Cal Hubbard (right) in the sixth inning of the second game of a doubleheader on June 12, 1948.

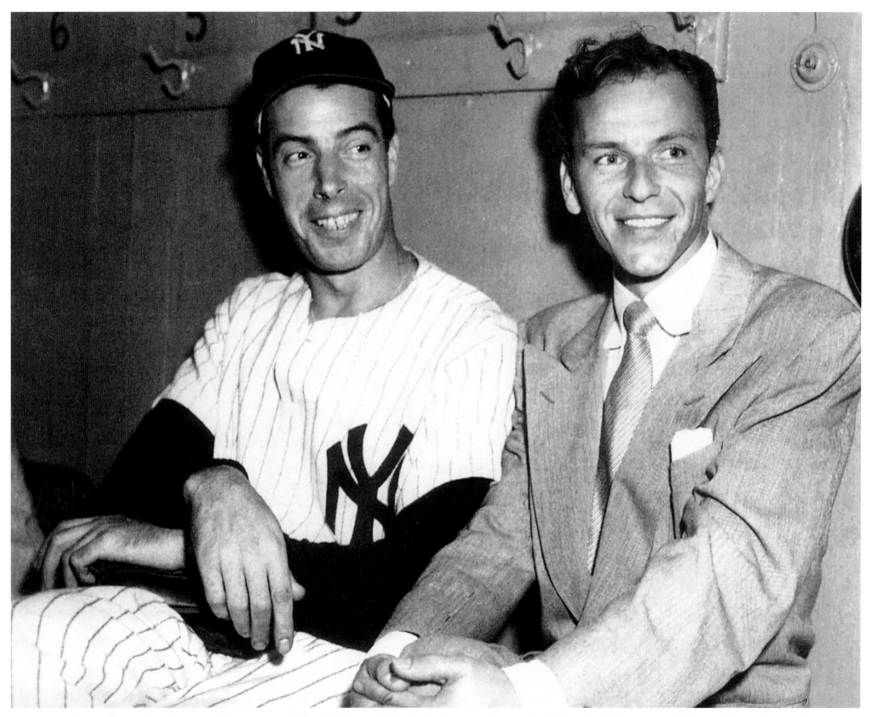

Two immortals. Joe DiMaggio, one of the most popular baseball players in America in the 1940s, shares a bench with Frank Sinatra—one of the most famous singers of his era—at Yankee Stadium in 1949.

Yankees fans boo the Boston Red Sox as they take the field for batting practice at Yankee Stadium on October 2, 1949. With one game left in the season, the Yankees and Red Sox were tied for first place in the American League with identical 96–57 records. The Yankees won the game 5–3 and took the pennant.

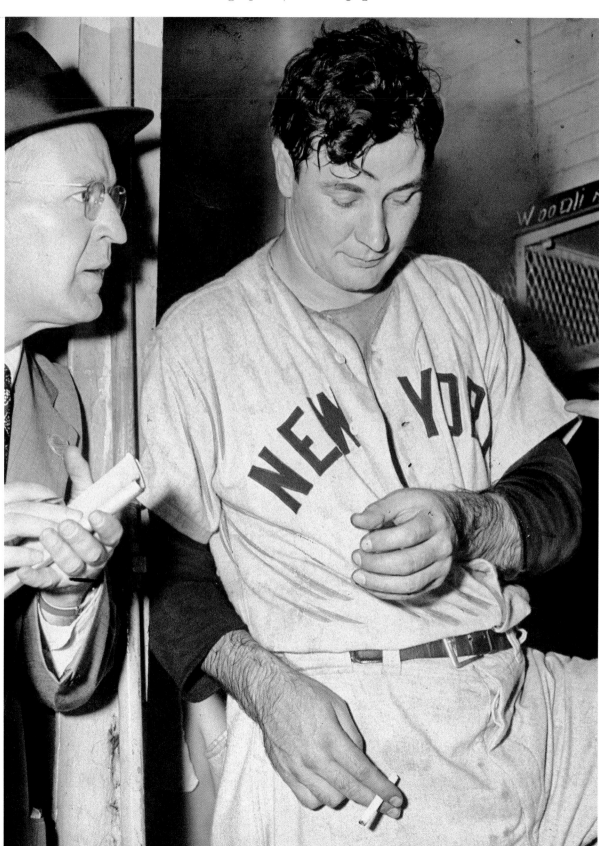

Yankees reliever Joe Page looks at his swollen hand after saving the decisive Game 5 of the World Series against the Dodgers at Ebbets Field on October 9, 1949.

461 FT.

Game 1 of the 1949 World Series between the Brooklyn Dodgers and the New York Yankees at Yankee Stadium. Joe DiMaggio (right) gives chase after Johnny Lindell (27) misjudged a fly ball hit by the Dodgers' Spider Jorgensen, allowing Jorgy to reach second. In the background are the monuments to Lou Gehrig, Miller Huggins, and Babe Ruth that stood in the field of play until 1973.

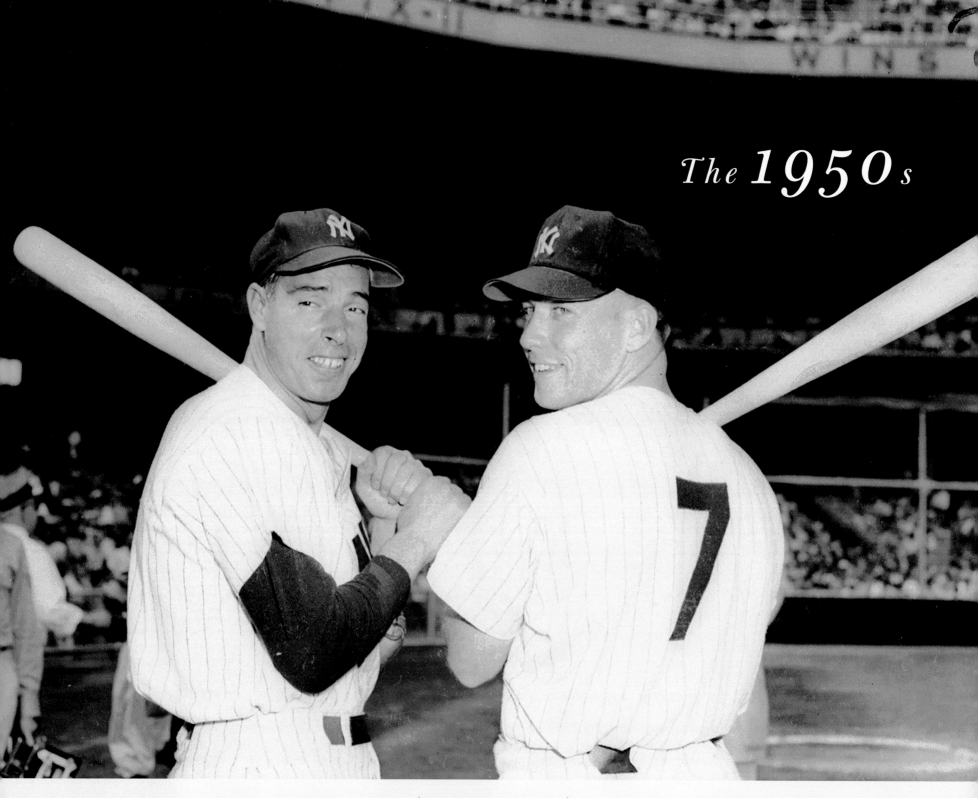

The 1950s

Joe DiMaggio and Mickey Mantle

YANKS CHAMPS

Purdue Upsets Notre Dame, 28-14

1950: The Yankees sweep the Phillies to win their second consecutive championship, and 13th overall.

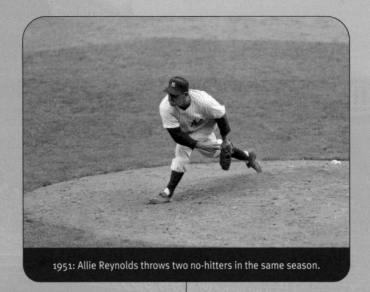

1951: Allie Reynolds throws two no-hitters in the same season.

1952: The Yankees beat the Brooklyn Dodgers in seven games, giving them their fourth consecutive title, while tying the mark they previously set from 1936 to '39 under manager Joe McCarthy. By doing this, Casey Stengel became only the second manager in history to win four straight titles.

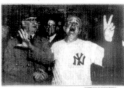

YANKEES CHAMPS

Martin's Hit Nails 5th in Row, 4-3

1953: In a rematch of the 1952 Series, the Yankees defeat the Dodgers four games to two, giving them five consecutive titles, a feat that's never been matched.

1950 1951 1952 1953 1954

April 17, 1951: Mickey Mantle makes his major league debut in a win over Ted Williams and the Red Sox at Yankee Stadium. He goes 1-for-4.

1951: In what would be the last World Series for Joe DiMaggio, who retired afterward, and the first for rookies Willie Mays and Mickey Mantle, the Yankees defeated the New York Giants four games to two to win their third straight crown.

April 17, 1953: Mickey Mantle hits one of the longest recorded home runs in history, a monstrous 562-foot shot that leaves Washington's Griffith Stadium.

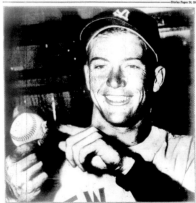

MANTLE SLAMS RECORD HR
GIANTS SPLIT; YANKS WIN

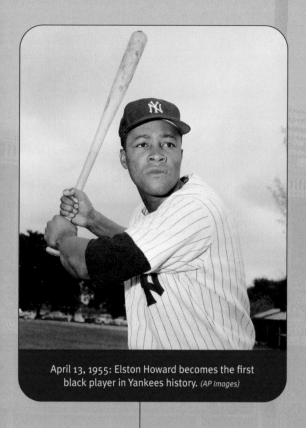

April 13, 1955: Elston Howard becomes the first black player in Yankees history. *(AP Images)*

October 8, 1956: Don Larsen pitches the only perfect game in World Series history.

1956: Mickey Mantle wins the Triple Crown.

1955 1956 1957 1958 1959

1956: After losing the 1955 World Series to the Dodgers in seven games, the Yankees returned the favor, taking the '56 Series in seven.

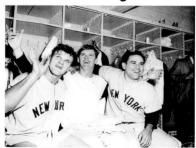

1958: The Yankees beat the Milwaukee Braves in seven games to win their seventh World Series title in 10 years.

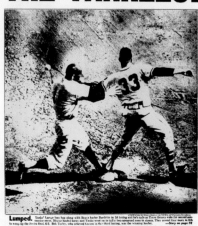

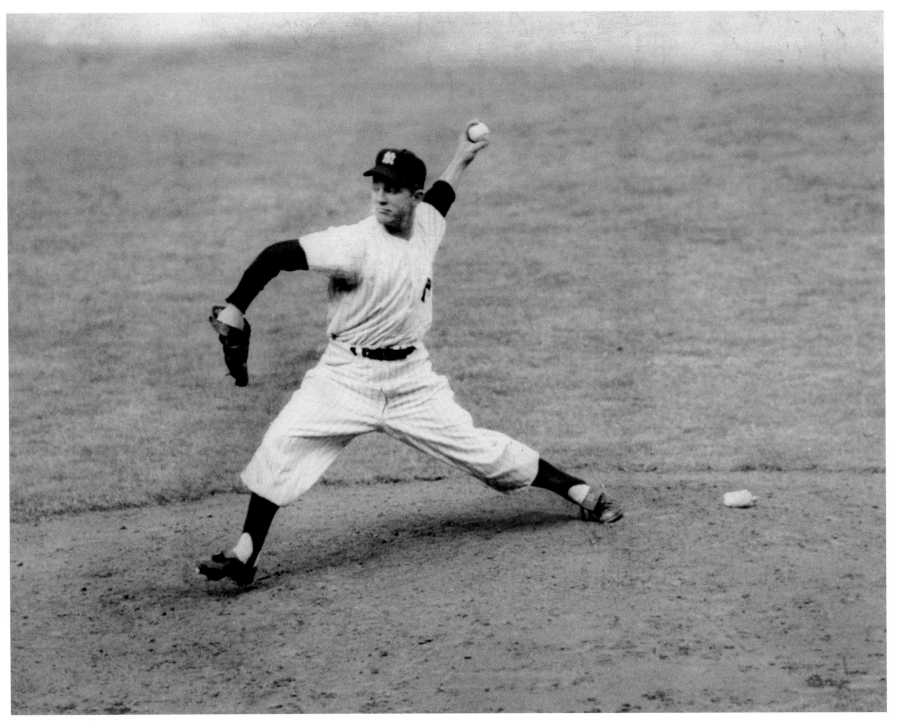

The Yankees' 21-year-old rookie left-hander Whitey Ford pitches in the ninth inning of Game 4 of the 1950 World Series against the Philadelphia Phillies at Yankee Stadium. Ford missed a complete game by one out, but after giving up two runs in the ninth, Allie Reynolds came in for the one-out save. The Yanks won the game 5–2 and the Series in four games.

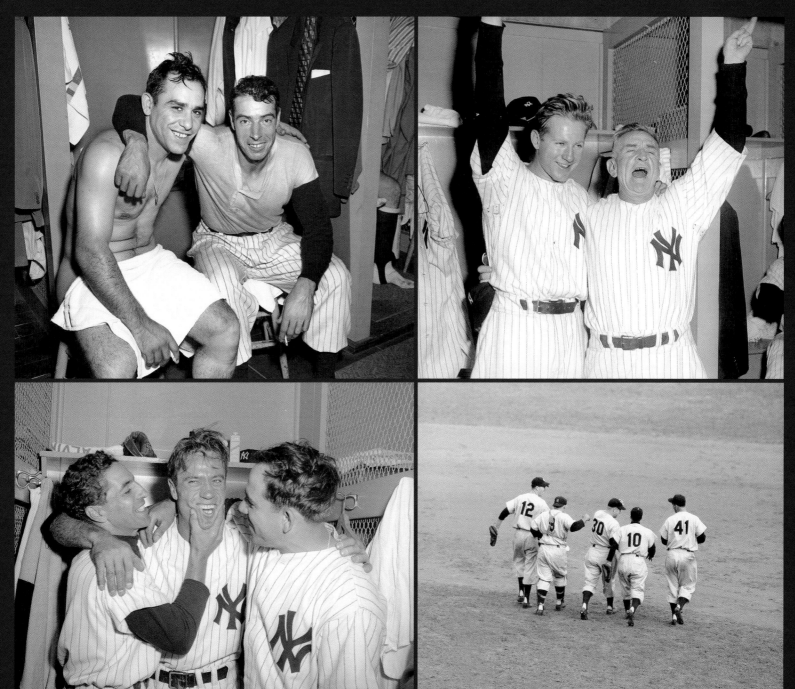

Yogi Berra and Joe DiMaggio (top left) celebrate at Yankee Stadium after making short work of the Phillies in the 1950 World Series, completing a sweep for the team's second straight championship. Whitey Ford (top right) rejoices with manager Casey Stengel after the finale. A jaunty crew of Yankees (bottom right) leaves the Polo Grounds after defeating the New York Giants 13–1 in Game 5 of the 1951 World Series: (left to right) Gil McDougald, Yogi Berra, Eddie Lopat, Phil Rizzuto, and Joe Collins. A grinning Hank Bauer (bottom left) is hugged in the Yankees locker room by Phil Rizzuto (left) and Yogi Berra after their Game 6 win over the Giants earned the Yankees their third straight title. Bauer's bases-loaded triple in the sixth put the Yankees ahead for good and his catch saved the victory.

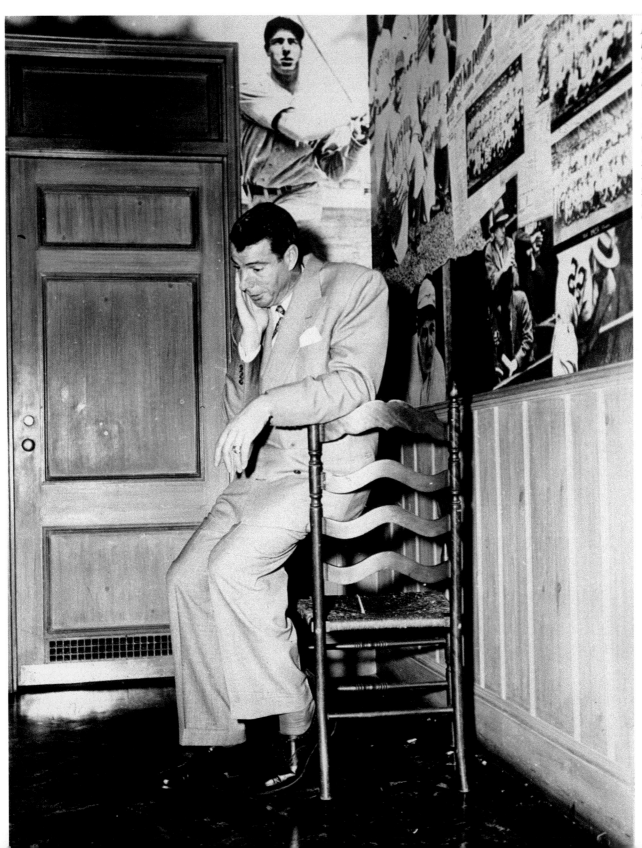

Joe DiMaggio ponders his future after announcing his retirement on December 12, 1951, after 13 years and a Hall of Fame career with the Yankees.

The next great Yankees center fielder, Mickey Mantle (facing page), slides in to score against Boston as Red Sox catcher Sammy White grabs a high throw from Dom DiMaggio on August 11, 1952, a 7–0 Yankees win.

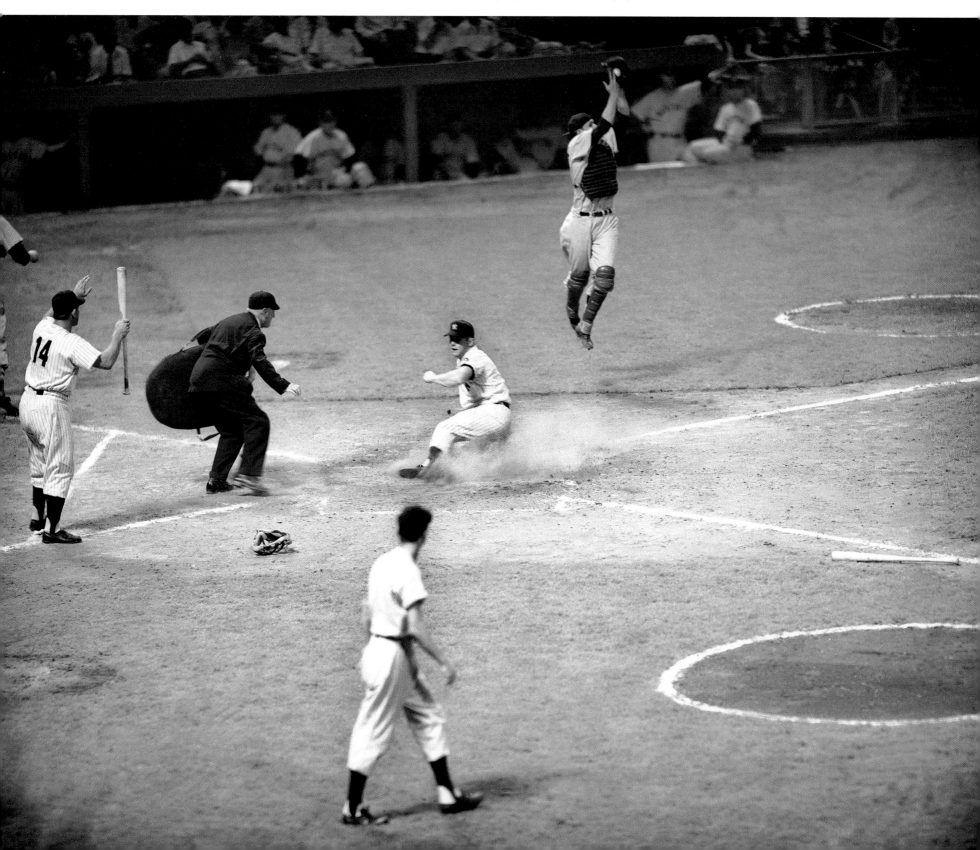

New York, Saturday, April 18, 1953

MANTLE CLOUTS RECORD 562-FT. HOMER

Ball Goes Out of Park; Yanks Win, 7–3

by Joe Trimble

Washington, D.C., April 17—Mickey Mantle, the magnificent moppet of the Yankees, today hit the longest home run in the history of baseball. The mass of muscle stepped to the plate in the fifth inning and drove a pitch completely over the left-field bleachers at Griffith Stadium, the first time this has ever happened. The ball landed in the backyard of a house and the entire distance of its flight was measured at 562 feet. The titanic smash, coming with a runner aboard, clinched the 7–3 victory for the Bombers over the Senators.

Babe Ruth is alleged to have hit one 500 feet in a Tampa exhibition game, but there is no recorded measurement of that. Only two other balls have ever been knocked over the bleacher wall here and both bounced in the seats before clearing the last barrier. Jimmy Foxx hit one and Joe DiMaggio, the other.

The other near-record blows at Griffith Stadium, but in different directions, were by Ruth and the Indians' Larry Doby. Babe hit one into the clump of trees beyond the center-field wall. A few years ago, Doby hit one to right center, into the loudspeaker atop the scoreboard. However, each of those only measured about 450 feet.

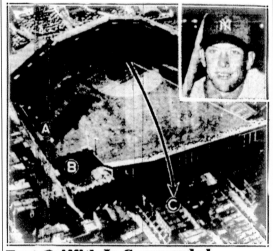

Fort Griffith Is Cannonaded

Mickey Mantle (upper right) of Bronx Bombers yesterday fired longest homer in history at Griffith Stadium. It traveled 562 feet before landing in back yard (C) beyond left field wall. Herculean clouts of past by Jimmy Foxx and Joe DiMaggio in same direction landed high up in bleachers. Other colossal clouts were by Larry Doby (A) and Babe Ruth (B).

Mantle, batting right-handed against lefty Chuck Stobbs, had a one-ball, no-strike count when he put his powerful shoulders into the pitch. It was a fastball, at just the proper height. The ball left the bat and soared so high that the Washington outfielders never made a move.

It struck the right-hand edge of the football scoreboard which is erected on the top of the bleachers and deflected off into the distance.

The street which parallels the bleacher wall is 5th Street, and the ball was found in the backyard of a house on Oakdale Street, a small street which bisects at about the point where Mantle's mighty wallop disappeared. The house, 434 Oakdale, is the fourth one down the block.

Here is the actual breakdown of the footage covered by this colossal clout:

The front wall of the bleachers is 391 feet away from home plate in left center. The depth of the bleacher structure on the ground is 66 feet. The height of the back wall is 55 feet and the ball cleared that by five. It is 105 feet from the back wall to the point at which the

ball was found. It was grabbed by Donald Dunaway, a 10-year-old lad, who scrambled over the fence of the yard to get it.

Arthur E. Patterson, Yankee publicity director, rushed outside the park and measured the distance after Donald showed him where he picked up the ball. Patterson then gave the kid a dollar for the ball and three new baseballs which will be autographed by the Yankee players and mailed to the alert youngster.

Mick's amazing feat completely overshadowed everything else. Things such as Eddie Lopat going eight innings to his first victory, a less majestic homer by Billy Martin and the Yanks' second 12-hit feast in two games here.

Lope was touched for 10 hits and was rather tired by the time the final inning arrived. He went out to work it but after a few warmup pitches walked off and let Tommy Gorman finish.

The game was tight until Mantle's epic wallop. The Yanks picked up a run in the third when Martin hit into the bleachers, his smack landing in the fifth of the 30 rows of seats. By Mantle standards, it was a bunt!

The Nats tied it in their half on singles by Twig Terwilliger and Ed Yost, with a sacrifice by Stobbs in between. The Bombers moved up again in the fourth on Hank Bauer's bloop double to center and Joe Collins' line single over short.

Yogi Berra walked with two out in the fifth and then Mantle let fly. That crusher was only part of Mickey's near perfect day. He also walked twice, got a safe bunt, and made out on a hard smash to third baseman Yost, who made a great stop. Mickey's bunt was a long one, too. He tried to drag it and succeeded in "bunting" it over second onto the outfield grass.

The lad just doesn't know his own strength. ▣

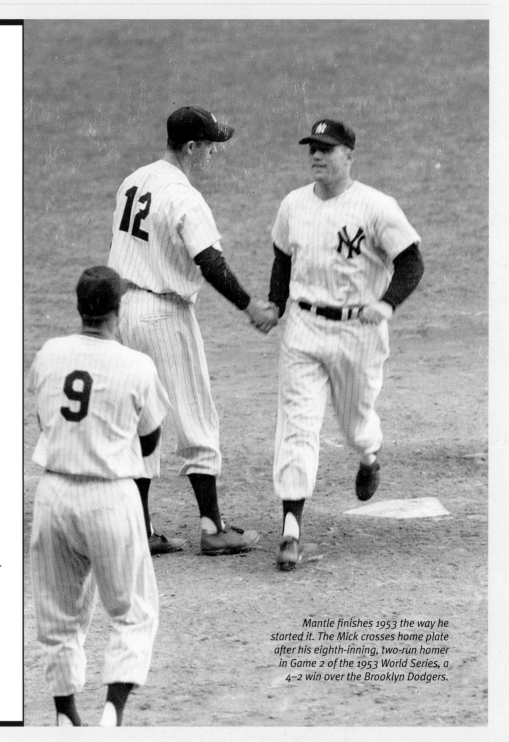

Mantle finishes 1953 the way he started it. The Mick crosses home plate after his eighth-inning, two-run homer in Game 2 of the 1953 World Series, a 4–2 win over the Brooklyn Dodgers.

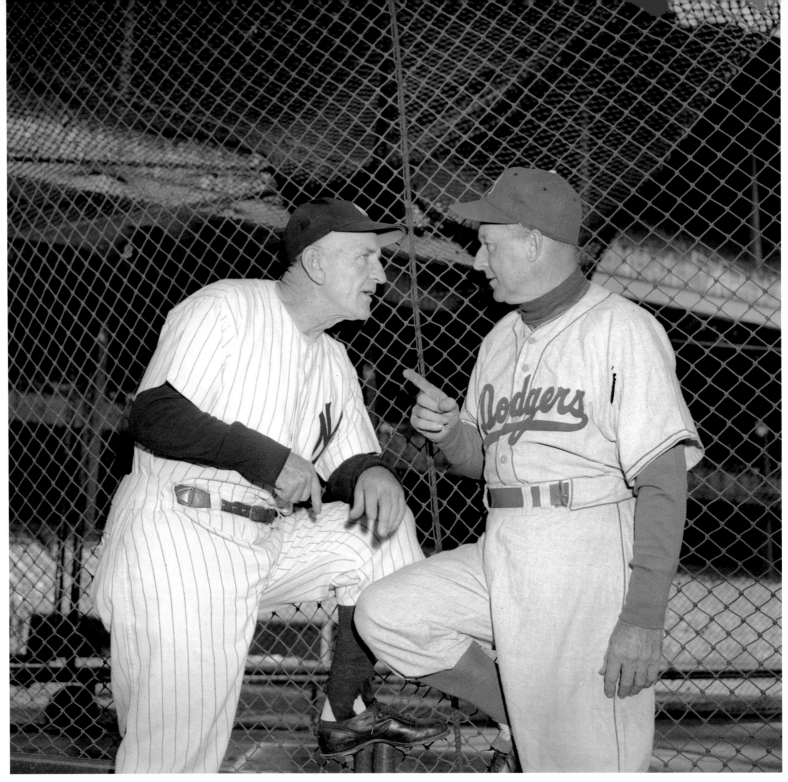

On September 29, 1953, New York Yankees manager Casey Stengel (left) and Brooklyn Dodgers skipper Chuck Dressen discuss the upcoming World Series. Between 1947 and 1956, the Yankees and Dodgers met six times in the Fall Classic. The Yankees won five of six, with the one Dodgers victory coming in 1955.

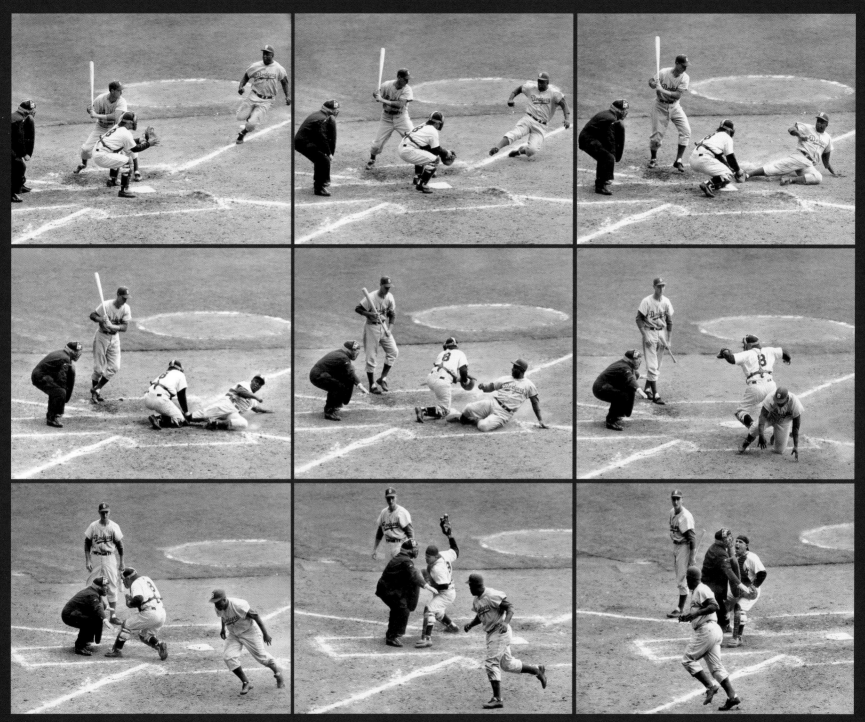

The Dodgers' Jackie Robinson, with two out in the eighth inning and Brooklyn trailing 6–4 in Game 1 of the 1955 World Series at Yankee Stadium, tries to steal home. Frank Kellert, the batter, steps aside as Whitey Ford pitches low. Yogi Berra puts his mitt in front of the plate in Robinson's path. It's close. Ump Bill Summers, behind Berra, calls Jackie safe. Yogi calls Summers a lot of things. The camera seems to agree with Yogi. The Dodgers lost the game but won the Series in seven.

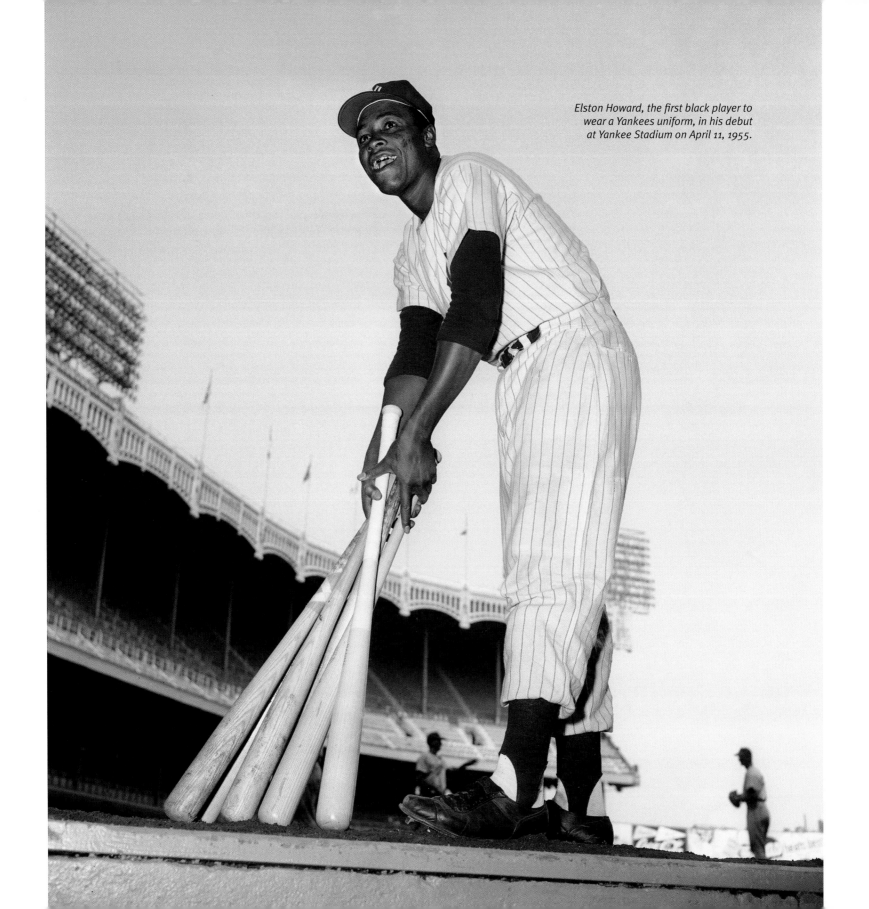

Elston Howard, the first black player to wear a Yankees uniform, in his debut at Yankee Stadium on April 11, 1955.

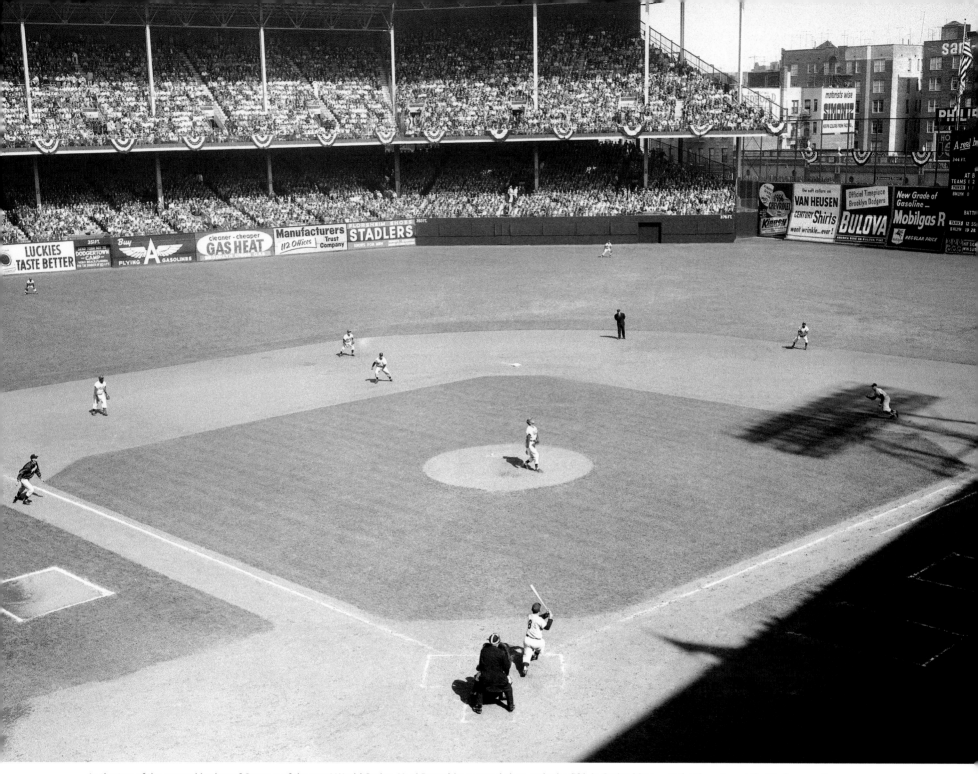

In the top of the second inning of Game 2 of the 1956 World Series, Yogi Berra hits a grand slam, only the fifth in Series history at the time, to put the Yankees up 6–0 over the Dodgers at Ebbets Field. But Yankees starter Don Larsen couldn't make it out of the bottom of the second, and the Yanks ended up losing 13–8.

New York, Tuesday, October 9, 1956

HISTORY IS MADE IN SERIES CLASSIC; LARSEN HURLS PERFECT GAME, WINS 2–0

by Joe Trimble

The unperfect man pitched a perfect game yesterday. Don Larsen, a free soul who loves the gay life, retired all 27 Dodgers in the classic pitching performance of all time as the Yankees won the fifth game, 2–0, at the Stadium and took a 3–2 edge in the set. In this first perfect World Series game, he made but 97 pitches, threw three balls to only one batter, and fanned seven. A man must be lucky as well as good to reach such an incredible height, and Don got four breaks, a "foul homer" which missed being fair by inches and three superb fielding plays on line drives.

This was only the second perfect game ever pitched in the majors, the other by right-hander Charley Robertson of the White Sox against Detroit on April 30, 1922. Larsen's was the first Series no-hitter, of course. There have been three one-hitters. Don, an affable, nerveless man who laughs his way through life, doesn't know how to worry. And that was his greatest asset in the pressure cauldron that was the big Bronx ballpark in the late innings, with the crowd of 64,519 adding to the mounting tension with swelling roars and cheers as one grim-faced Dodger after another failed to break through his serves.

With the tension tearing at their nerves and sweat breaking out on the palms of the onlookers, Larsen seemed to be the calmest

man in the place. He knew he had a perfect game and was determined to get it. In the ninth inning, though inwardly tense, he kept perfect control of himself and the ball. Only when pinch-hitter Dale Mitchell was called out on strikes to become the 27th dead Dodger, did Larsen show emotion.

A grin broke across his face as Yogi Berra dashed up to him. Berra jumped wildly into Don's arms, the pitcher grabbing and carrying the catcher like a baby for a few strides. Then the entire Yankee bench engulfed the pair of them and ushers and cops hustled the ballplayers off the field and into the safety of the dugout before the crowd could get at them.

The Yankee fielders ran up to shake his hand, and Don had a special hug for Mickey Mantle, whose fourth-inning homer had given him a lead and whose great catch of a liner by Gil Hodges had saved things in the fifth.

Andy Carey, who has been the sloppiest man in the Series afield, also helped on two plays. The third baseman deflected Jack Robinson's liner in the second inning, leaping and pawing the ball to shortstop Gil McDougald, who made the throw to first in time. The play wasn't close.

Carey's other contribution came in the eighth when the pressure was on everybody. Hodges was the hitter then, too. Gil took a half

(Continued on p. 68)

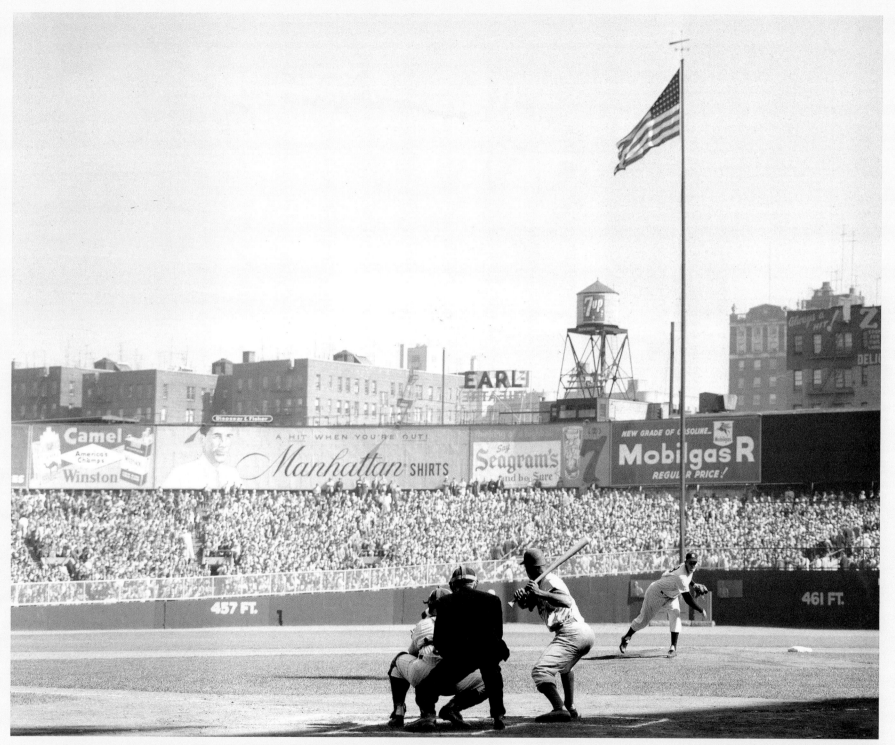

Perfection personified. Don Larsen's first pitch of Game 5 to Brooklyn's Jim Gilliam—of course, it was a strike. Larsen hurled the first and still only perfect game in World Series history, a 2–0 victory to give the Yankees a 3–2 lead over the Dodgers in the '56 Series.

swing and hit a low liner which Andy gloved one-handed, bobbled a bit, and then held while on the run.

The other nod from Lady Luck didn't involve a fielder. In the fifth inning, Sandy Amoros drove a screaming liner into the right-field stands. But it veered to the right side of the foul pole, missing by about four inches. Larsen then got the little Dodger to ground out to Billy Martin and end the inning.

The party of the second part in this incredible sizzler was the man who may have been pitching his last World Series game, Sal Maglie. The 39-year-old right-hander, who had won the opener of the Series, pitched a handsome game himself.

Sal gave up but five hits and Mantle's home run was the only one until the sixth, when the Bombers made three more and gained their other run. Maglie whiffed five, fanning the side in the eighth. Sal retired the first 11 batters before Mantle hit into the right-field seats.

That was the switcher's third of this Series and eighth altogether. Sal pitched him outside to a 2–2 count and then came inside, where Mickey likes 'em as a lefty batter.

The other run developed in the sixth after Carey led off with a single to center and Larsen bunted him along. Bauer cracked a hard grounder through the left side. Amoros charged it and might have had a chance to get Carey at the plate, but the fielder momentarily bobbled the ball.

Joe Collins followed with the third hit of the inning, Bauer taking third. The crowd looked for more heroics from Mantle, the next batter, but it was the Dodger infield which drew the cheers. Hodges grabbed Mickey's hot smash with his foot on first base and then

Pitch Man —By Leo

YOUSE CAN'T WIN AG'INST DAT KINDOVA PITCH!

HIT

LARSEN

BOY—DID HE MIX 'EM UP?

FAST BALL

CURVE

CHANGE UP

threw to Campanella to hang up Bauer in a rundown. Campy made a poor peg during the chase, but Robinson dove for it and made a return throw while on his knees. Then Jack jumped up and took the toss from Roy and tagged near third base.

Larsen struck out the first two batters of the game, Gilliam and Reese. It was Pee Wee who got the furthest with Don, working the count to 3–2 before ump Babe Pinelli called him out.

Robinson led off the second inning and hit a screamer. Carey's glove darted upwards as he leaped, and the ball hit it. By the grace of providence, the deflection was toward McDougald who scooped up the bounding ball for a simple play at first.

Maglie was the next man to hit a ball hard, but his third-out liner in the third inning went right at Mantle, who was playing him shallow.

There was one out in the fifth when Hodges crashed a long line drive to left-center. Mantle raced over and made a spectacular backhand catch on the full run. That ball would have been a homer in Brooklyn, as it was hit over 380 feet.

In the eighth, Larsen made his lone fielding play when he grabbed Robinson's hard hopper with his glove hand. Then it was that Hodges stroked the liner which Carey intercepted a few inches off the ground, juggled while leaning over and running, and then held. The spectators shouted wildly when Don completed the inning with a soft flyout by Amoros.

The crowd gave Larsen a tremendous hand when he came up to bat in the eighth, standing up to applaud. Then, after the Yankees were retired, he went back to the mound to get the last three outs—the three men who stood between him and baseball immortality.

The Dodgers, still trying to win, dug in. Carl Furillo fouled off a couple and then flied to Hank Bauer in right field. Campy belted a long drive into the upper left-field seats, but it was foul by many yards, then grounded weakly to Martin. Mitchell then came up to bat for Maglie and the Stadium rocked with roars of anticipation.

The first pitch to the left-swinger was a fast one which was on the outside, high. Then Don got a low curve over for a strike. Then another fastball which Mitchell swung at and missed.

Now, for the first time, Larsen was visibly affected. There he stood, one strike away from the most amazing feat in Series history. Don stepped off the mound, turned around to look at the outfielders and took off his hat. Then he threw another curve that Mitch fouled.

Casey Stengel then moved two of the outfielders, Mantle and Bauer, a few feet to the left. Mitchell, a slap hitter, seldom pulls the ball to right. Besides, Berra was going to call for a fastball.

Don, who pitches without a windup, then made his next throw, a fastball letter high, and as Pinelli's right hand went up, the whole baseball world exploded.

The fans at radio and TV sets all over the nation knew it was a perfect game all the way. Announcers Vince Scully and Mel Allen didn't try to disguise it in that silly superstition that to talk about it would jinx the pitcher.

So an incredible character who laughs at training rules, reads comic books, and describes himself as "the night-rider," has become the classic pitcher in all baseball legend. His has been a fantastic season.

(NEWS foto by Al Pucci)

Still Shaky. Don Larsen, who admitted his knees wobbled in the 9th, is congratulated by Sal Maglie who—ironically enough—also had no-hitter this year.

He started it with an escapade in St. Petersburg during spring training, when he drove his car into an electric light pole after falling asleep at the wheel at five o'clock in the morning. Instead of fining him, Stengel used psychology and named Don as opening day pitcher. He won, beating Washington.

Then Don went bad and had to be removed from the starting rotation. He showed some flashes as a reliever and was reinstated as a starter in the last two months of the season. Over the last month, Larsen was the Yankees' best pitcher, with two four-hitters and a three-hitter, as well as a string of four victories to the finish.

He started the second game of the Series Friday at Ebbets Field and helped blow the 6–0 lead in the second inning. So, in his up-and-down way of life, he came back with the first perfect Series game.

The best previous demonstration of perfection was by Herb Pennock, Yankee left-hander, who went seven and one-third innings against the Pirates in the 1927 Series before allowing a base runner. Schoolboy Rowe of Detroit matched that span against the Cards in 1934 after St. Louis had scored two runs.

The three one-hitters were pitched by Ed Reulbach for the Cubs against the White Sox in 1906, Claude Passeau of the Cubs against Detroit in 1945, and Floyd Bevens, Yankee right-hander who went eight and two-thirds innings in the 1947 set, only to lose the game on Cookie Lavagetto's pinch double with two out in the ninth.

So the whole country last night was toasting Don Larsen—and that's quite a switch. The toast? "Larsen, that's all!" 🔲

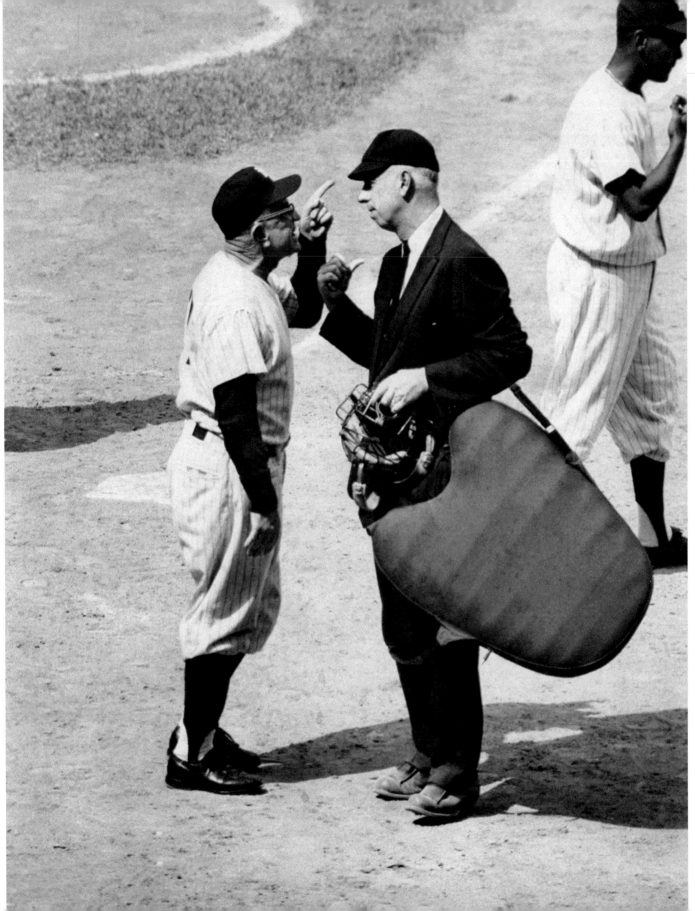

Longtime Yankees manager Casey Stengel instructs plate umpire John Flaherty on a finer point of the game during a June 1959 contest at Yankee Stadium.

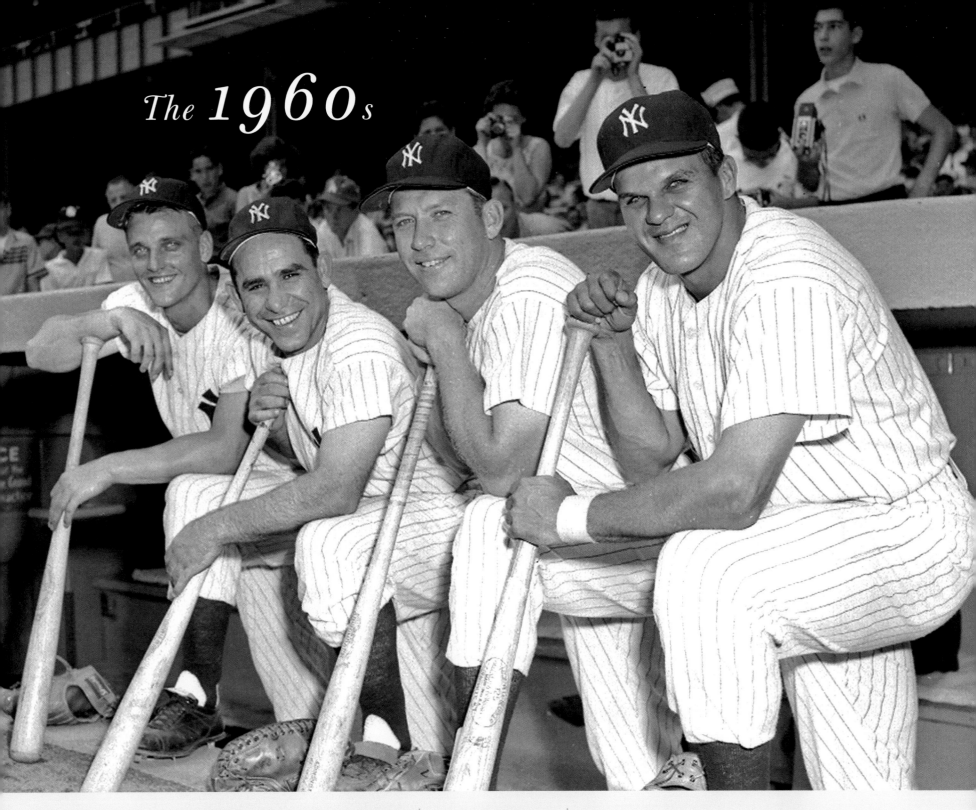

The 1960s

Roger Maris, Yogi Berra, Mickey Mantle, and Moose Skowron

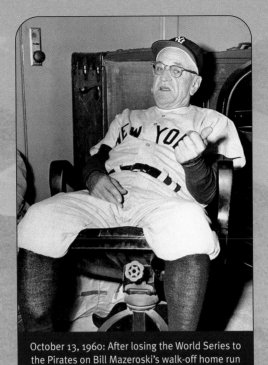

October 13, 1960: After losing the World Series to the Pirates on Bill Mazeroski's walk-off home run in Game 7, Casey Stengel is fired. In Stengel's 12 years as Yankees manager he won the AL pennant 10 times and the World Series seven times.

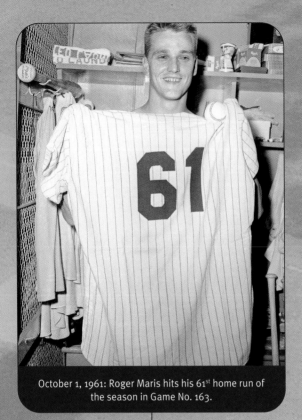

October 1, 1961: Roger Maris hits his 61st home run of the season in Game No. 163.

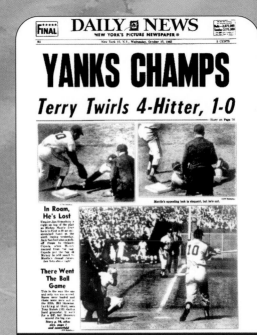

October 16, 1962: With two outs in the bottom of the ninth in a one-run Game 7, Bobby Richardson catches Willie McCovey's line drive to give the Yankees the victory over San Francisco, and their 20th World Series title in franchise history.

1960 1961 1962 1963 1964

1961: Whitey Ford wins the AL Cy Young Award, breaks Babe Ruth's World Series scoreless inning streak record, and wins World Series MVP honors all in the same season.

October 1963: Yogi Berra retires and is named Yankees manager, replacing Ralph Houk, who becomes general manager.

1961: The Yankees beat the Cincinnati Reds four games to one to win their 19th World Series in the last 39 years.

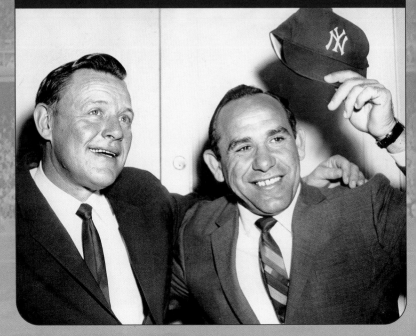

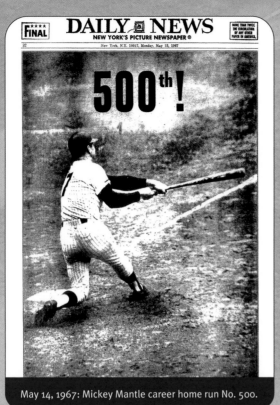

May 14, 1967: Mickey Mantle career home run No. 500.

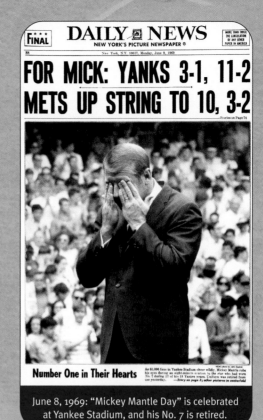

June 8, 1969: "Mickey Mantle Day" is celebrated at Yankee Stadium, and his No. 7 is retired.

1965 1966 1967 1968 1969

November 1964: CBS purchases the Yankees.

March 1, 1969: Mickey Mantle retires.

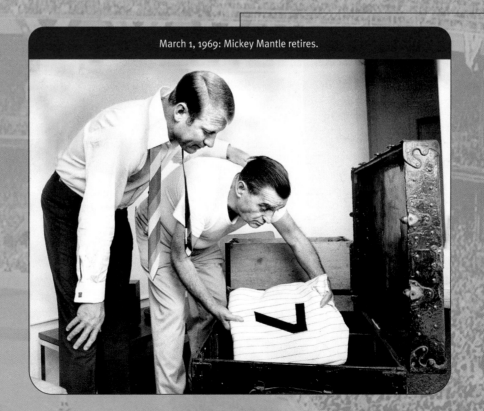

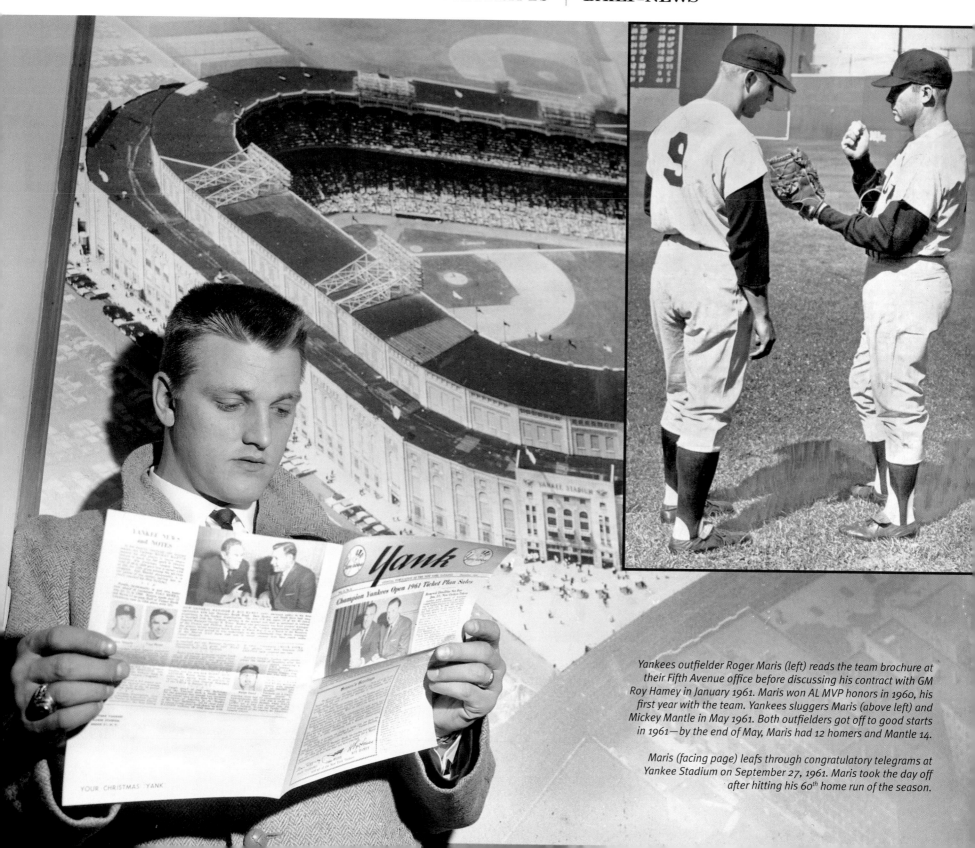

Yankees outfielder Roger Maris (left) reads the team brochure at their Fifth Avenue office before discussing his contract with GM Roy Hamey in January 1961. Maris won AL MVP honors in 1960, his first year with the team. Yankees sluggers Maris (above left) and Mickey Mantle in May 1961. Both outfielders got off to good starts in 1961—by the end of May, Maris had 12 homers and Mantle 14.

Maris (facing page) leafs through congratulatory telegrams at Yankee Stadium on September 27, 1961. Maris took the day off after hitting his 60th home run of the season.

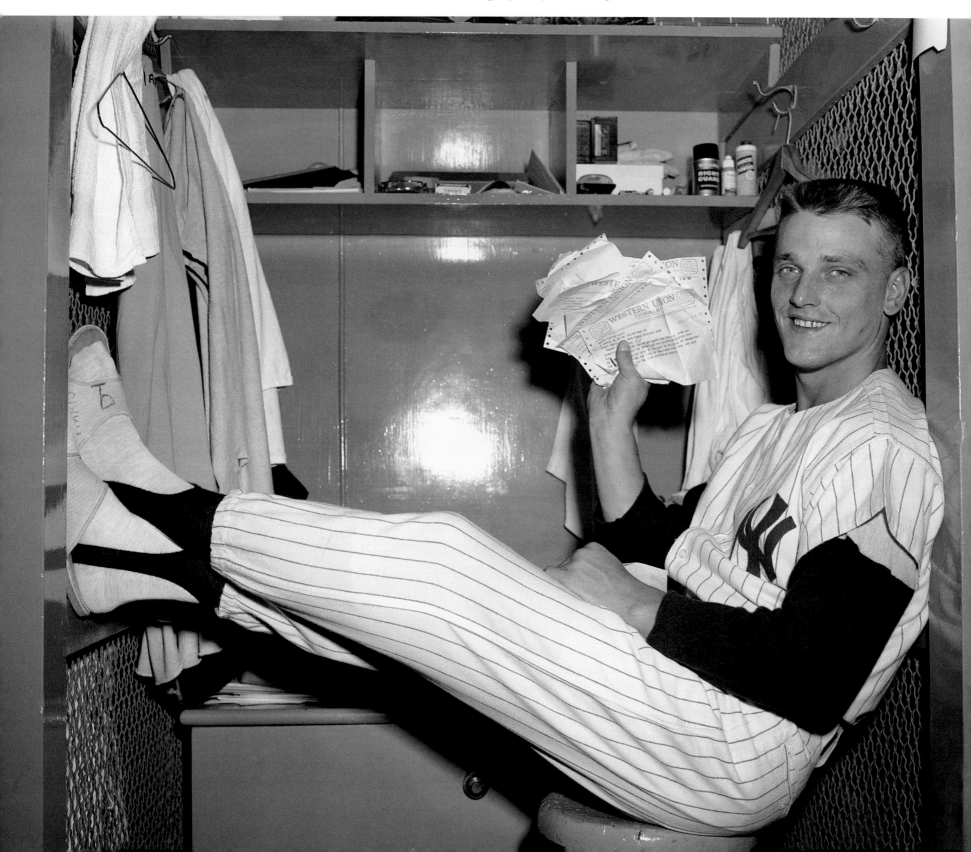

New York, Monday, October 2, 1961

ROGER SURPASSES BABE WITH NO. 61

Historic HR Gives Yanks 1–0 Win

by Joe Trimble

The Sultan of Swat has been pushed from his pinnacle as all-time home-run king by Rajah the Rapper. In the fourth inning yesterday at the Stadium, a white baseball soared through the sunshine on a high arc and trailed clouds of glory into the right-field stands. That mighty drive of about 360 feet was Roger Maris' 61st, surpassing the 60 hit by Babe Ruth in 1927.

"It is the greatest homer I ever hit," the hard-nosed, 27-year-old Yankee slugger said afterwards, his face still drawn with the strain of his achievement. That was an understatement. It was the greatest home run any man ever hit because nobody else has ever hit 61 in a major league season.

Of course, it came in the team's 163rd game and, by grace of Commissioner Ford Frick, will be listed as not having been made over a 154-game schedule. This year, the expanded AL played 162 games. Actually, due to a tie in each season, Ruth got his in 155 games while Maris took 163.

The drive was the only run as the Yankees concluded a great year with their 109th victory by beating the Red Sox, 1–0.

Tracy Stallard, 24-year-old right-hander, was the pitcher who drew a vicarious share of immortality by throwing the ball which Maris drove into the sixth row of the lower deck and into the clawing right hand of Sal Durante, a 19-year-old from Coney Island.

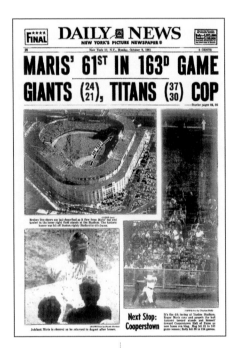

This was truly the "Golden Gopher." It means an immediate five grand for Durante, a truck driver, and about $300,000 for Maris in royalties, endorsements, and appearances over the next three years. Agent Frank Scott is the authority for the player's expected revenue.

"This was the big one," Maris said afterward, as fotogs posed him with a Yankee uniform shirt No. 61. "I can't remember much after I hit it. I was happy. I just wanted to run around those bases. When I got to the dugout, everybody from one end to the other shook my hand. Then they pushed me out onto the playing field to take a bow."

That he did, waving his cap to a standing ovation by the 23,154 fans. Rog then ducked back to the bench but Hector Lopez and some others pushed him out again and he took another bow.

Now that he had 61 in '61, how about 62 in '62?, he was asked.

"I don't want to think about that now," he said. "I'm grateful for everything I've gotten."

Maris eventually will get the ball—for his own but probably will turn it over to the Hall of Fame at Cooperstown. How about the bat?

"I'll never hit another ball with it," he said. "I'm going to keep it for myself." (For posterity, it is a 35-inch, 33-ounce Louisville Slugger.)

Maris' big bash came on his 588th official time at bat. Ruth got his 60th on his 537th time up. Stallard got him on a long drive to left field in the first inning, an area the pull-hitting Rajah seldom exploits.

"He threw a pitch outside and I just went with it," Rog explained. "I didn't want to hit it to left."

When Rog came up in the fourth, Stallard was real careful. He threw the first ball outside, and the fans booed. The second was low, across Rog's shoetips and almost in the dirt.

Maris knocked the dirt out of his spikes before the third pitch and set himself as Stallard pumped. In came a fastball, high and a bit to the outside. Rog pivoted with the smooth swing and there was a roar as the ball soared toward the right-field seats. It was well over toward the Yankee bullpen, fair enough—but would it be far enough?

There wasn't too much doubt about that, either. Clinton, the right fielder, backed to the stands, then Lou gave up helplessly as the drive landed in the sixth row, a cataract of flailing arms and buffeting bodies out of which Durante came up with the prize.

Stallard wasn't downcast at being the victim of the greatest home run of all time.

"I tried to get him out," the young pitcher said later. "I would rather have had him hit a homer than walk him four times. I have nothing to be ashamed of. He hit 60 off others, didn't he?

"It was a fastball. When I let it go, I wasn't sure where it was going. When I heard the solid wood, I thought it might go out."

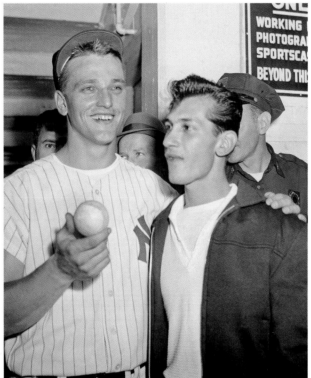

Sal Durante presents Roger Maris with the ball he laced for his 61st homer of the year on October 1, 1961.

Actually, Maris hit all 61 home runs in a span of 153 games and that doesn't count one that was washed out in Baltimore on July 17. Rog didn't hit one in the first 10 games because he started the season in one of his long slumps, making only six singles in his first 33 at-bats and being dropped to seventh in the batting order before connecting for No. 1 against Detroit's Paul Foytack.

Incidentally, it was on July 17, too, that Frick insisted that Maris or Mickey Mantle had to break the 60 barrier in 154 decisions.

Maris said that he didn't come to the park yesterday feeling he would get No. 61 but that he was "hopeful." Manager Ralph Houk said he, himself, did wake up yesterday with the feeling Rog would hit the big one.

"I figured this kind of a pitcher (Stallard is fast and doesn't have real good control) might be the one for him. Those others (Bill Monbouquette and Don Schwall, Red Sox pitchers who stopped Rog Friday and Saturday) keep the ball low and are hard to lift against. I thought Stallard might throw the kind of pitch he could hit out."

Incidentally, that was the Yanks' 240th homer, a major league record. They had 230 in 154 games, nine more than the previous high.

Diamond dust: Jim Turner, former Yankee pitching coach who has same job with Reds, dropped by to visit Yankee players and scout the Bombers. "Guess I've learned all I can here," he gagged after talking with Yogi for a few minutes.... Reds arrived last night (they're at the Roosevelt Hotel) and will work out at 1:30 PM today and tomorrow. Yanks practice at 11:00 AM same days.... 📷

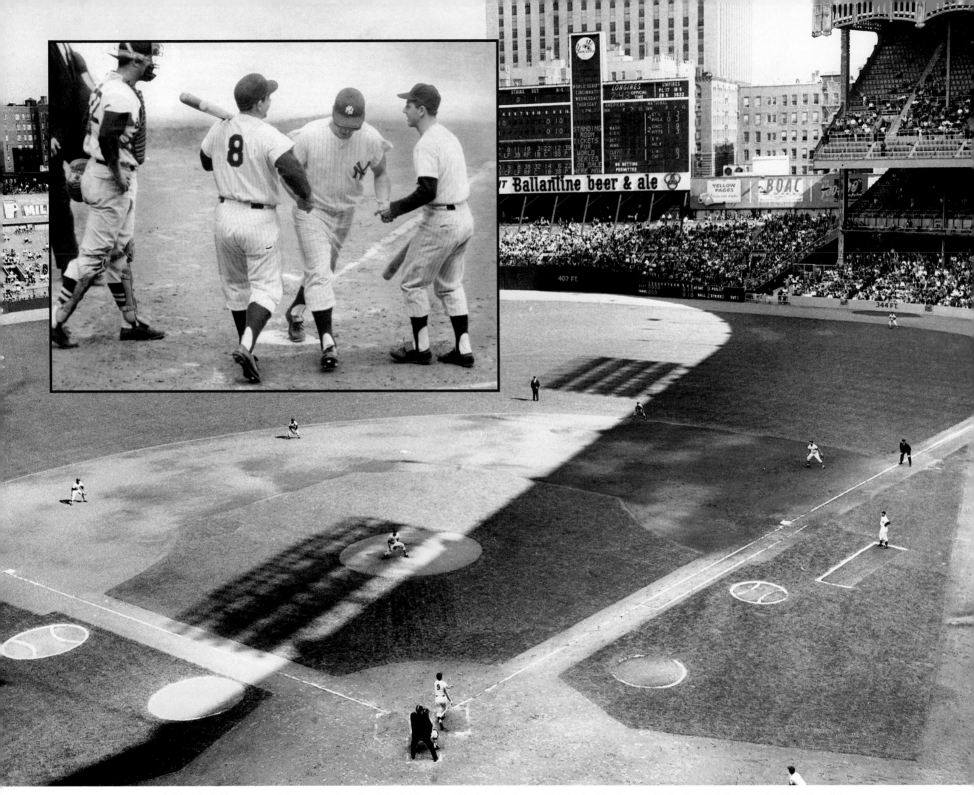

Roger Maris hits his 61ˢᵗ home run of the season into the right-field seats at Yankee Stadium, off of the Red Sox's Tracy Stallard on October 1, 1961. Maris (inset) is congratulated by teammate Yogi Berra (8) and the bat boy as he crosses home plate.

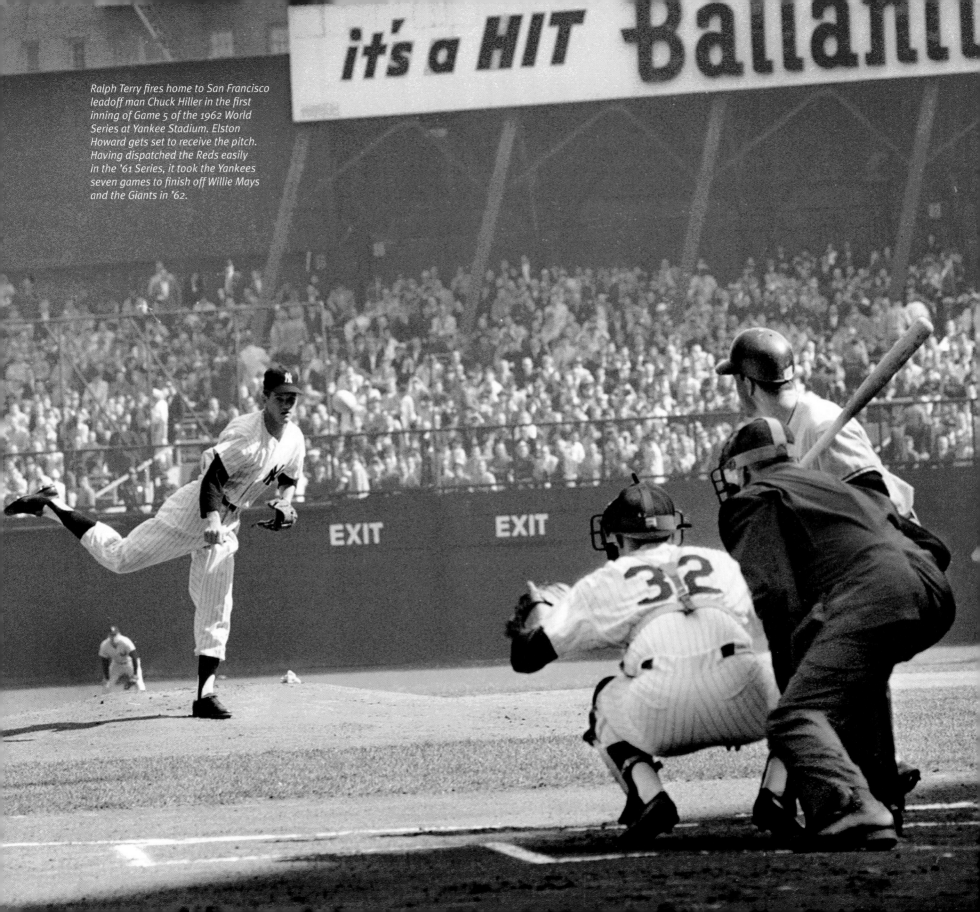

Ralph Terry fires home to San Francisco leadoff man Chuck Hiller in the first inning of Game 5 of the 1962 World Series at Yankee Stadium. Elston Howard gets set to receive the pitch. Having dispatched the Reds easily in the '61 Series, it took the Yankees seven games to finish off Willie Mays and the Giants in '62.

it's a HIT Ballant

EXIT EXIT

Ralph Terry, on Greenwich Avenue, takes the wheel of a Corvette given to him by Sport Magazine as the MVP of the 1962 World Series. Terry won Game 5 for the Yankees, a 5–3 complete-game victory over the Giants, then came back and hurled a complete-game, 1–0 shutout in Game 7 at Candlestick Park. Over three starts, he pitched 25 innings with a 1.80 ERA.

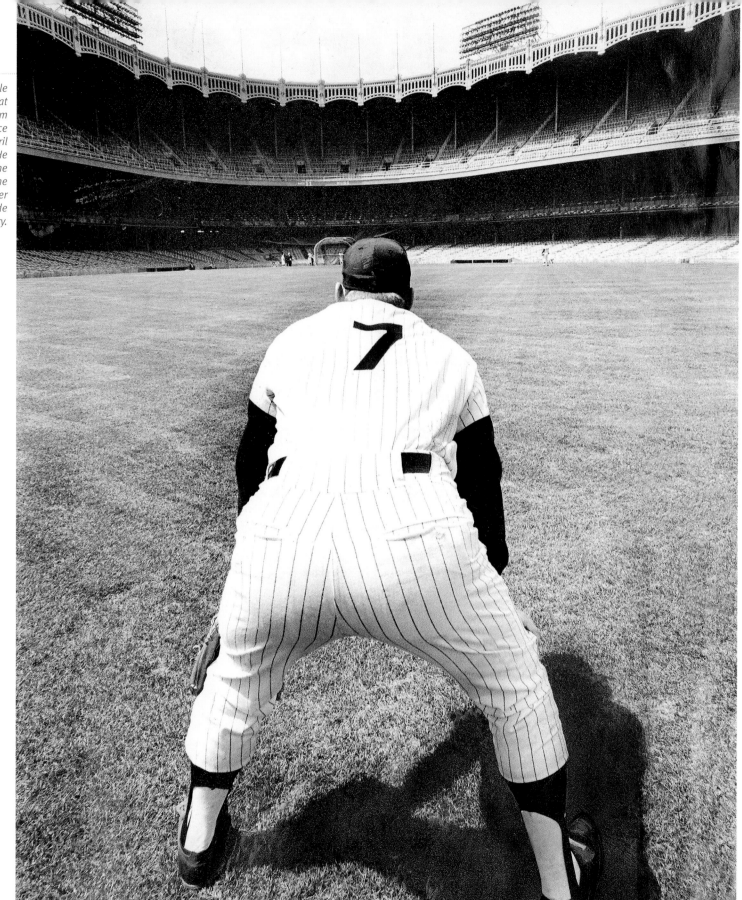

Mickey Mantle works out at Yankee Stadium during a practice session on April 26, 1963. He returned to the lineup for first time in two weeks after suffering a side injury.

Yogi Berra, Joe Pepitone, Elston Howard, and Clete Boyer (left to right) check over the lumber after a new shipment of bats arrived on September 30, 1963, for the World Series against the Los Angeles Dodgers. The new bats didn't help, however, as Sandy Koufax and the Dodgers held the Yankees to just four runs over four games, sweeping the Bombers for the 1963 championship.

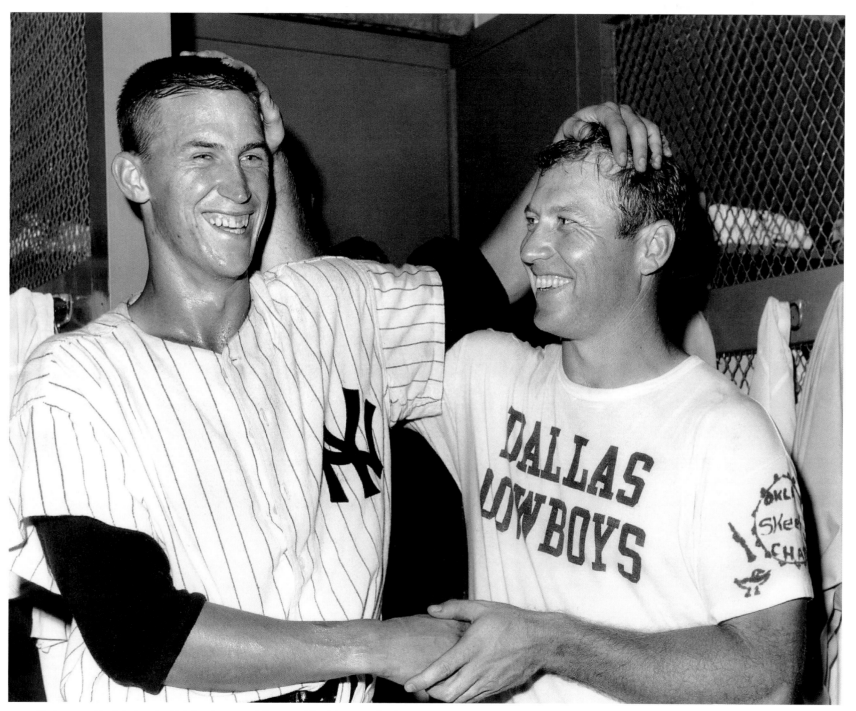

Yankees rookie right-hander Mel Stottlemyre celebrates with Mickey Mantle after getting the victory over the Boston Red Sox at Yankee Stadium on August 12, 1964. It was Stottlemyre's first start in the major leagues, and Mantle hit two homers to seal the win.

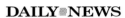

Mickey Mantle kneels on first base after being doubled up on Joe Pepitone's lineout during a game against the White Sox at Yankee Stadium on June 9, 1967. The Yankees were in the midst of their third losing season in a row, their worst multi-season under-.500 slump since 1912–1915.

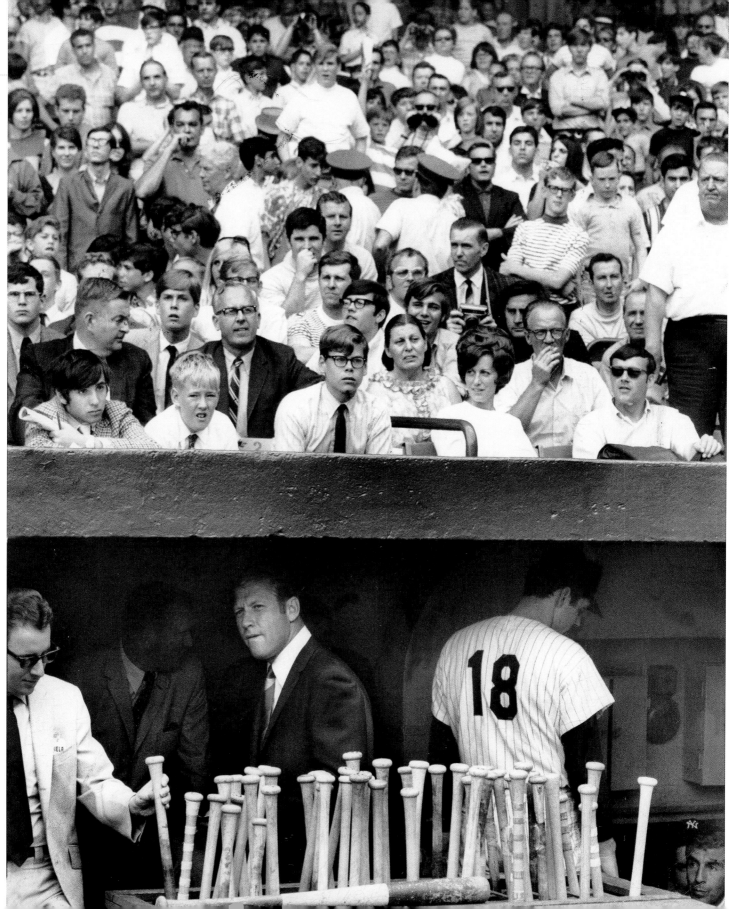

Mickey Mantle in the dugout on Mickey Mantle Day at Yankee Stadium on June 8, 1969, where his No. 7 jersey was retired following his retirement in March.

Mantle (next page) wipes his eyes as 60,096 fans give him an eight-minute standing ovation that day.

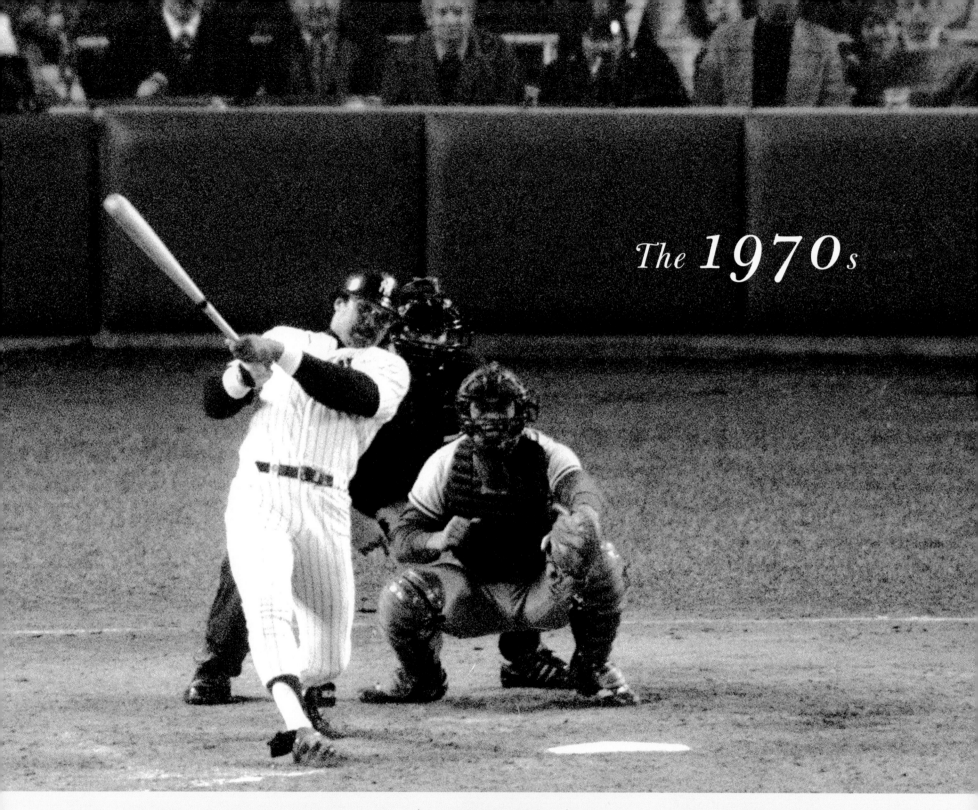

The 1970s

100 YEARS IN PINSTRIPES | DAILY●NEWS | *The New York Yankees in Photographs*

Reggie Jackson

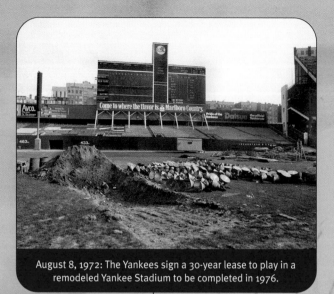

August 8, 1972: The Yankees sign a 30-year lease to play in a remodeled Yankee Stadium to be completed in 1976.

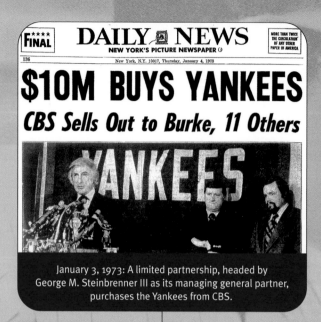

FINAL

DAILY NEWS
NEW YORK'S PICTURE NEWSPAPER

136 New York, N.Y. 10017, Thursday, January 4, 1973

$10M BUYS YANKEES
CBS Sells Out to Burke, 11 Others

MORE THAN TWICE THE CIRCULATION OF ANY OTHER PAPER IN AMERICA

January 3, 1973: A limited partnership, headed by George M. Steinbrenner III as its managing general partner, purchases the Yankees from CBS.

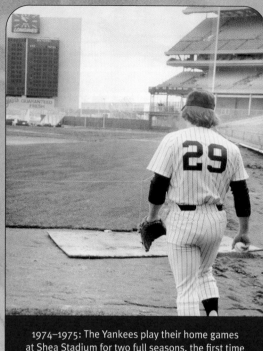

1974–1975: The Yankees play their home games at Shea Stadium for two full seasons, the first time they had to play outside Yankee Stadium since 1922 (the Yanks go 90–69 at Shea over that span).

1970 1971 1972 1973 1974

September 30, 1973: Ralph Houk resigns as manager.

December 31, 1974: Free agent Jim "Catfish" Hunter signs a then-record five-year, $3.2 million contract.

August 1, 1975: Billy Martin replaces Bill Virdon for his first of five stints as manager.

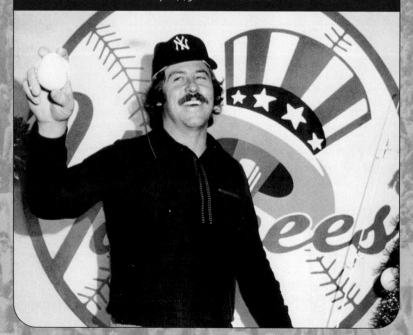

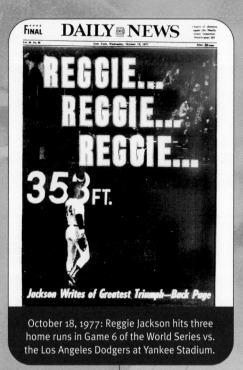

October 18, 1977: Reggie Jackson hits three home runs in Game 6 of the World Series vs. the Los Angeles Dodgers at Yankee Stadium.

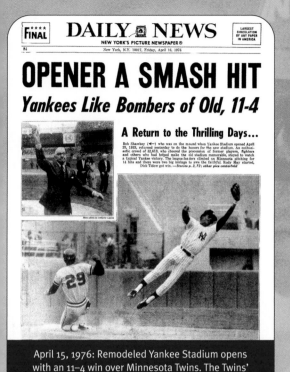

April 15, 1976: Remodeled Yankee Stadium opens with an 11–4 win over Minnesota Twins. The Twins' Dan Ford hits the first home run.

November 29, 1976: Free agent Reggie Jackson signs a five-year contract.

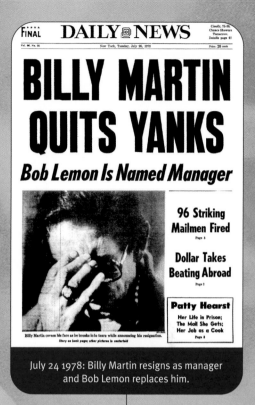

July 24 1978: Billy Martin resigns as manager and Bob Lemon replaces him.

1975 **1976** **1977** **1978** **1979**

October 14, 1976: Chris Chambliss' ninth-inning home run off Mark Littell in Game 5 of the ALCS vs. Kansas City gives the Yankees their 30th pennant.

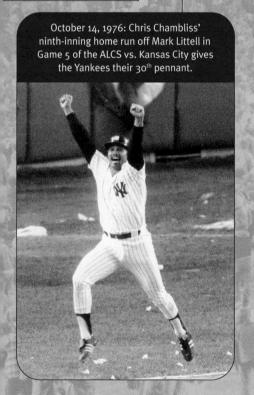

June 16, 1978: Ron Guidry establishes a franchise record by striking out 18 batters in the Yankees' 4–0 win vs. California at Yankee Stadium.

July 29, 1978: On Old-Timers' Day, the Yankees announce that Billy Martin will return as Yankees manager in 1980 and Bob Lemon will become GM.

1978: The Yankees come from 14 games behind Boston to force only the second playoff game in AL history. They beat the Red Sox 5–4 at Fenway on a Bucky Dent homer over the Green Monster. The Yanks go on to win the ALCS vs. Kansas City and their second straight World Series, beating the Dodgers again.

June 18, 1979: Billy Martin returns as Yankees manager, replacing Bob Lemon.

August 2, 1979: Yankees Captain Thurman Munson dies in a plane crash in Canton, Ohio, at age 32. His jersey No. 15 is immediately retired.

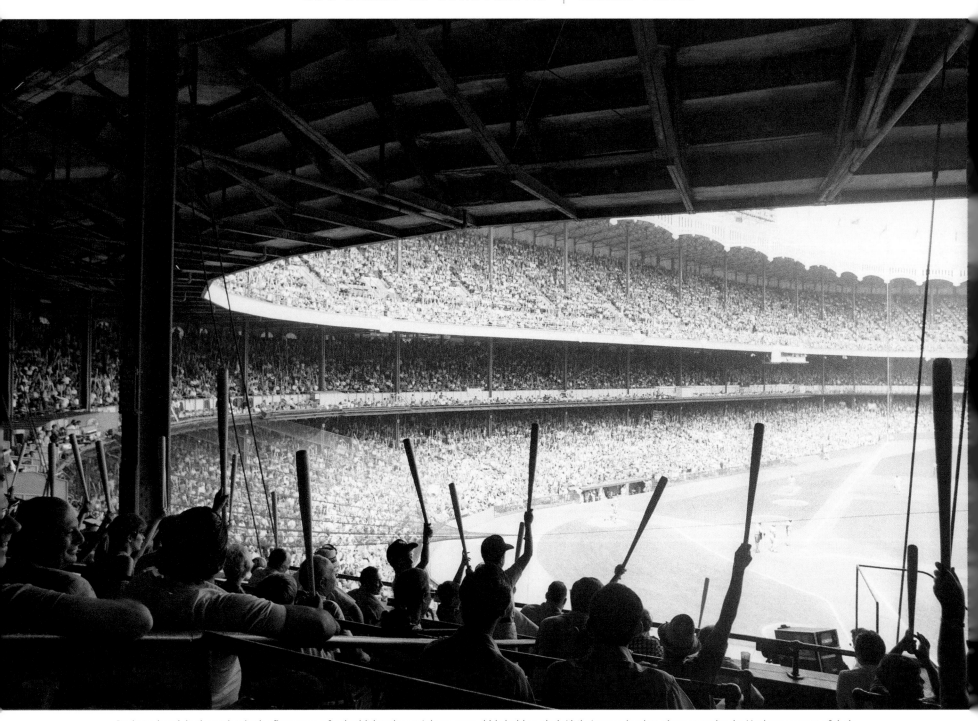

During a break in the action in the first game of a doubleheader on July 19, 1970, kids hold up their Little League lumber given away by the Yankees as part of their "Bat Day" promotion. It turned out the Yankees could have used some, as they got swept by the California Angels 5–2 and 3–1.

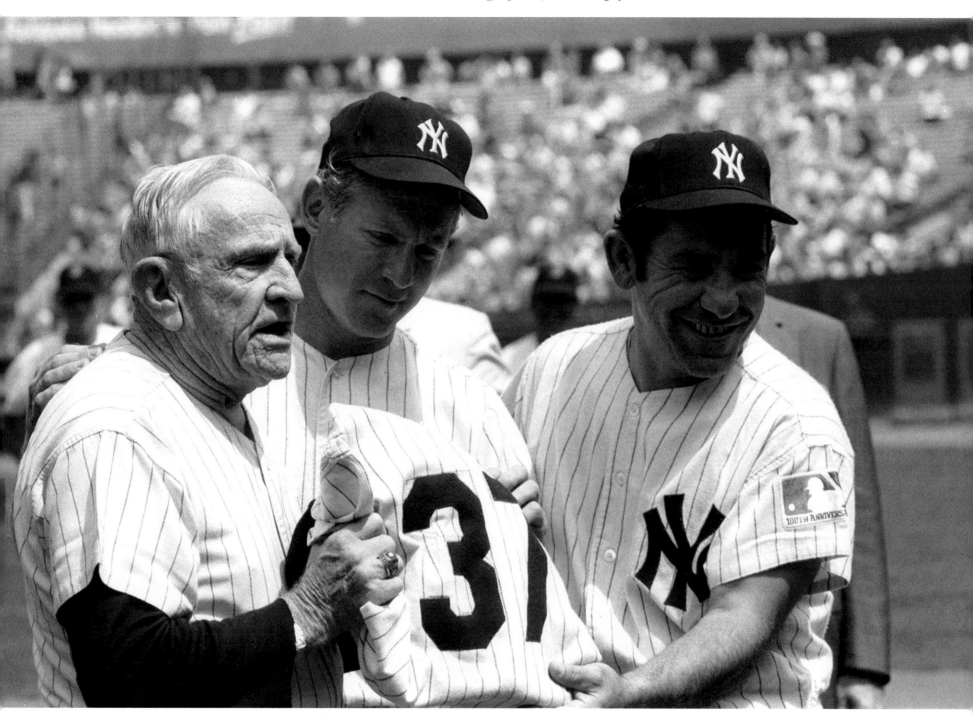

Whitey Ford (center) and Yogi Berra (right) present Casey Stengel with his No. 37 jersey, which was retired by the Yankees on August 9, 1970.

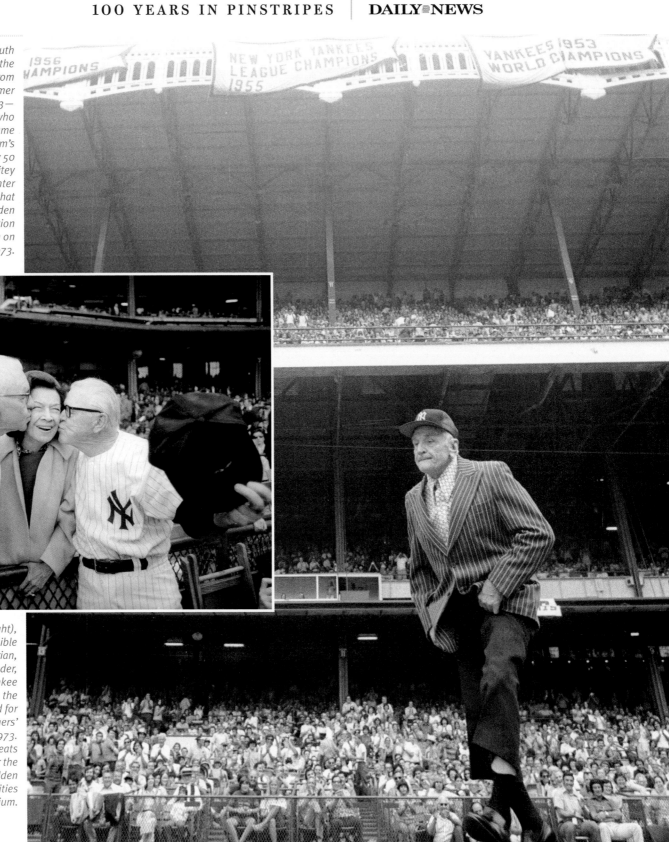

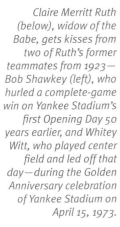

Claire Merritt Ruth (below), widow of the Babe, gets kisses from two of Ruth's former teammates from 1923—Bob Shawkey (left), who hurled a complete-game win on Yankee Stadium's first Opening Day 50 years earlier, and Whitey Witt, who played center field and led off that day—during the Golden Anniversary celebration of Yankee Stadium on April 15, 1973.

Casey Stengel (right), the irrepressible raconteur, octogenarian, and peerless leader, jogs onto the Yankee Stadium field to the cheers of the crowd for the 27th Old-Timers' Day on August 11, 1973. Dozens of Yankee greats were on hand for the continuing Golden Anniversary festivities for the Stadium.

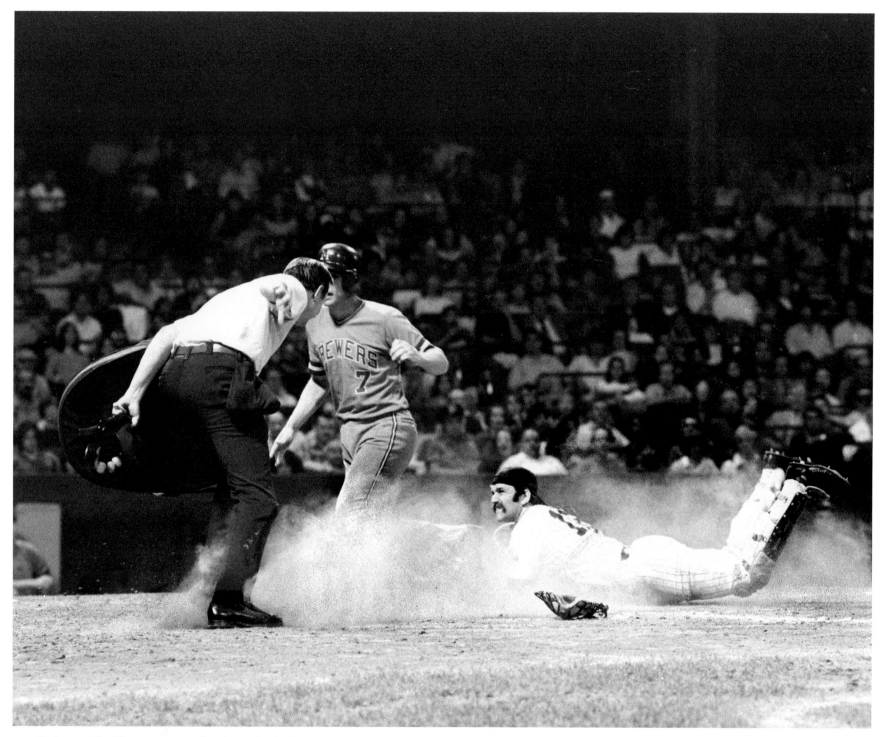

Yankees catcher Thurman Munson dives into a cloud of dust to put the tag on the Milwaukee Brewers' Don Money, who tried for home on a Bobby Mitchell grounder in the sixth inning at Yankee Stadium on September 7, 1973. Money was out, but the Yanks fell, 5–0.

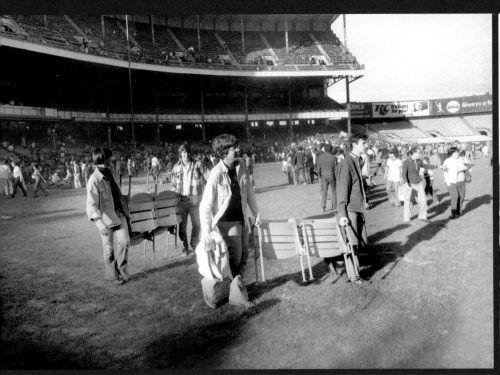

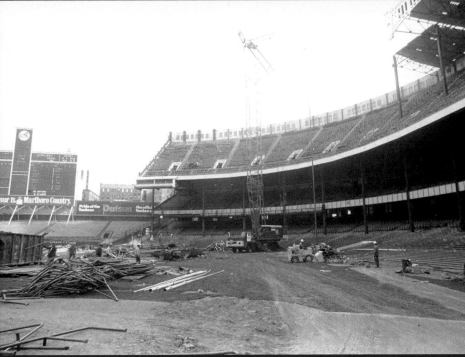

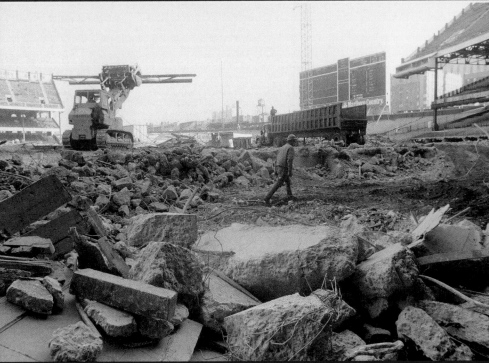

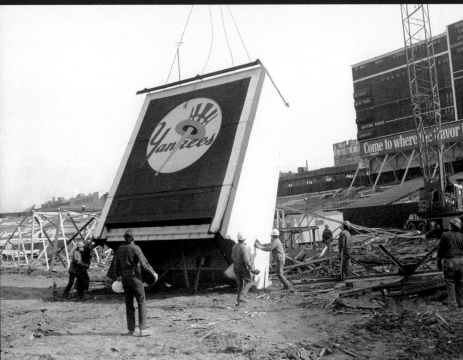

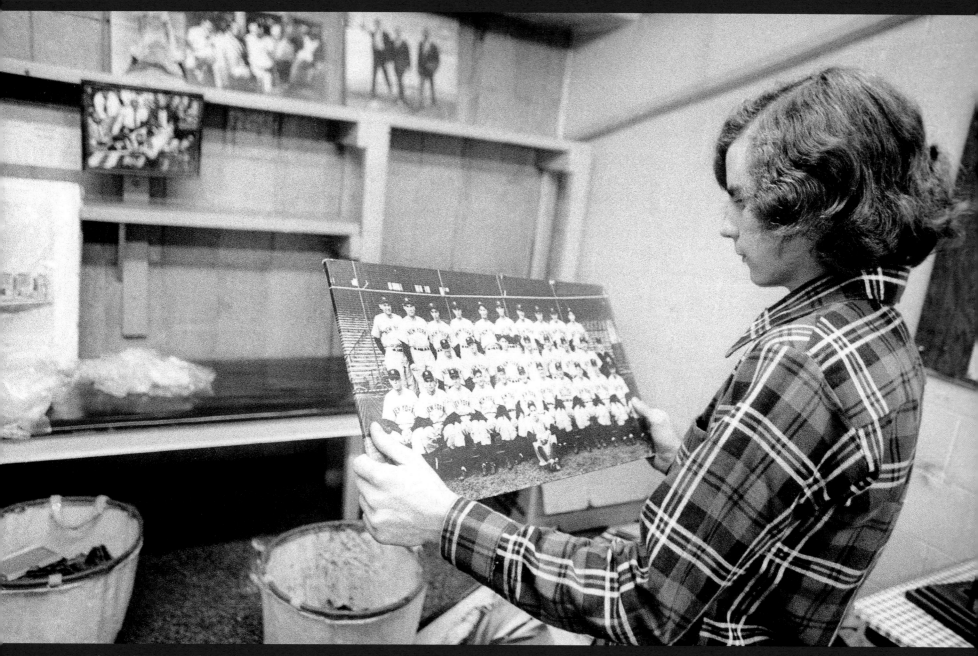

After the final game of the season is played at old Yankee Stadium, an 8–5 loss to Detroit on September 30, 1973, fans (facing page, top left) walk off with improvised souvenirs of the House That Ruth Built—the seats they were sitting in. The next day, renovation of Yankee Stadium begins. Tearing down the old ballpark unearths a treasure trove of memorabilia. A Stadium brick could be had for a buck. Seats that once went for $1.10 for an afternoon could be owned for $10. Photos went for up to $350. Dave Donnelly (above) of Queens, then age 15, looks over a photo of a championship Yankees team from 1943.

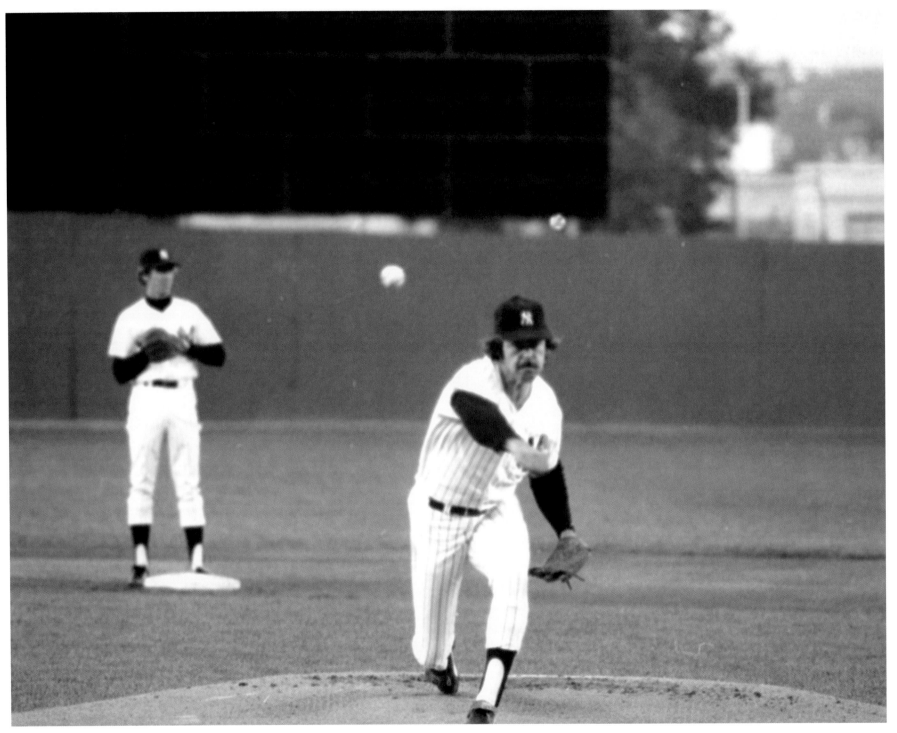

Catfish Hunter, who signed one of the first multimillion-dollar, free-agent contracts in Major League Baseball with the Yankees in January 1975, takes a warmup toss during a game in June against the California Angels at Shea Stadium, the Yankees' temporary home for the 1974 and 1975 seasons. Billy Martin (facing page), hired on August 1, 1975, jaws at umpire Don Denkinger in his first game as skipper on August 2, as third baseman Graig Nettles joins in the discussion.

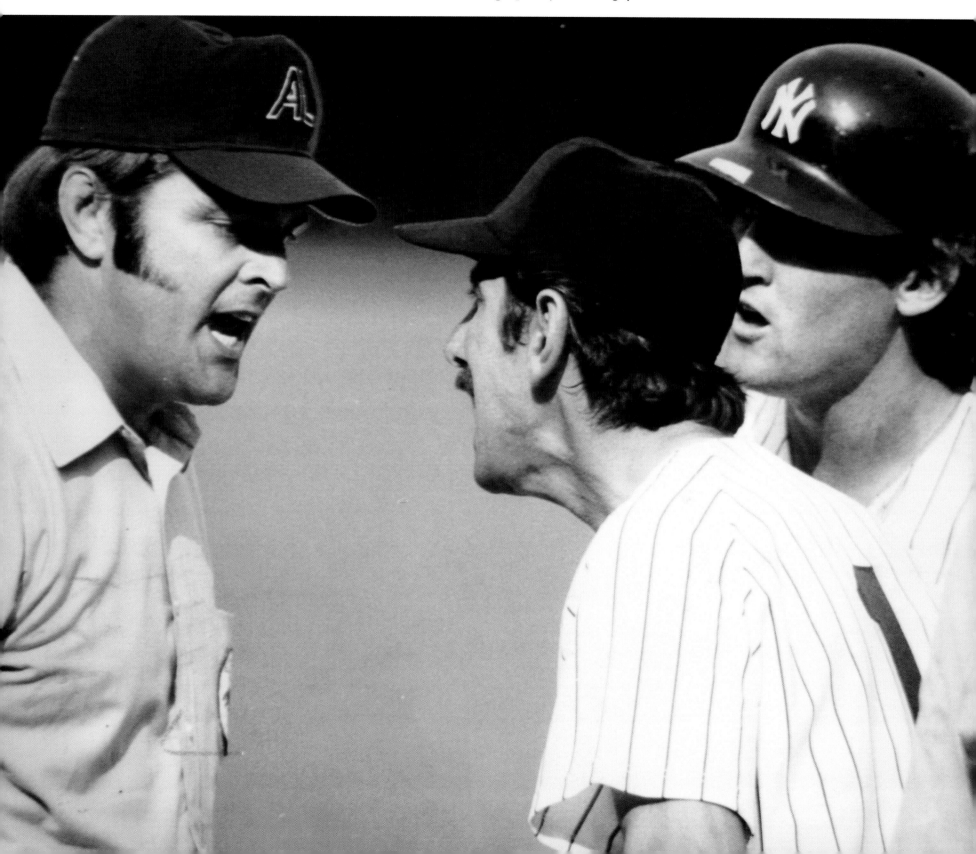

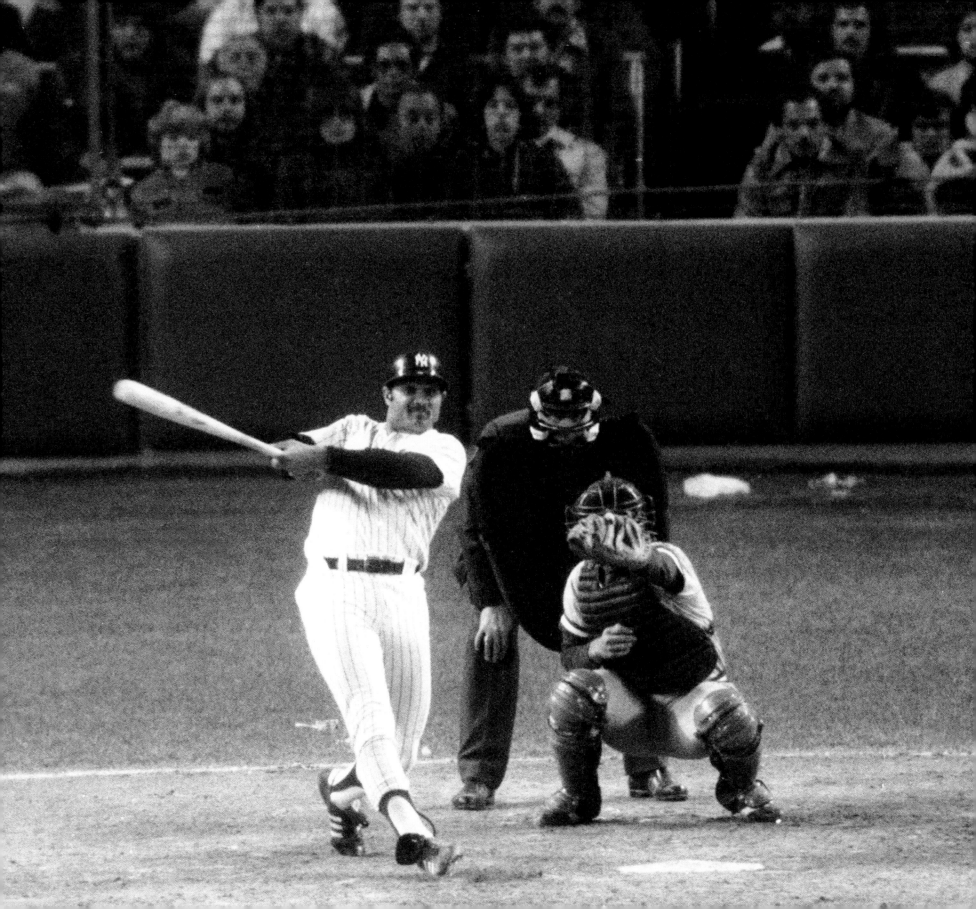

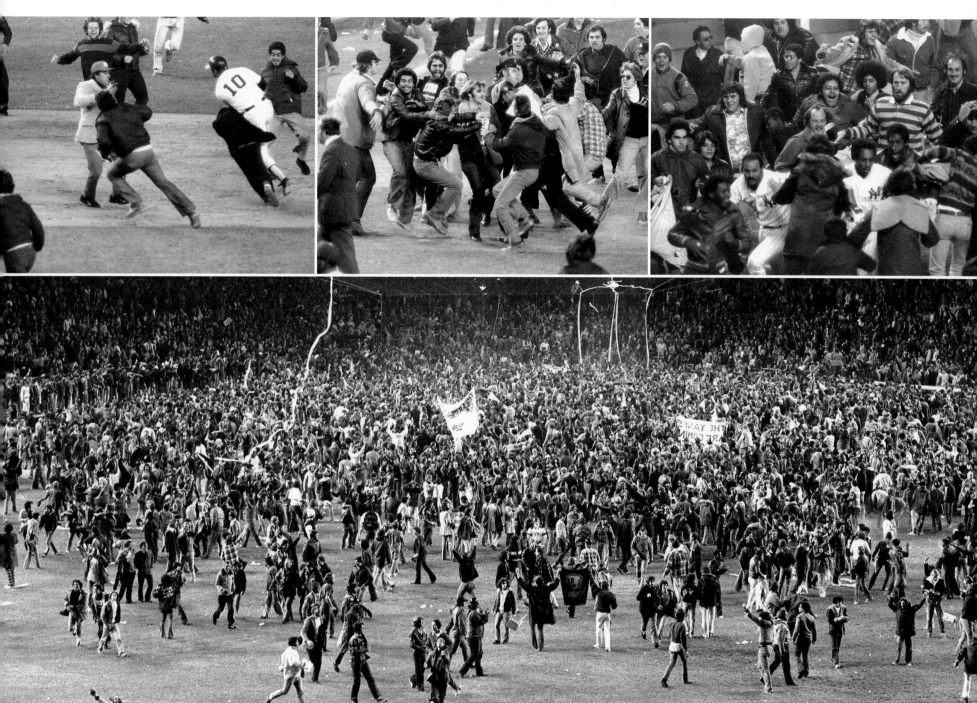

Yankees fans' hopes sank when Kansas City's George Brett homered with two on in the eighth inning of Game 5 of the 1976 ALCS to tie it at 6–6 in the best-of-five series. But their spirits soared with the crack of the bat when Yankees first baseman Chris Chambliss, leading off the Yankees ninth, swung and sent the ball over the right-field fence for a game- and pennant-winning home run. The Stadium turned to bedlam, and Chambliss was mobbed as he rounded second on his way to home plate.

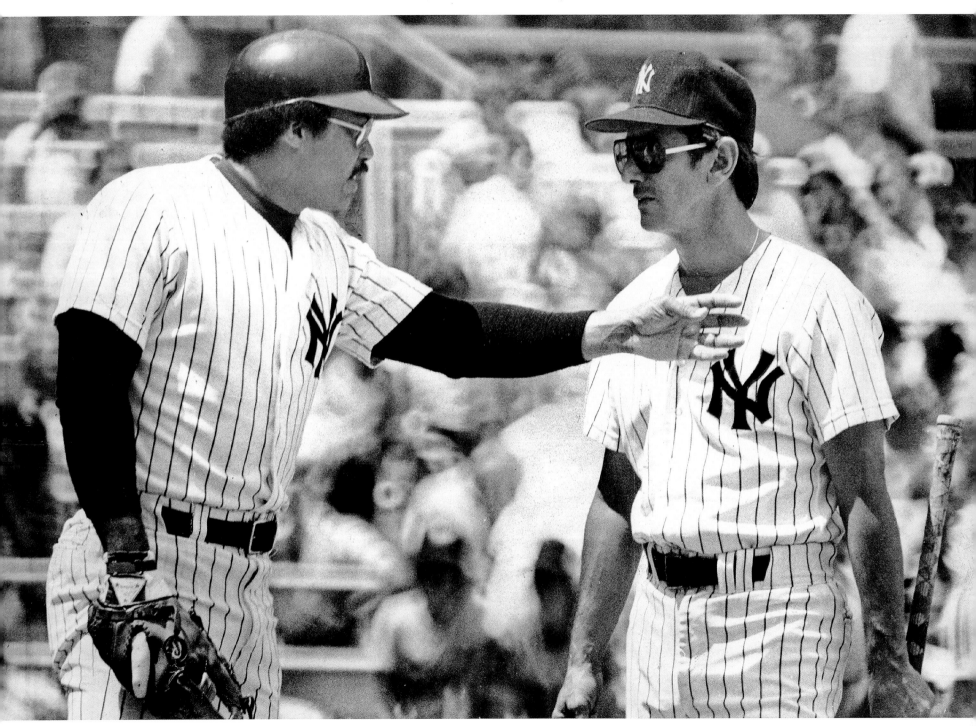

In the midst of a turbulent 1977 season that saw the arrival of star free agent Reggie Jackson (left) and the clash of egos that followed between him and manager Billy Martin (right), Jackson makes his point to Martin during a game at Yankee Stadium in July.

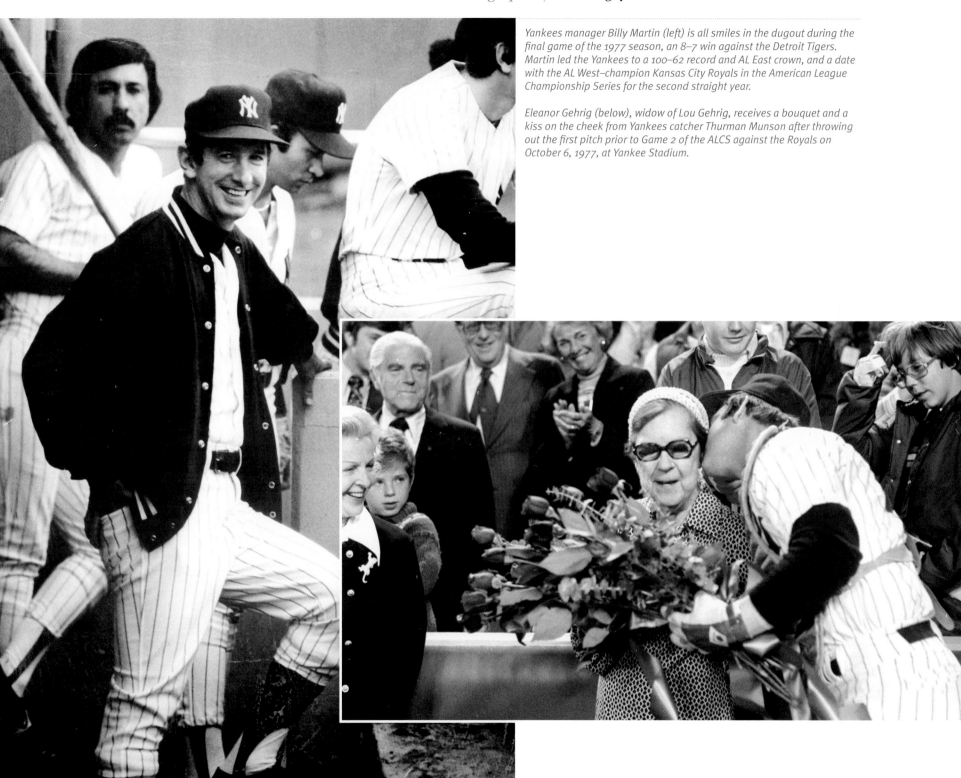

Yankees manager Billy Martin (left) is all smiles in the dugout during the final game of the 1977 season, an 8–7 win against the Detroit Tigers. Martin led the Yankees to a 100–62 record and AL East crown, and a date with the AL West–champion Kansas City Royals in the American League Championship Series for the second straight year.

Eleanor Gehrig (below), widow of Lou Gehrig, receives a bouquet and a kiss on the cheek from Yankees catcher Thurman Munson after throwing out the first pitch prior to Game 2 of the ALCS against the Royals on October 6, 1977, at Yankee Stadium.

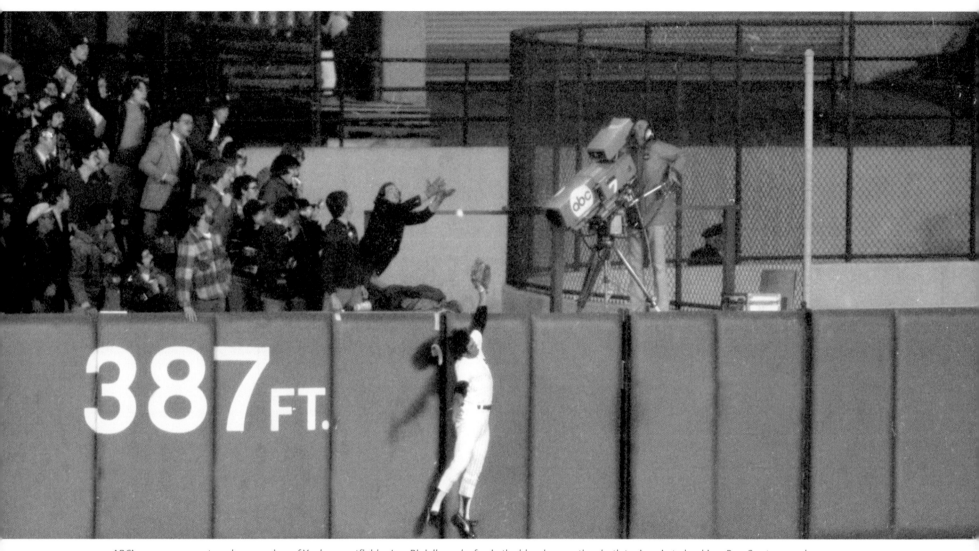

ABC's cameraman gets a close-up view of Yankees outfielder Lou Piniella and a fan in the bleachers as they both try in vain to haul in a Ron Cey two-run home run at Yankee Stadium in the first inning of Game 2 of the 1977 World Series. The Dodgers went on to win the game 6–1 but lost the Series in six games. Yankees catcher Thurman Munson (facing page) watches the flight of the ball in Game 6 of the 1977 World Series against the L.A. Dodgers at Yankee Stadium.

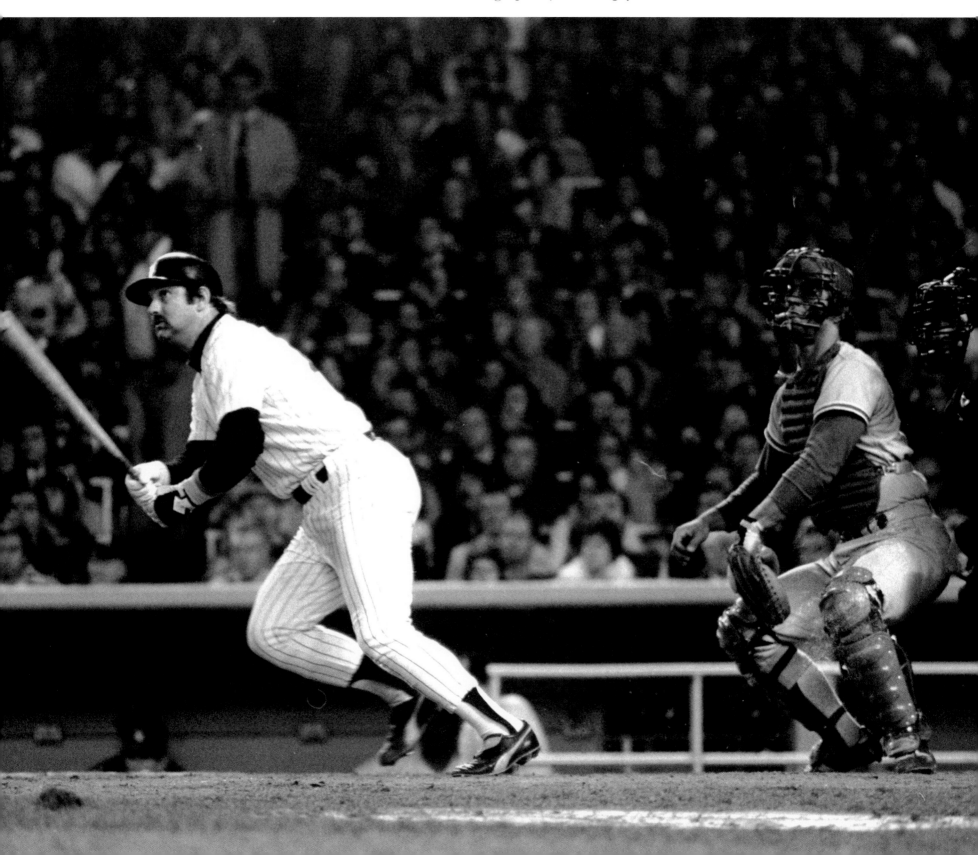

New York, Wednesday, October 19, 1977

REGGIE . . . REGGIE

Jax' 3 HRs Give Yanks Series, 8–4

by Phil Pepe

The strange saga of the '77 Yankees, which began in turmoil and continued in turbulence, ended in dramatic triumph last night as they rode the home-run bat of Reggie Jackson to their first world championship in 15 years and 21st of all time.

Only hours after Billy Martin was given a vote of confidence and a substantial bonus for a job well done and the assurance he would be back next year, Jackson crashed three home runs in succession, all on the first pitch, to drive in five runs and lead the Yankees to an 8–4 victory over the Dodgers and win the World Series in six games.

His three homers in one game tied a record established by another Yankee slugger, Babe Ruth, in the 1926 and 1928 Series. It was the first time a player had hit three home runs in three consecutive at-bats and Jackson's five homers for the Series also set a record. Jackson's hitting overshadowed the efforts of Mike Torrez, who pitched his second complete-game victory of the Series, and Chris Chambliss, whose two-run homer in the second wiped out a 2–0 advantage the Dodgers took in their first at-bat.

Mike Torrez got off to a flying start, retiring Davey Lopes on a bouncer to short with a 1–1 pitch. He then got Bill Russell to hit the second pitch on the ground to second baseman Willie Randolph for another easy out.

Things turned sour when Bucky Dent bobbled Reggie Smith's bouncer for an error and Thurman Munson's passed ball on a swinging strike one sent Smith to second. Torrez then threw four balls to Ron Cey and followed by throwing two balls to Steve Garvey, who lined the next pitch past first baseman Chris Chambliss into the right-field corner. As Reggie Jackson ran the ball down,

Garvey raced to third and Smith and Cey scored. Torrez left Garvey at third by slipping a third strike past Dusty Baker.

Burt Hooton picked up in the last of the first where he left off in Game 2, when he held the Yankees to five hits and retired the last eight hitters. He got them in order in the first, aided by a fine play in left by Baker, who went into the seats for Mickey Rivers' leadoff pop. Randolph and Munson were retired on bouncers to shortstop Russell.

Torrez retired the Dodgers in order in the second and the Yankees came firing back in their half. Hooton walked Jackson on four pitches and threw two straight balls to Chambliss before putting a strike over. The next pitch probably was a strike, too. Chambliss, struggling during the entire postseason, drilled it deep into the right-field seats to tie the game at 2–2.

The fans didn't have long to enjoy Chambliss' home run and the tie game, which lasted for two batters in the Dodger third. The third batter, Smith, drove a shot into the right-field seats to untie it. It was Smith's third homer of the Series and the Dodgers' ninth, tying an NL record.

After the Yankees went down in order in the third, the Dodgers came back and threatened once more. With one out, Rick Monday looped a broken-bat single over short and Steve Yeager followed with a shot inside third. The ball bounced off the left-field barrier and Lou Piniella played the ricochet quickly and alertly, firing to Randolph to catch Yeager to stretch. Torrez then fanned Hooton to leave another Dodger stranded at third.

Munson gave the Yankees a start in the fourth, leading off with a single on the first pitch, a line drive to left. Jackson also hit the

first pitch, pulling it on a searing line into the lower right-field seats, his third homer of the Series, to put the Yankees ahead, 4–3. As he rounded the bases and spotted the TV cameras on him, Jackson mouthed "Hi, mom," twice. He was greeted in the jubilant Yankee dugout first by Martin, who patted Reggie on the cheek.

When the count went to 2–1 on Chambliss, Tom Lasorda reached into his bullpen and came up with Elias Sosa to replace Hooton. Chambliss lifted a pop to short left that Russell and Baker misplayed, the ball dropping untouched for a double.

Graig Nettles did his job, pulling the ball to the right side to move Chambliss to third, from where he scored easily on Piniella's deep fly to left.

Control problems continued to plague Torrez in the fifth as he went 2–0 on Lopes before popping him up, then went 2–0 on Russell as Martin went to the mound and Sparky Lyle went to work in the bullpen. Torrez completed the walk to Russell, then faced the dangerous Smith. But Reggie hit the first pitch on a bouncer to short and Dent started a 6-4-3 double play.

The Yankees pressed their advantage in the last half of the fifth, Rivers leading off with a single. Attempting to bunt him over, Randolph bunted into a force. Munson then drove deep to center, bringing up Jackson, "an October ballplayer," according to Munson.

With his characteristic flair for the dramatic, Jackson ripped into Sosa's first pitch, as he had done in the previous inning, and ripped a carbon-copy line-drive homer into the lower right-field seats. It was Reggie's second homer in two innings and fourth in the Series, tying a record held by many.

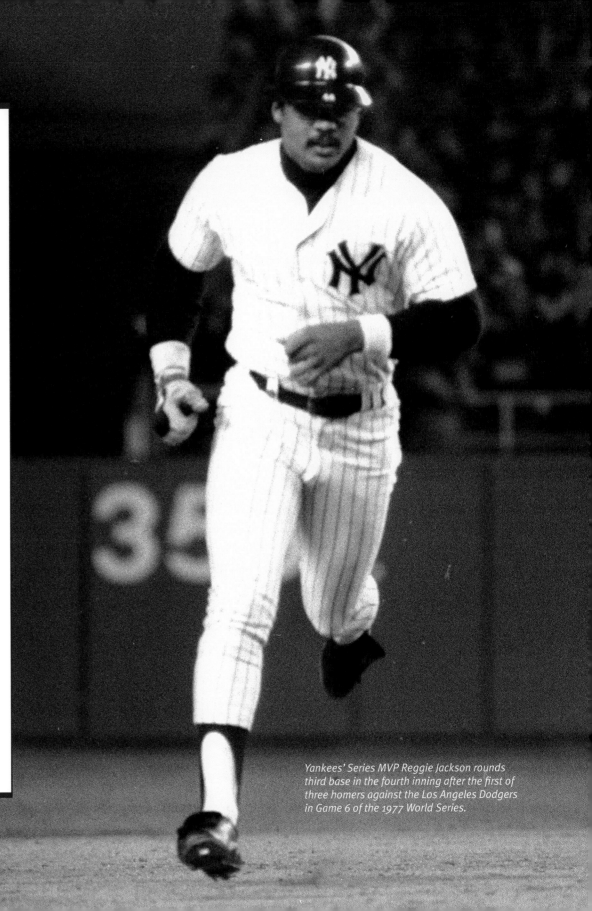

Yankees' Series MVP Reggie Jackson rounds third base in the fourth inning after the first of three homers against the Los Angeles Dodgers in Game 6 of the 1977 World Series.

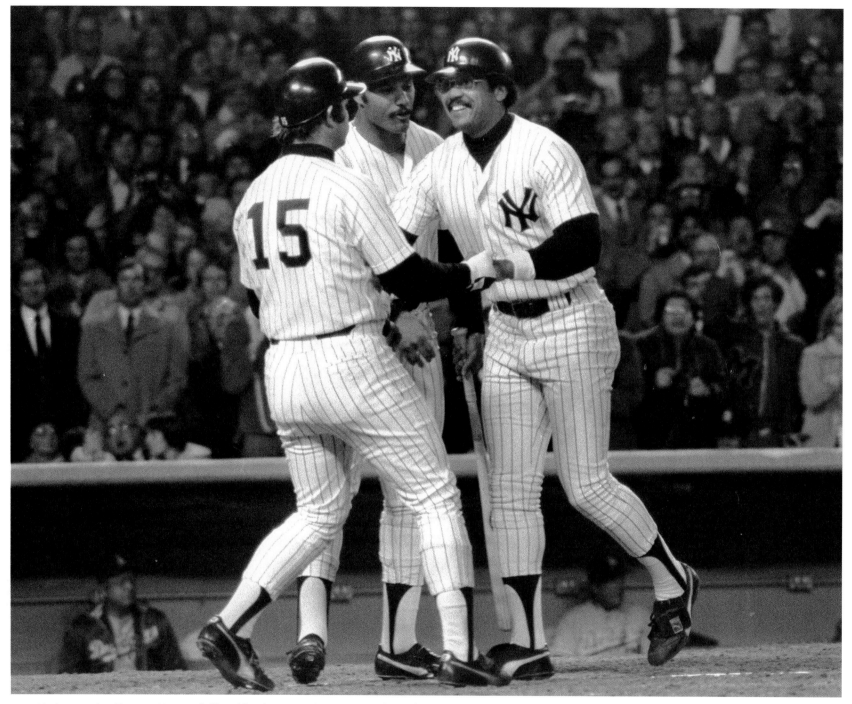

Yankees catcher Thurman Munson (left) and first baseman Chris Chambliss (center) lead the welcoming committee in the fourth inning for Reggie Jackson after the first of his three home runs against the Dodgers in Game 6 of the 1977 World Series at Yankee Stadium.

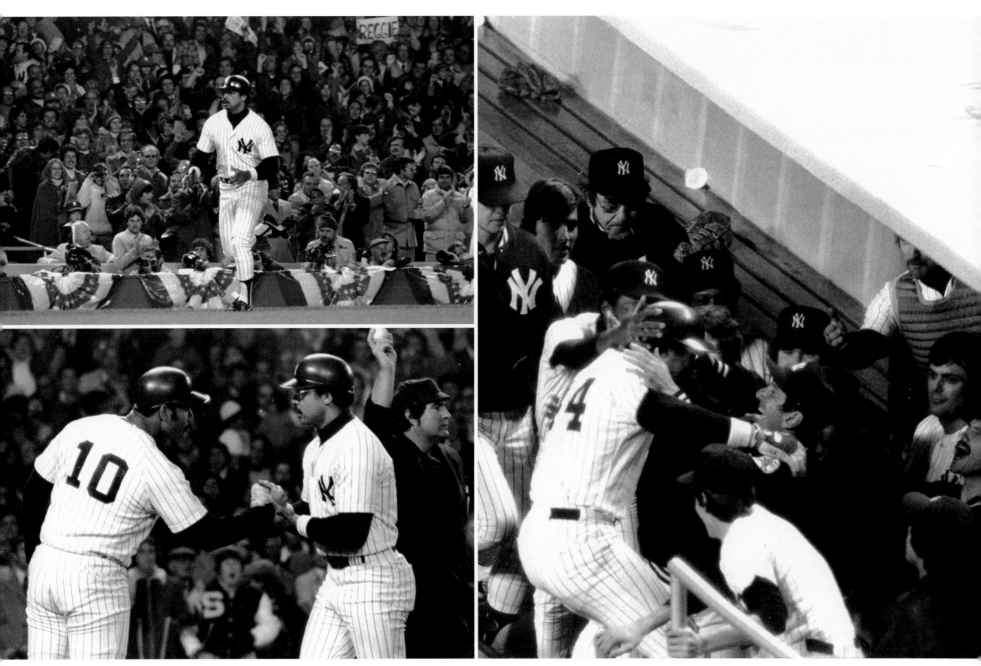

Reggie Jackson (top left) nonchalantly trots toward home plate, past some of the 56,407 deliriously happy fans after he neatly stroked the second of his three home runs in the fifth inning against the Dodgers in Game 6. Jackson (bottom left) is congratulated by Chris Chambliss (10) after touching home. Yankees manager Billy Martin (right) is one of the happiest Yankees in the dugout as he greets Jackson after he hit the first of his three homers.

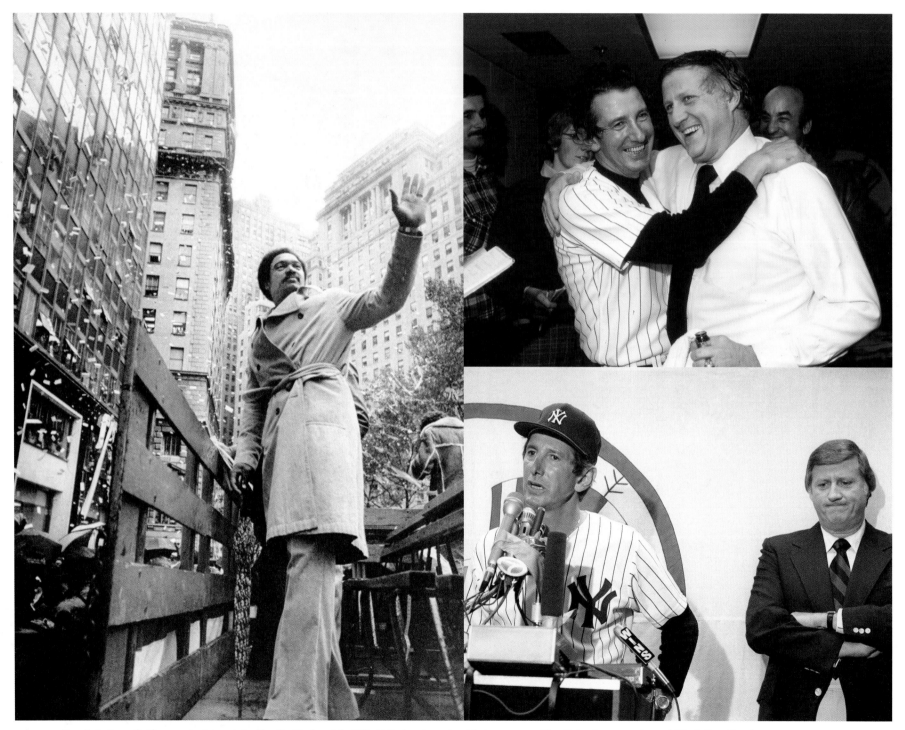

Reggie Jackson (left) waves to fans celebrating the Yankees' first World Series championship in 15 years with a ticker-tape parade past City Hall on October 20, 1977. Yankees manager Billy Martin (top right) hugs Yankees owner George Steinbrenner after the 1977 All-Star Game, but during a press conference (bottom right) in July 1978 must field questions about his resignation from the manager position as Steinbrenner looks on.

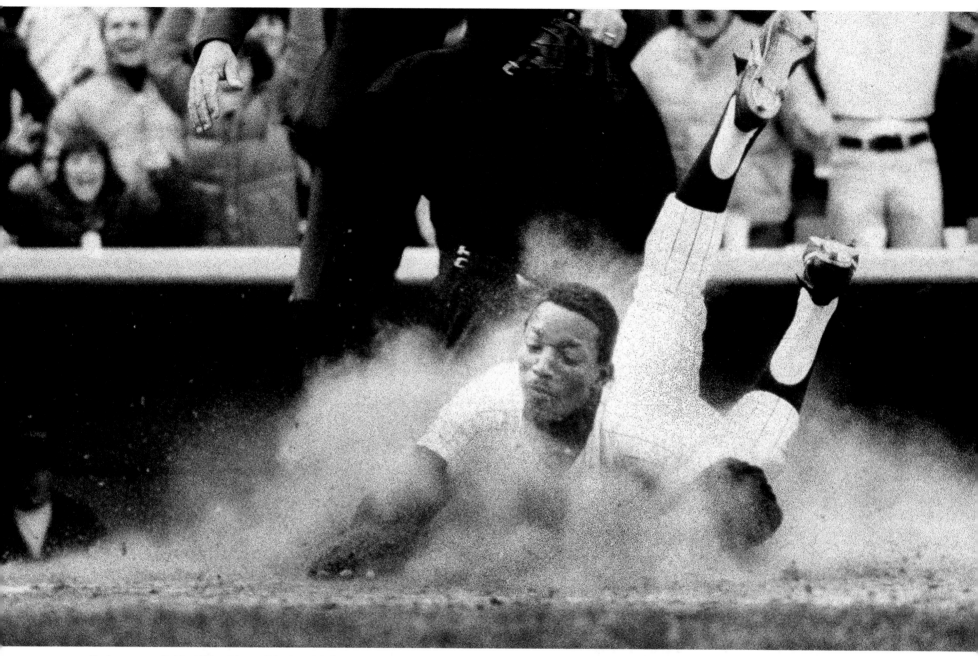

Yankees center fielder Mickey Rivers slides in safely for a game-winning, inside-the-park, two-run home run in the bottom of the eighth against the Chicago White Sox at Yankee Stadium on April 15, 1978.

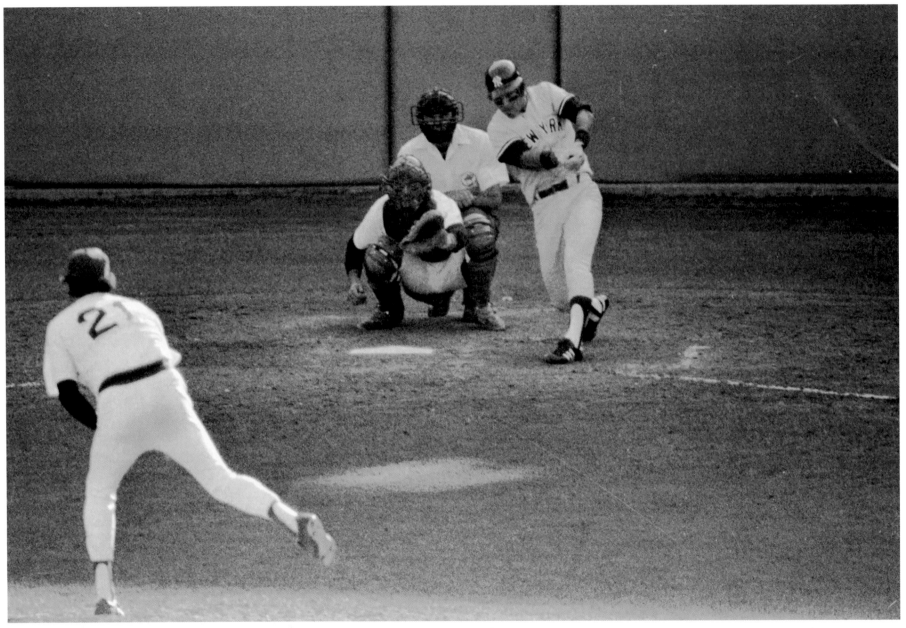

Capping one of the most incredible and unlikely comebacks in baseball history, Yankees shortstop Bucky Dent smacks a three-run home run off of Boston Red Sox (and former Yankees) pitcher Mike Torrez at Fenway Park in 1978 to turn a 3–1 deficit into a 4–3 lead. The Yanks, who had been 14 games behind the Red Sox in July and then managed to blow a three-and-a-half-game lead with two weeks left in the season, held on for a 5–4 win in the one-game playoff for the AL East title. The Yankees went on to defeat the Los Angeles Dodgers in the World Series for the second straight year, with Dent named World Series MVP. Photo courtesy of AP Images

After hitting the go-ahead home run in the playoff against Boston, Bucky Dent hit .417 and drove in seven runs in the Yankees' 1978 World Series victory over the Dodgers to earn MVP honors. On November 23, he rides atop the big apple on the Daily News float at Macy's Thanksgiving Day Parade.

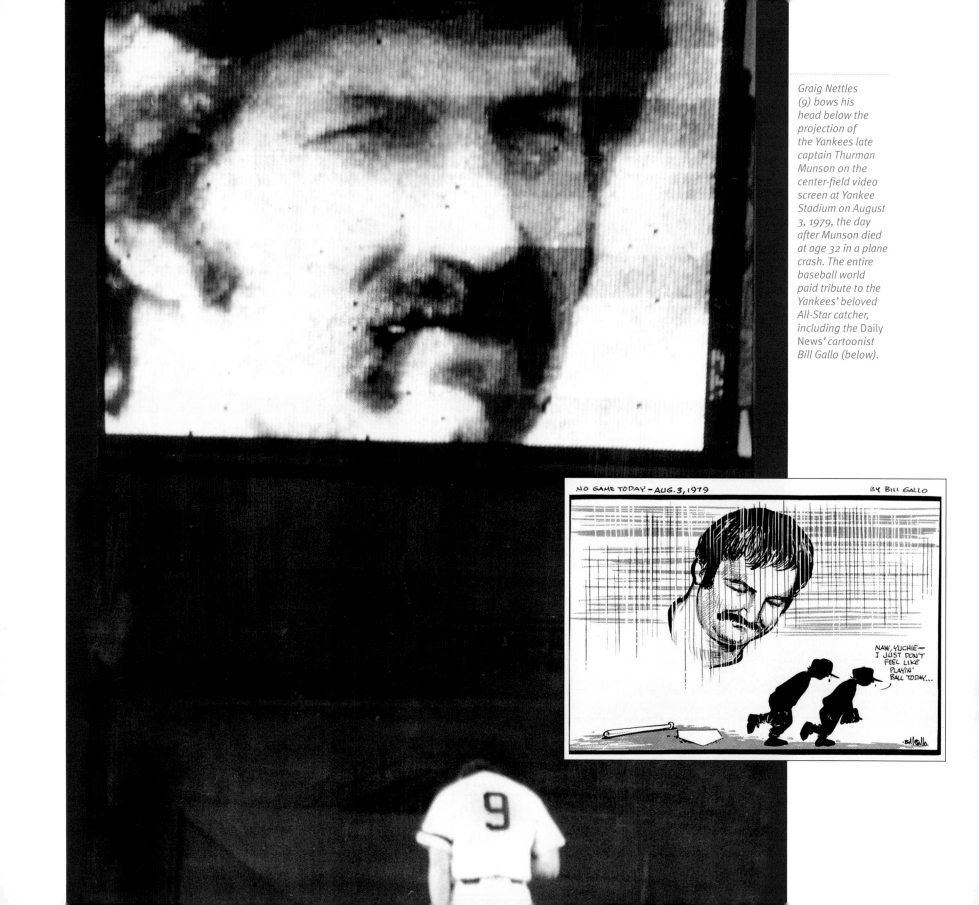

Graig Nettles (9) bows his head below the projection of the Yankees late captain Thurman Munson on the center-field video screen at Yankee Stadium on August 3, 1979, the day after Munson died at age 32 in a plane crash. The entire baseball world paid tribute to the Yankees' beloved All-Star catcher, including the Daily News' cartoonist Bill Gallo (below).

NO GAME TODAY - AUG. 3, 1979 BY BILL GALLO

NAW, YUCHIE— I JUST DON'T FEEL LIKE PLAYIN' BALL TODAY...

Bill Gallo.

The 1980s

Dave Winfield, Rickey Henderson, and Don Mattingly

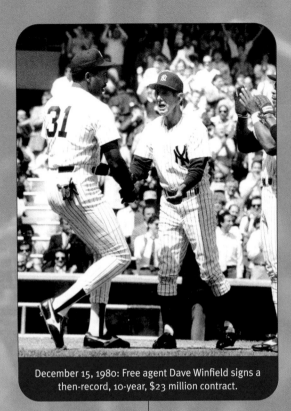

December 15, 1980: Free agent Dave Winfield signs a then-record, 10-year, $23 million contract.

September 6, 1981: Bob Lemon is named manager for the second time, replacing Gene Michael.

April 26, 1982: Gene Michael becomes manager for the second time, replacing Bob Lemon. *(AP Images)*

August 3, 1982: Clyde King is named Yankees manager, replacing Gene Michael.

July 4, 1983: Dave Righetti pitches only the sixth regular-season no-hitter in franchise history and the first since 1951, a 4–0 win vs. the Red Sox at Yankee Stadium. *(AP Images)*

1980 1981 1982 1983 1984

1981: The Yankees win their 33rd pennant but lose to the Dodgers in the World Series for only the third time in 11 meetings. *(AP Images)*

July 24, 1983: The Yankees and Kansas City Royals play the infamous "Pine Tar" game at Yankee Stadium. George Brett hits a two-out, ninth-inning home run off Goose Gossage to give the Royals an apparent 5–4 lead. The umpires nullify the homer because the pine tar on Brett's bat was above the allowable 18 inches and Brett is called out for using an illegal bat. The Yankees win 4–3.

August 18, 1983: Kansas City's protest is upheld and the "Pine Tar" game concludes with the Royals winning 5–4. When play is resumed, Yankees pitcher Ron Guidry is in center field for the final out of the top of the ninth while left-handed first baseman Don Mattingly is at second. Royals reliever Dan Quisenberry retires the Yankees in order in the bottom of the ninth.

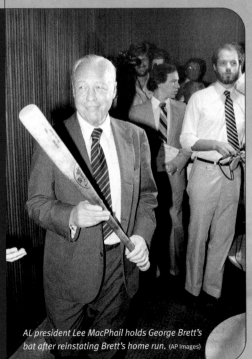

AL president Lee MacPhail holds George Brett's bat after reinstating Brett's home run. (AP Images)

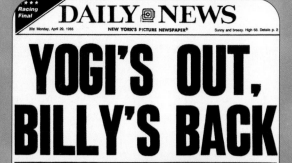

DAILY ◎ NEWS

NEW YORK'S PICTURE NEWSPAPER®

30¢ Monday, April 29, 1985 — Sunny and breezy. High 68. Details p. 2

YOGI'S OUT, BILLY'S BACK

HI, YANKEE FANS— HAVE I GOT A GUY FOR YOU!

—B.Gallo.

April 28, 1985: Billy Martin is named manager for the fourth time, replacing Yogi Berra.

1985: Don Mattingly wins the AL MVP award.

July 18, 1987: Don Mattingly homers off Texas' Jose Guzman to tie Dale Long's major league record of hitting a home run in eight consecutive games (Mattingly hits 10 home runs during the streak).

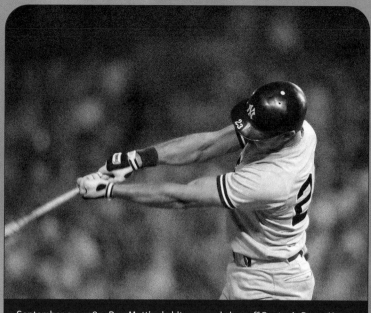

September 29, 1987: Don Mattingly hits a grand slam off Boston's Bruce Hurst, setting a major league record with six grand slams in a season. *(AP Images)*

August 18, 1989: Bucky Dent replaces Dallas Green as Yankees manager.

1985 **1986** **1987** **1988** **1989**

October 17, 1985: Lou Piniella is named manager, replacing Billy Martin. October 22, 1987: Martin replaces Piniella as manager with Piniella becoming Martin's boss as general manager. June 23, 1988: Martin is replaced as manager of the Yankees for the fifth and final time, by Piniella, who is named manager for the second time. *(AP Images)*

December 25, 1989: Billy Martin dies in an automobile accident at age 61.

December 14, 1985: Roger Maris dies at age 51 in Houston, Texas.

December 9, 1987: The Yankees sign a 12-year television contract with Madison Square Garden Network.

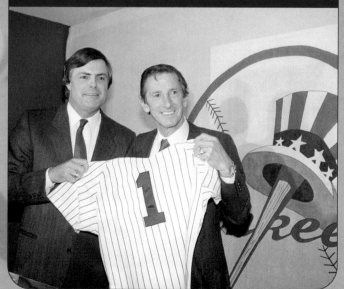

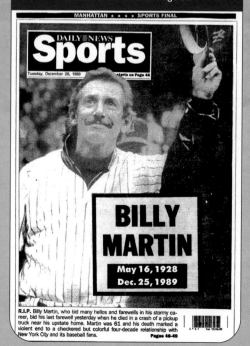

MANHATTAN ★ ★ ★ ★ SPORTS FINAL

DAILY ◎ NEWS Sports

Tuesday, December 26, 1989 — starts on Page 44

BILLY MARTIN

May 16, 1928
Dec. 25, 1989

R.I.P. Billy Martin, who bid many hellos and farewells in his stormy career, bid his last farewell yesterday when he died in a crash of a pickup truck near his upstate home. Martin was 61 and his death marked a violent end to a checkered but colorful four-decade relationship with New York City and its baseball fans. **Pages 46-49**

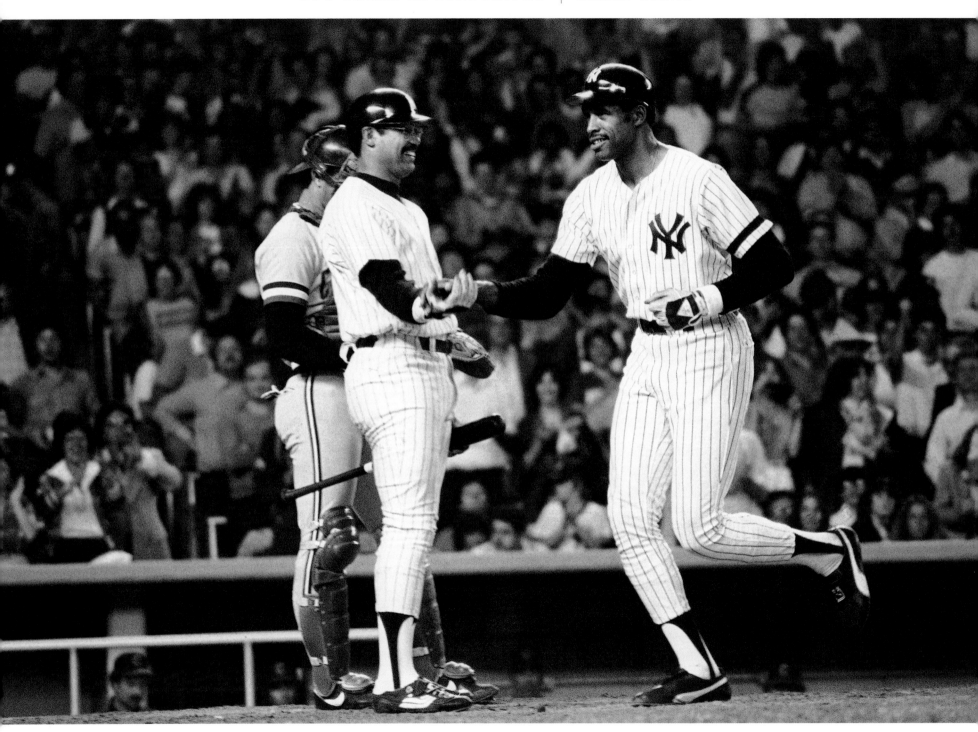

Yankees outfielder Dave Winfield (right) is greeted at home plate by Reggie Jackson after Winfield hit his first home run in Yankee Stadium on May 25, 1981.
Photo courtesy of AP Images

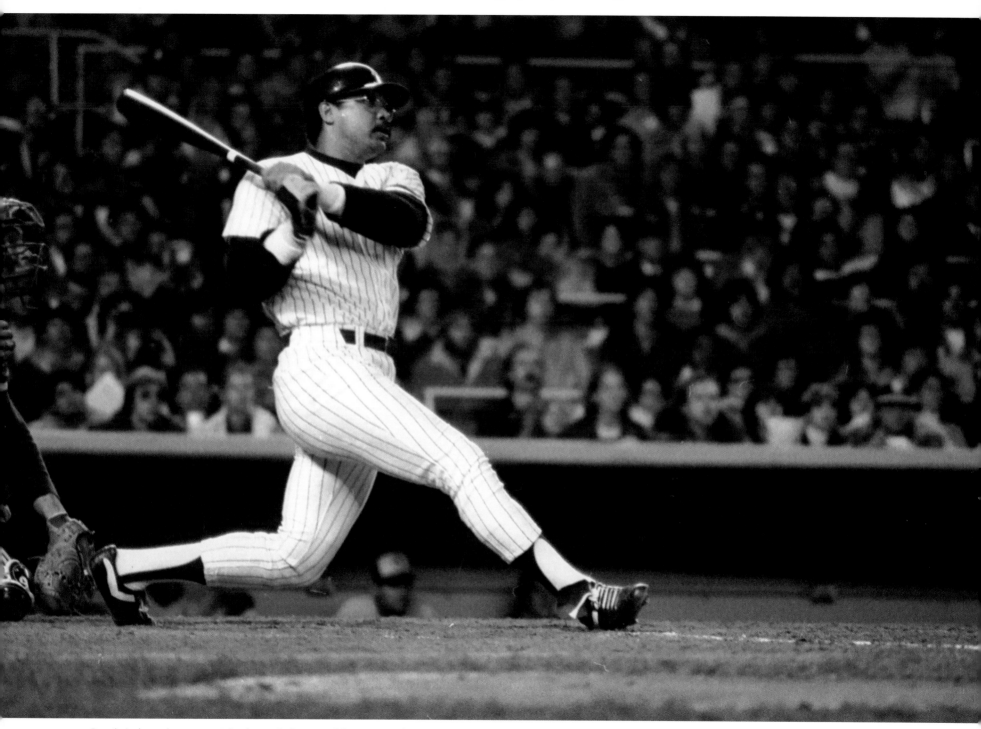

Reggie Jackson rips a game-tying homer in Game 5 of the 1981 American League East Division Series against the Milwaukee Brewers. The Yanks beat the Brewers 7–3, winning the series 3–2, going on to face the Yanks' former manager, Billy Martin, and the Oakland A's in the ALCS.

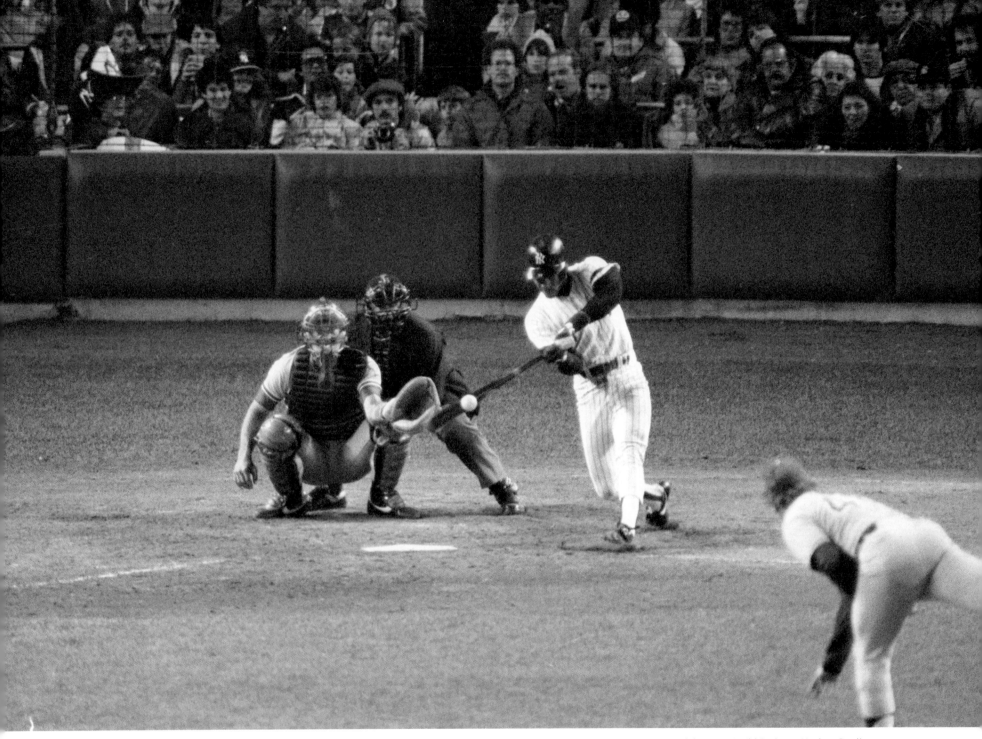

Yankees second baseman Willie Randolph connects for a home run off Los Angeles Dodgers pitcher Burt Hooton in Game 6 of the 1981 World Series at Yankee Stadium. The third-inning solo shot gave the Yankees a short-lived 1–0 lead. Photo courtesy of AP Images

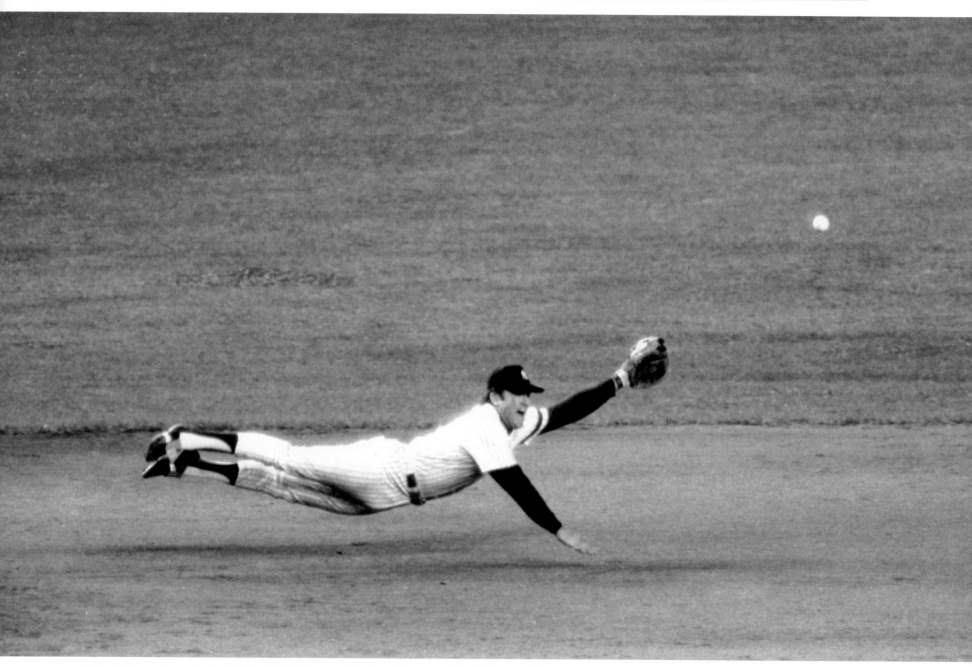

Graig Nettles can't reach a shot off the bat of Dodgers catcher Steve Yeager as their sixth-inning offensive attack is extended during Game 6 of the 1981 World Series. The Dodgers defeated the Yankees 9–2 to take the Series four games to two and win the championship.

New York, Tuesday, July 5, 1983

A NO-HIT FOURTH!

Righetti's Fireworks Awe Red Sox, 4–0

by Eric Compton

Six days ago, Dave Righetti had a career total of 61 starts and no shutouts. As of 4:46 yesterday afternoon, he had 63 starts and two shutouts. And, more importantly, a no-hitter.

Righetti became the first Yankee pitcher in 27 years to pitch a no-hitter yesterday, as he dominated the Red Sox in a 4–0 masterpiece viewed by a holiday crowd of 41,077 at the Stadium. Righetti's no-no was the first by a Yankee since Don Larsen had his perfecto against the Dodgers in the 1956 World Series, and the first in the regular season since Allie Reynolds performed the feat against the Red Sox in September of 1951. It also was the first by a left-hander in Yankee Stadium. And, to add another first, it was the first no-hitter in the majors since Nolan Ryan tossed his fifth, against the Dodgers on September 26, 1981, in the Astrodome.

Not since Larsen's no-hitter had any pitcher been unhittable in the Stadium. Some, though, have come close. A bid by another young lefty, Boston's Billy Rohr, lasted until there were two outs in the ninth in the Yanks' home opener in 1967. Righetti, who struck out nine and walked four, was determined not to blow his chance.

"We had gotten a couple of runs in the eighth so I didn't have to worry about giving up a walk and then a homer and have the game tied," Righetti (10–3) said. "I was just going to let it all hang out. I wanted to keep their guys off base before the big guys like (Jim) Rice and Tony (Armas) got a chance."

He needn't have worried. Jeff Newman led off the ninth by working out a walk, bringing up Glenn Hoffman. "He broke up a no-hitter on me in the seventh two years ago," Righetti said. "I knew he'd by trying to go to left with the ball so I tried to keep it down and in on him and hope we'd get a grounder."

Righetti got his grounder, and it should have been a double play. But Andre Robertson's relay to first pulled Don Mattingly's foot ever so slightly off the bag, and instead of two out and nobody on, Righetti had to battle a one-on, one-out situation with the top of the Sox order coming up.

"After that first grounder, I told the guys, 'Relax, you'll get another one,'" Righetti said. "And then they did get another."

Righetti induced Jerry Remy to bounce to Robertson at second, moving the runner to second and moving Righetti just one out from immortality. His battle plan to the red-hot Wade Boggs was to throw nothing but hard stuff.

"If I'm going to lose it at that point, it's going to be off my best pitch," Righetti said. "I was going to throw hard fastballs, then a slider."

The plan worked to perfection. Boggs, who entered the game with a .361 average, worked the count to 2–2 and then went down on a slider. "He's a great hitter but I don't think he was looking for a slider there," Righetti said.

Butch Wynegar agreed. "You want him to hit your best pitch," the Yankee catcher said, "and I thought if he got a fastball he could hit a flare to left. So we went with a slider."

Righetti and Wynegar knew from the start that there was something special in Righetti's left arm. The southpaw blew the Sox away in the early innings, striking out seven in the first three innings. He got a break in the fourth when Boggs hit a hard shot right at center fielder Dave Winfield and a bigger break in the sixth when Hoffman's bloop to short left held up long enough for Roy Smalley to get under it.

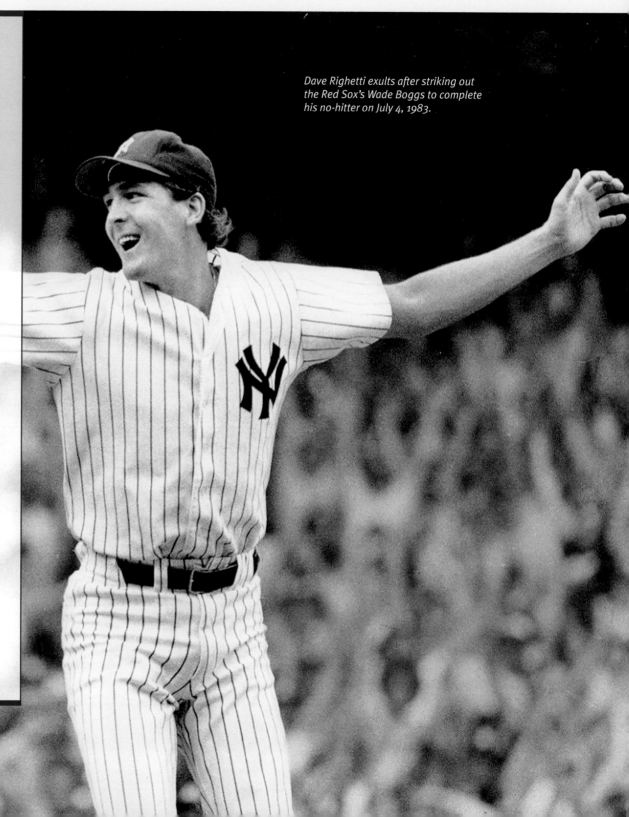

Dave Righetti exults after striking out the Red Sox's Wade Boggs to complete his no-hitter on July 4, 1983.

"I thought when that hit the bat, it was trouble," Smalley said, "but then when I got back on the grass, I knew I had a chance."

Righetti walked Rice in the seventh but induced Armas to ground sharply into a double play, and then Steve Kemp gave him an extra bit of help by climbing into the right-field seats to snare Dwight Evans' foul pop leading off the eighth. He made it through that inning, and then had to sit nearly 20 minutes while his teammates put together a two-run rally that broke the game open.

"I was sitting there thinking, 'Geez, let's go, let's get it over with one way or the other,'" Righetti said. "I was anxious, pumped up, and I wanted it over with."

He did, in dramatic fashion, and the crowd erupted as Wynegar sprinted from behind the plate in a leap reminiscent of Yogi Berra's leap into Larsen's arms in 1956.

"I didn't know what to do. I wanted to cry," Righetti said. "But then I saw Butch coming and I thought he would kill me."

As it turned out, Wynegar hit him harder than the Red Sox had.

Yanks took their time attacking Sox starter John Tudor. Three straight singles, the last by Andre Robertson, broke open a scoreless tie in the fifth and Don Baylor had a solo homer to left in the sixth. Steve Kemp singled in two runs in the eighth… Graig Nettles was a late scratch due to a case of pinkeye…Yanks passed the million mark in attendance. They drew 147,037 in four games with Boston and are now at 1,009,156 through 39 home dates… Righetti's nine strikeouts were a season high.

On December 20, 1984, Dale Berra was traded from the Pittsburgh Pirates to the Yankees, allowing him to come home and play for his father, manager Yogi Berra.

Billy Martin, hired for the fourth time as Yankees manager, this time replacing Yogi Berra, gets ready to try on his Yankees No. 1 uniform on May 3, 1985.

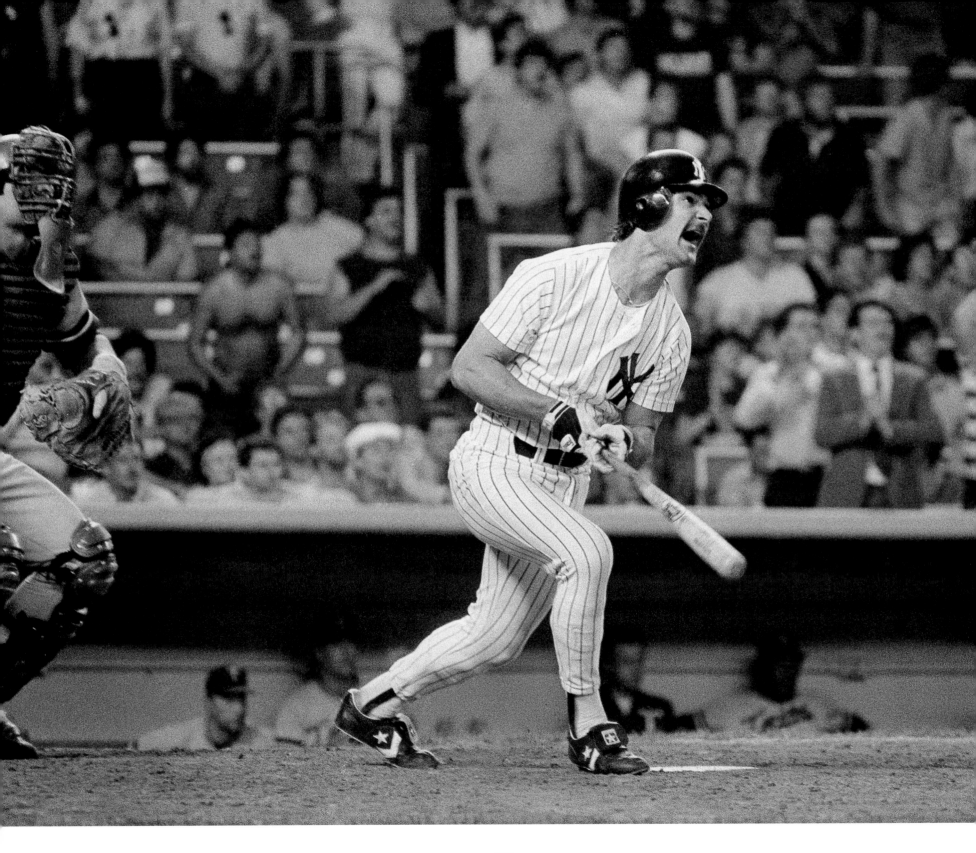

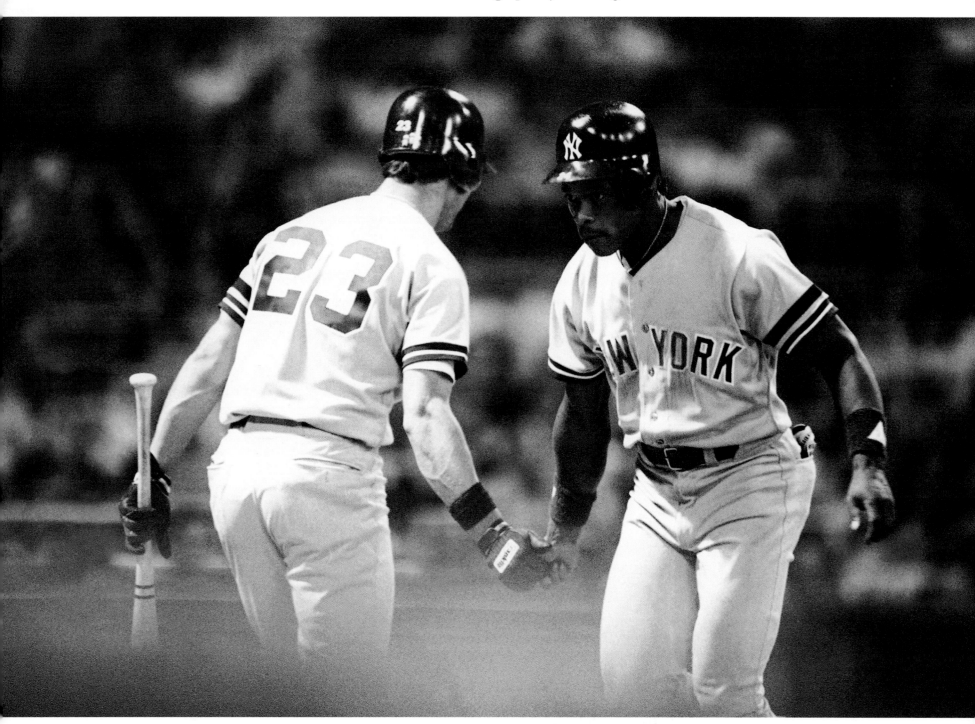

Don Mattingly (facing page) watches his three-run home run with two out in the bottom of the ninth leave Yankee Stadium on May 13, 1985. The homer gave the Yankees a 9–8 win over the Minnesota Twins, after the Yankees had been behind 8–0. Mattingly (above) congratulates Rickey Henderson after Henderson hit a seventh-inning, tie-breaking home run that won the game against the Chicago White Sox on May 5, 1986. Photos courtesy of AP Images

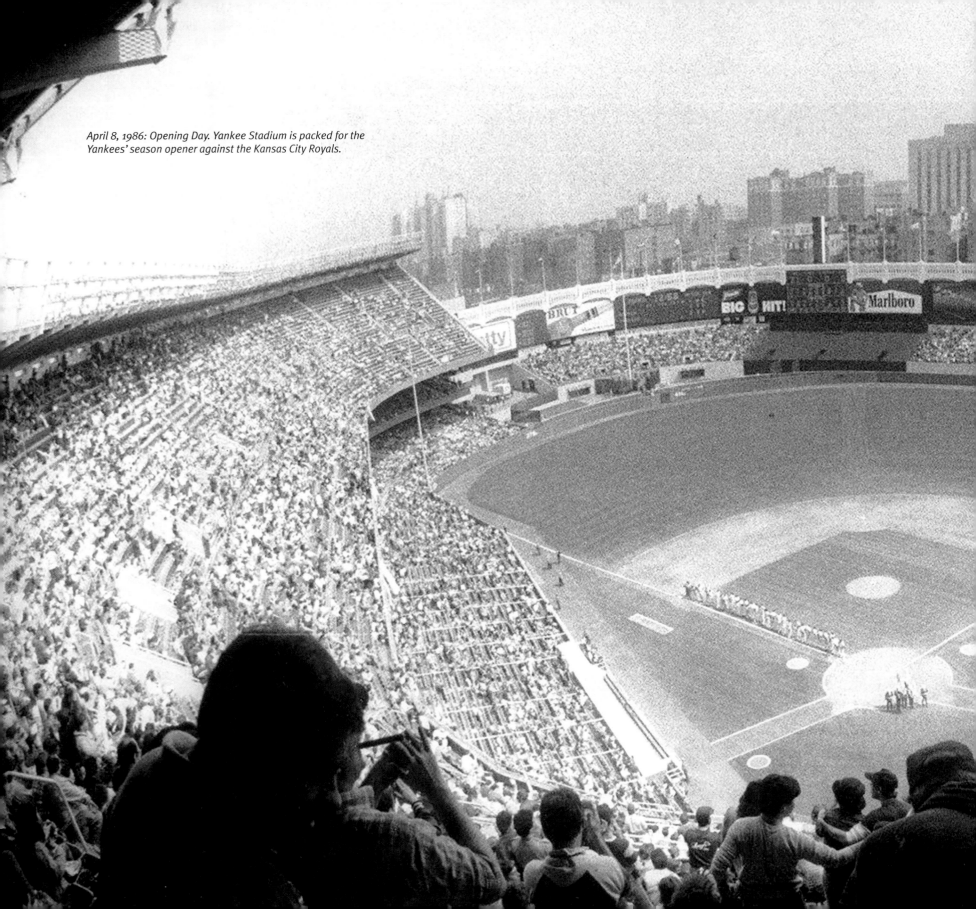

April 8, 1986: Opening Day. Yankee Stadium is packed for the Yankees' season opener against the Kansas City Royals.

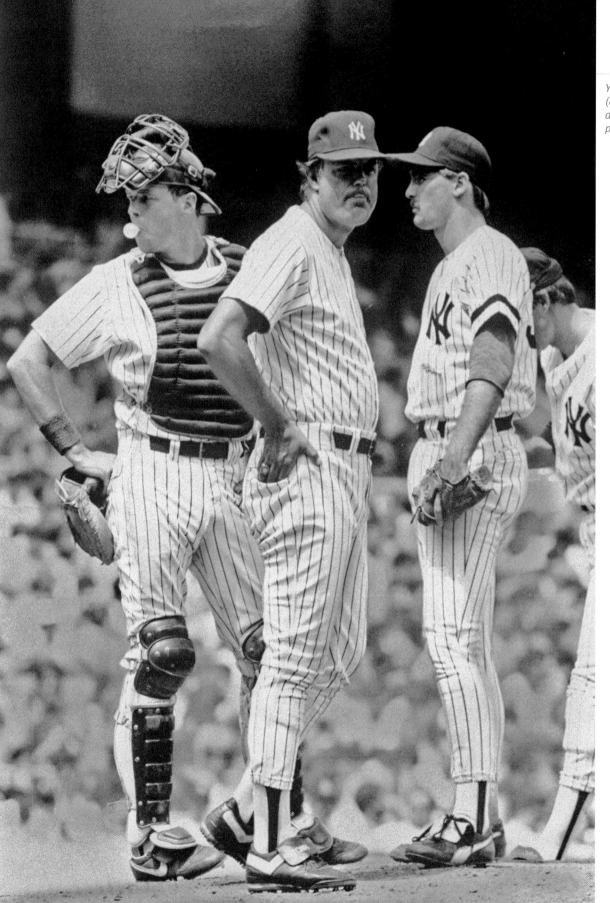

Yankees manager Lou Piniella (center), catcher Butch Wynegar, and Doug Drabek await the relief pitcher during a game in July 1986.

Dallas Green, who replaced Lou Piniella as Yankees manager after the 1988 season (who replaced Billy Martin after Martin replaced Piniella) argues with umpire Derwood Merrill in August 1989. Green didn't make it out of August before being replaced by Bucky Dent.

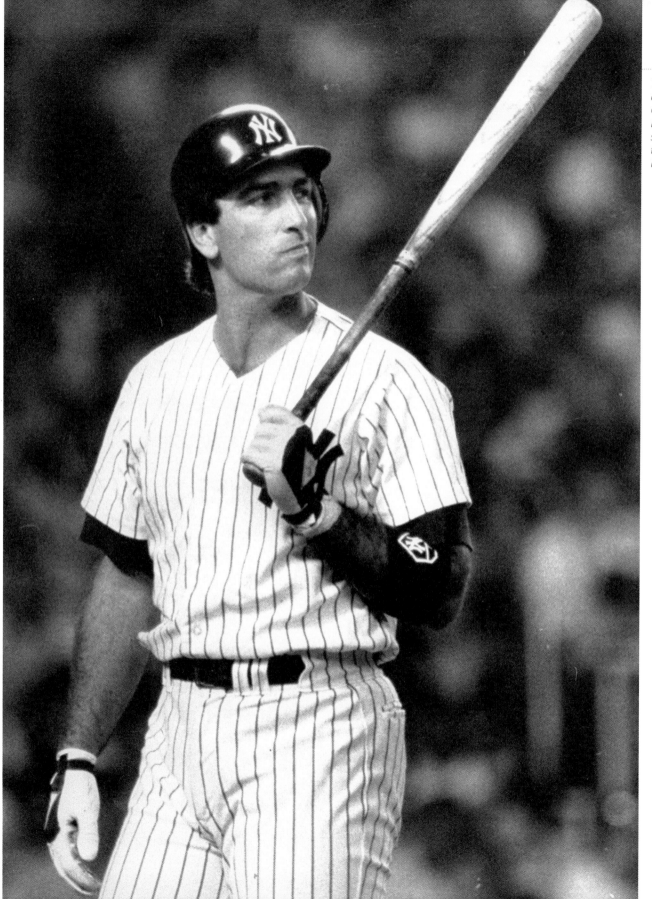

The Yankees signed free agent and former St. Louis Cardinals slugger Jack Clark in 1988. After one subpar season, however, he was traded to the San Diego Padres.

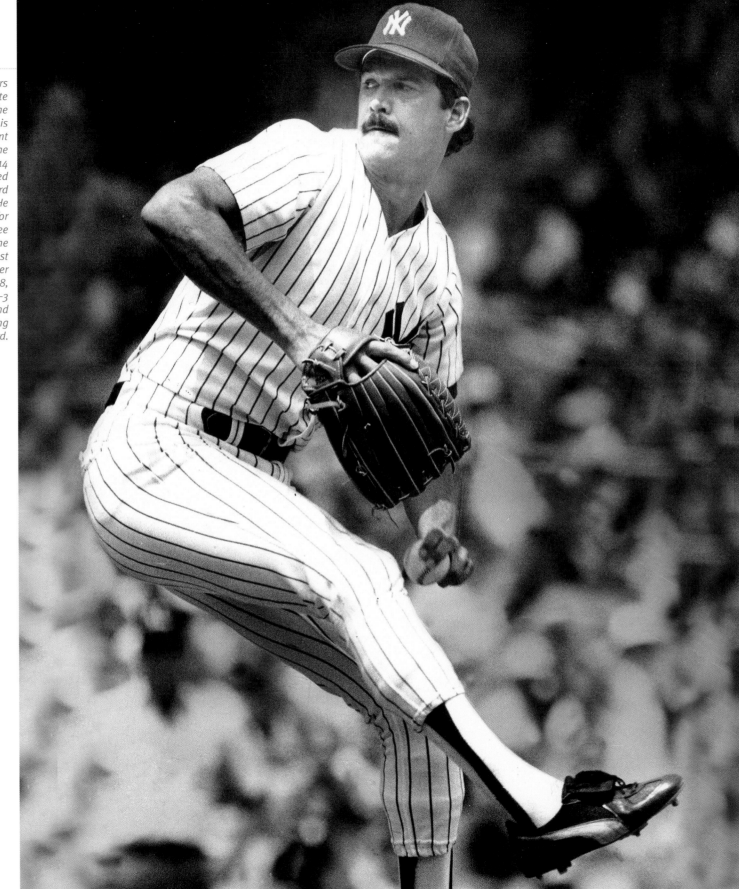

Ron Guidry delivers against the White Sox in 1988, the final year of his career, spent entirely with the Yankees. In his 14 years, he amassed a 170–91 record and a 3.29 ERA. He won 20 games for the Bombers three times and had one of the greatest seasons any pitcher ever had in 1978, when he went 25–3 with a 1.74 ERA and won the Cy Young Award.

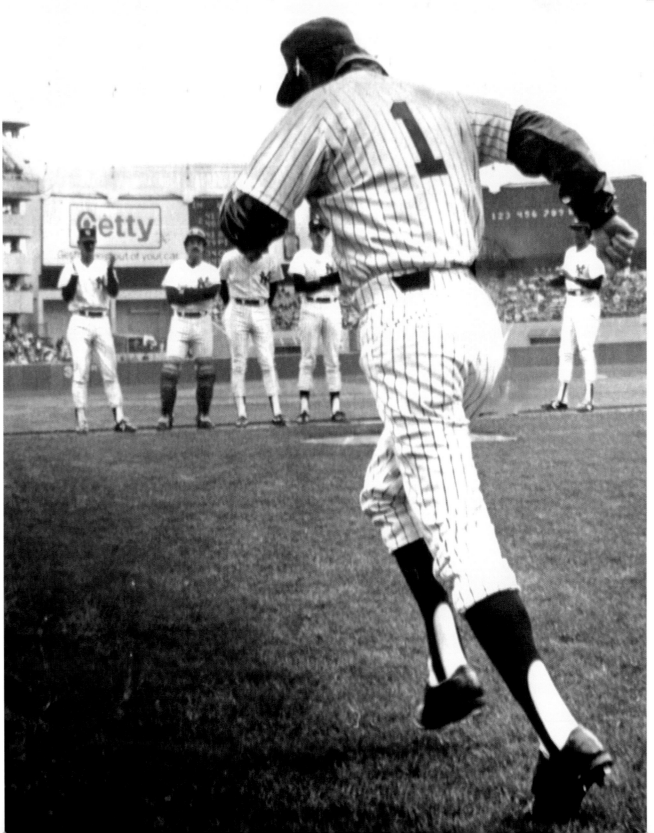

Billy Martin runs onto the Yankee Stadium grass during introductions on Opening Day, 1983. Martin died on Christmas Day in 1989 at the age of 61 in a car accident near his home in Upstate New York. He spent six-plus years as a player with the Yankees in the 1950s, during which he was part of four world championship teams. He managed the Twins, Tigers, Rangers, and A's, and led the Yankees five different times as manager, bringing home a World Series title in 1977.

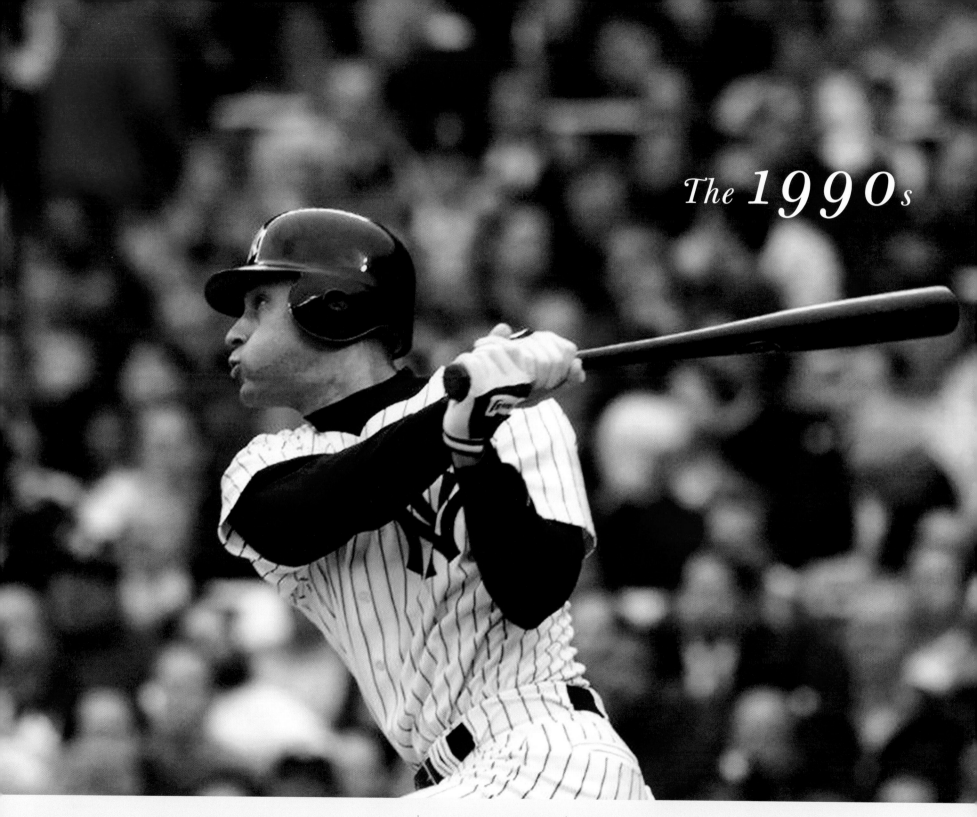

The **1990**s

Derek Jeter

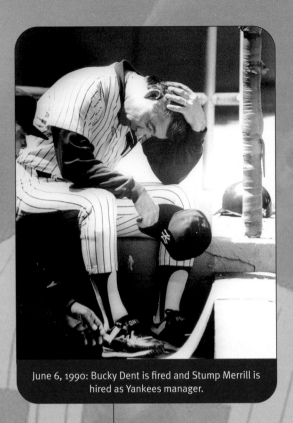

June 6, 1990: Bucky Dent is fired and Stump Merrill is hired as Yankees manager.

June 1, 1992: The Yankees select shortstop Derek Jeter in the first round with the sixth overall pick of the Major League Baseball draft.

August 14, 1993: On "Reggie Jackson Day," Jackson's jersey No. 44 is retired.

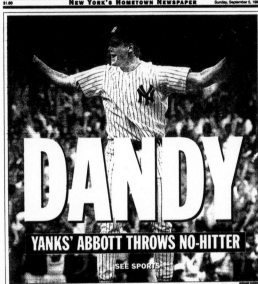

September 4, 1993: Jim Abbott pitches a 4–0 no-hitter over the Indians at Yankee Stadium.

1990 1991 1992 1993 1994

July 30, 1990: George Steinbrenner is handed a lifetime suspension from baseball by commissioner Fay Vincent for paying gambler Howie Spira $40,000 to smear Dave Winfield. Steinbrenner is reinstated three years later.

1995: The Core Four—Derek Jeter, Andy Pettitte, Jorge Posada, and Mariano Rivera—debut. The Yankees return to the postseason for the first time since 1981, losing 3–2 in the AL Division Series against the Seattle Mariners.

August 13, 1995: Mickey Mantle dies of cancer at age 63 in Dallas, Texas. August 25, 1996: A monument in honor of Mickey Mantle is unveiled in Yankee Stadium's Monument Park.

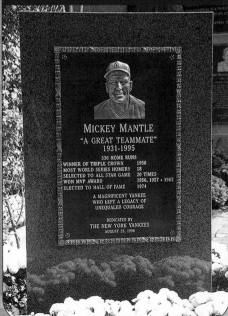

CLUELESS JOE

TORRE HAS NO IDEA WHAT HE'S GETTING INTO

IAN O'CONNOR – PAGE 74

November 2, 1995: Joe Torre is hired as Yankees manager, replacing Buck Showalter, to less-than-universal acclaim.

May 14, 1996: Dwight Gooden hurls only the eighth regular-season no-hitter in Yankees history, a 2–0 blanking of the Seattle Mariners at Yankee Stadium.

June 16, 1996: Mel Allen, the legendary "Voice of the Yankees" from 1939 to 1964, dies at age 83 in Greenwich, Connecticut.

January 22, 1997: Don Mattingly officially announces his retirement at a media conference at Yankee Stadium.

1998: The Yankees establish an AL record with 114 wins, breaking the mark of 111 by the 1954 Cleveland Indians. They then complete a four-game sweep of the San Diego Padres in the World Series for the franchise's 24th world championship. With their 114–48 regular season and 11–2 postseason record, the club went 125–50 overall.

GREATEST!

YANKEES SWEEP SAN DIEGO PADRES

March 8, 1999: Joe DiMaggio dies at age 84 in Hollywood, Florida. April 25, 1999: A monument in honor of Joe DiMaggio is unveiled in Yankee Stadium's Monument Park.

September 9, 1999: Jim "Catfish" Hunter dies at age 53 in Hertford, North Carolina, of ALS (Lou Gehrig's Disease).

1995 1996 1997 1998 1999

October 26, 1996: The championship returns to the Bronx after the Yanks defeat the Atlanta Braves in Game 6 of the World Series. It is their 23rd title and the beginning of a dynasty.

May 17, 1998: David Wells tosses only the 14th regular-season perfect game in baseball history, the first ever by a Yankee.

July 18, 1999: On "Yogi Berra Day," David Cone tosses only the 15th regular-season perfect game in baseball history. Don Larsen threw out the ceremonial first pitch.

October 27, 1999: The Yankees play the last game of the century and complete a sweep of the Braves to capture their 25th championship. The 4–1 win is also the club's 12th straight in World Series play, tying the record of the 1927, 1928, and 1932 Yankees.

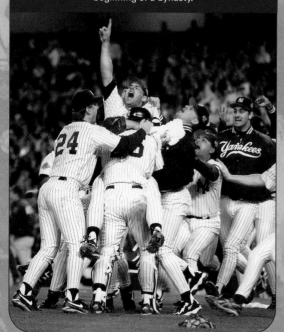

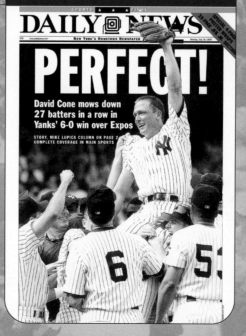

PERFECT!

David Cone mows down 27 batters in a row in Yanks' 6-0 win over Expos

STORY, MIKE LUPICA COLUMN ON PAGE 2
COMPLETE COVERAGE IN MAIN SPORTS

TEAM OF THE CENTURY

Yanks sweep Braves to capture their 25th World Series championship

DAILY NEWS

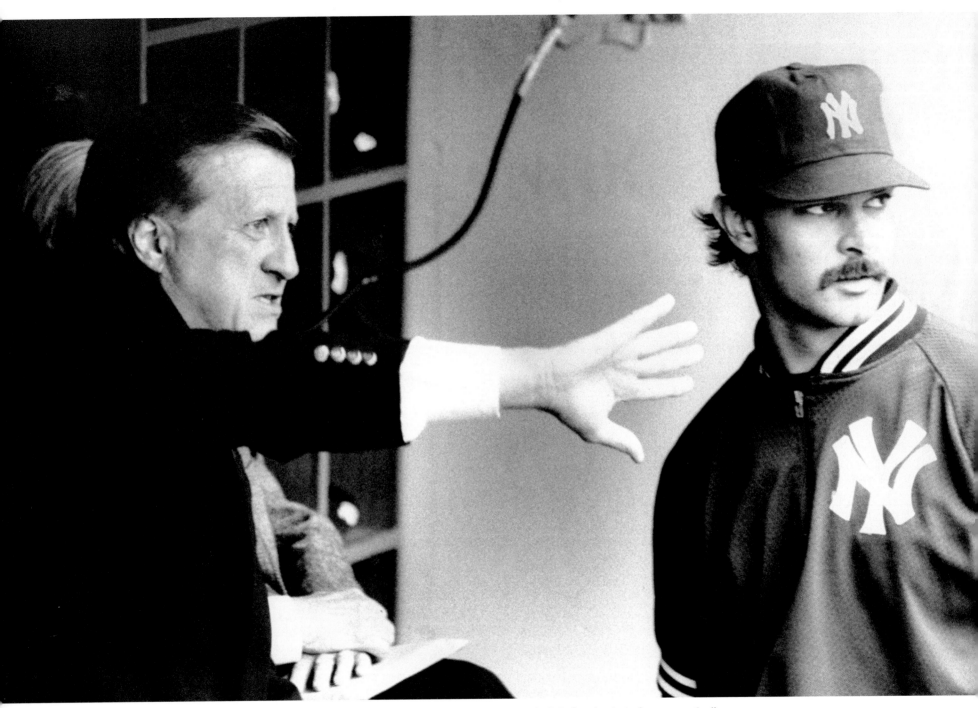

New York Yankees owner George Steinbrenner gives some advice to first baseman Don Mattingly before the start of a game on April 30, 1990.

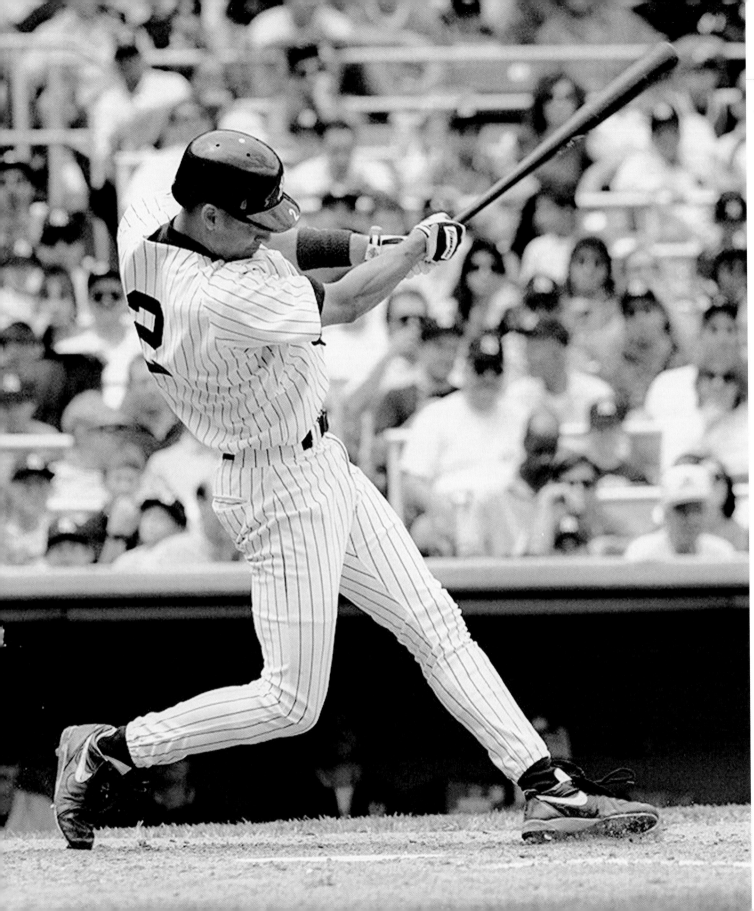

Yankees shortstop Derek Jeter, who made his major league debut on May 29, 1995, hits a double against the Angels on June 4.

Jeter and center fielder Bernie Williams (facing page), arrive in the dugout after scoring on a Jim Leyritz single during a game against the Mariners on June 10, 1995. Jeter only played in 15 games in 1995, but would be back with the Yankees to stay in '96.

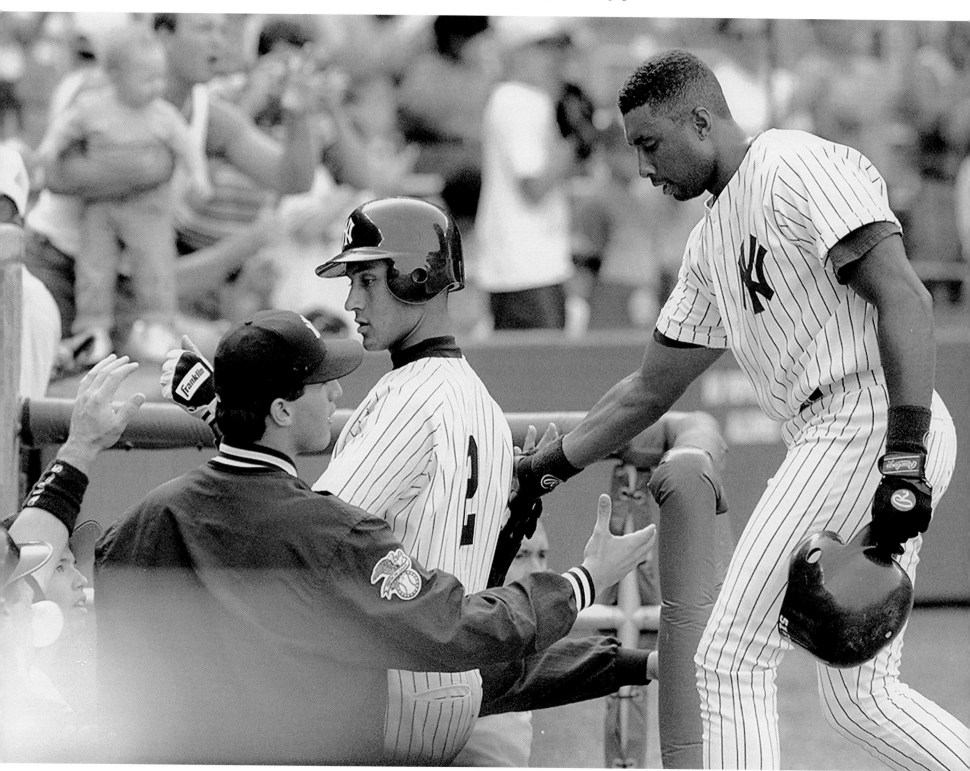

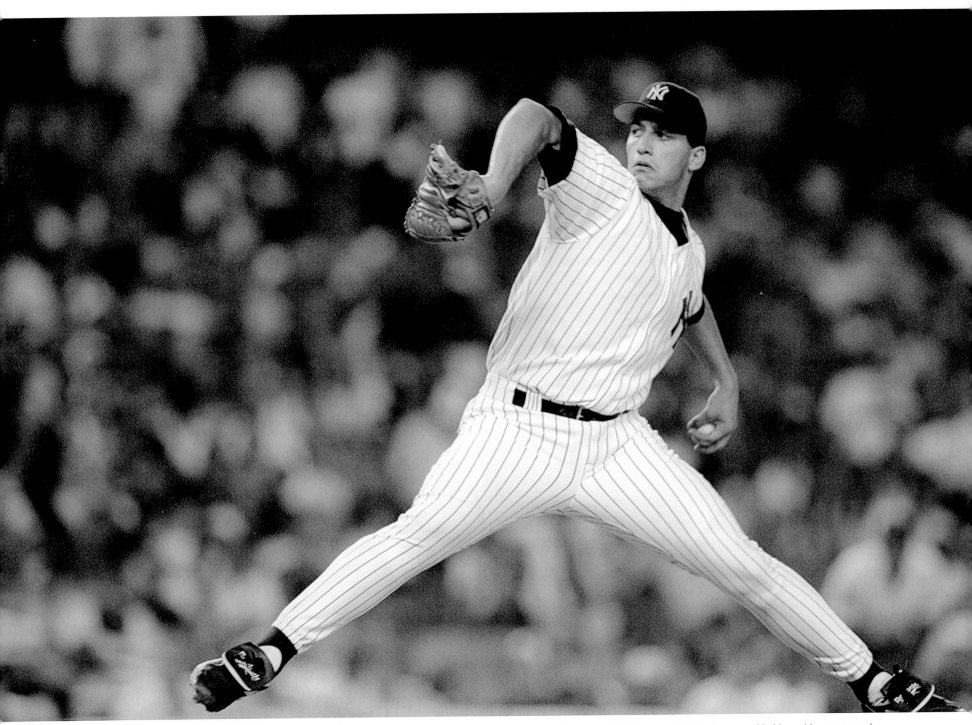

Yankees left-handed starter Andy Pettitte pitches at Yankee Stadium during a game against the White Sox on July 18, 1995. Pettitte impressed in his rookie season and would go on to become one of the most consistent—and winningest—pitchers with the Yankees during their five championship campaigns from 1996 to 2009.

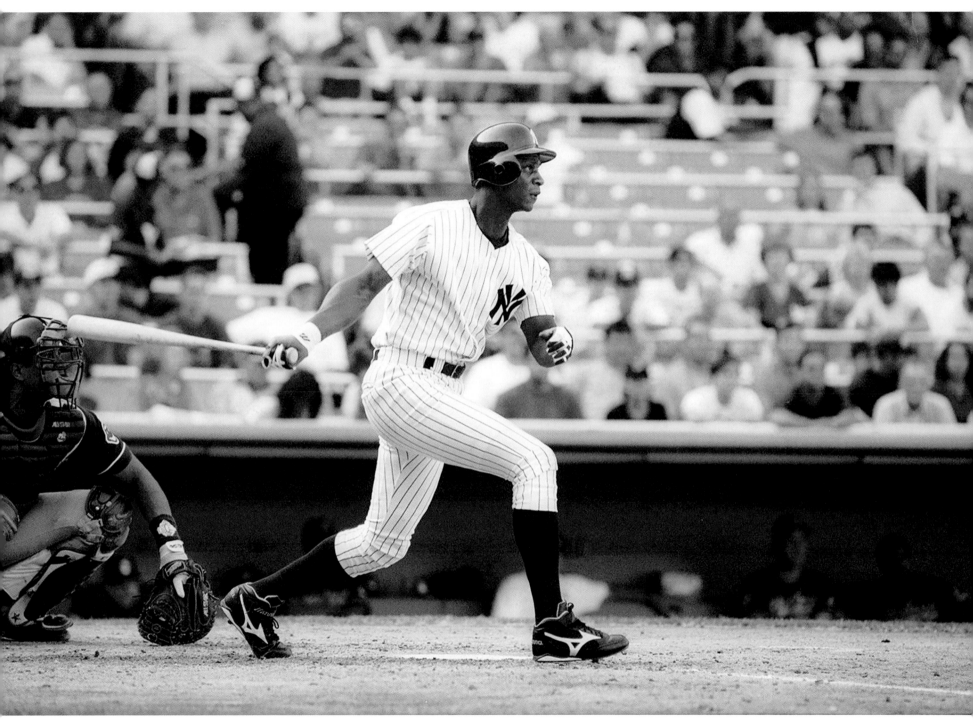

Darryl Strawberry bats against the Cleveland Indians at Yankee Stadium in August 1995. The former Met got a second chance in the Big Apple when he signed with the Yankees in 1995 and finished his career in pinstripes.

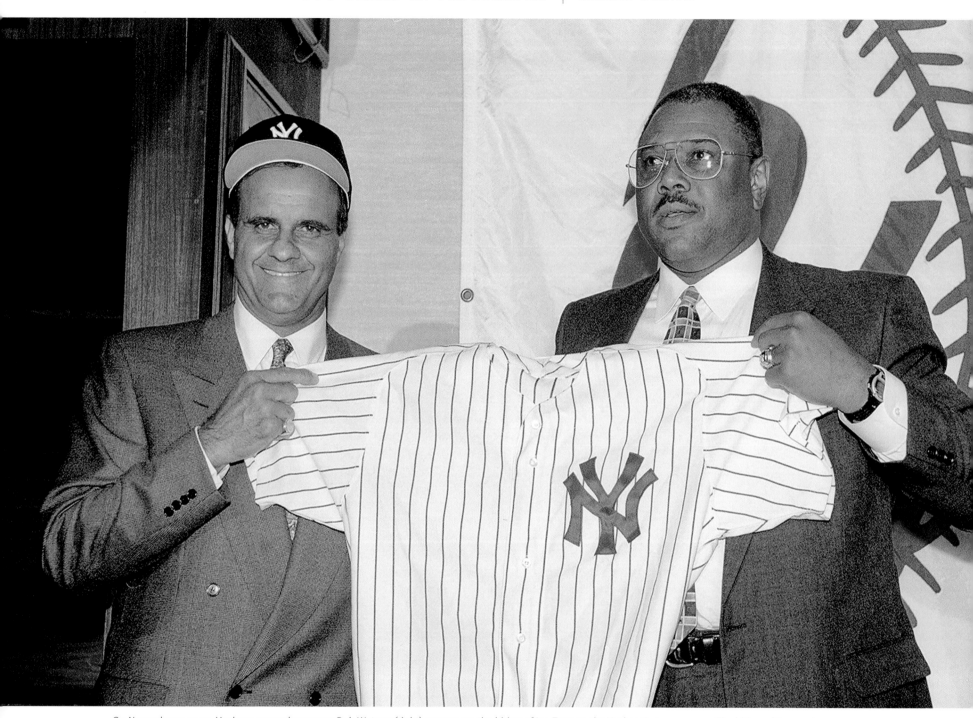

On November 2, 1995, Yankees general manager Bob Watson (right) announces the hiring of Joe Torre as the Yankees' new manager. The hiring of Torre, who as manager of the Mets, Braves, and Cardinals had amassed a record of 894–1,003, one division title, and no postseason victories, was met with mixed reviews.

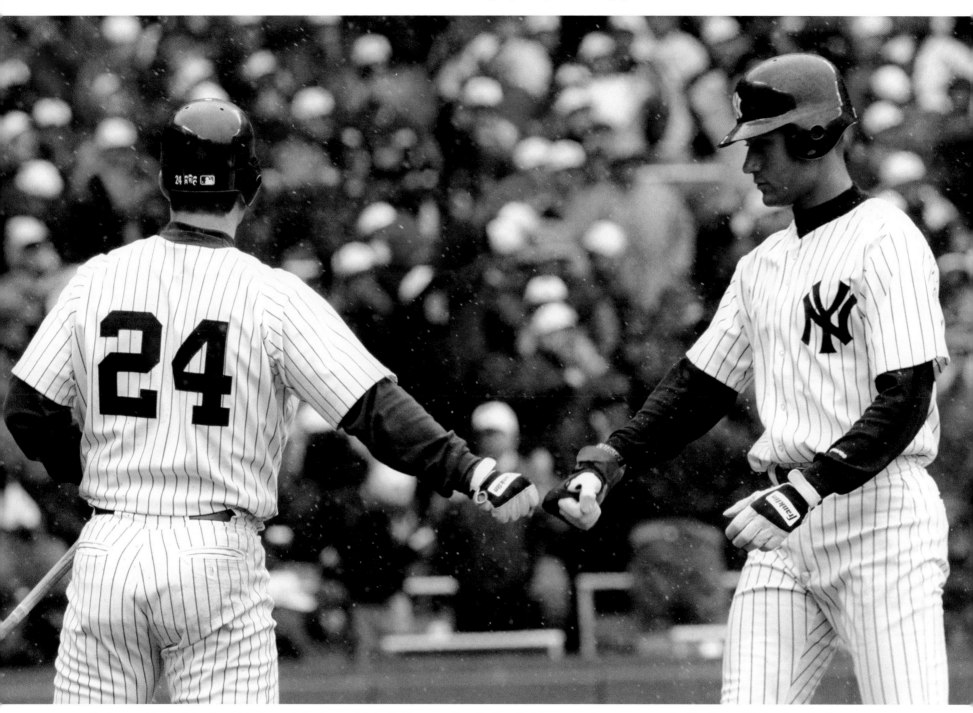

Yankees rookie shortstop Derek Jeter is greeted at home plate by first baseman Tino Martinez (24), in a snowy home opener against the Kansas City Royals on April 9, 1996. Jeter would win Rookie of the Year honors in '96. He and Martinez, who came over to the Yankees in a trade with the Mariners after the '95 season, would become mainstays of the 1990s–2000s Yankees championship teams.

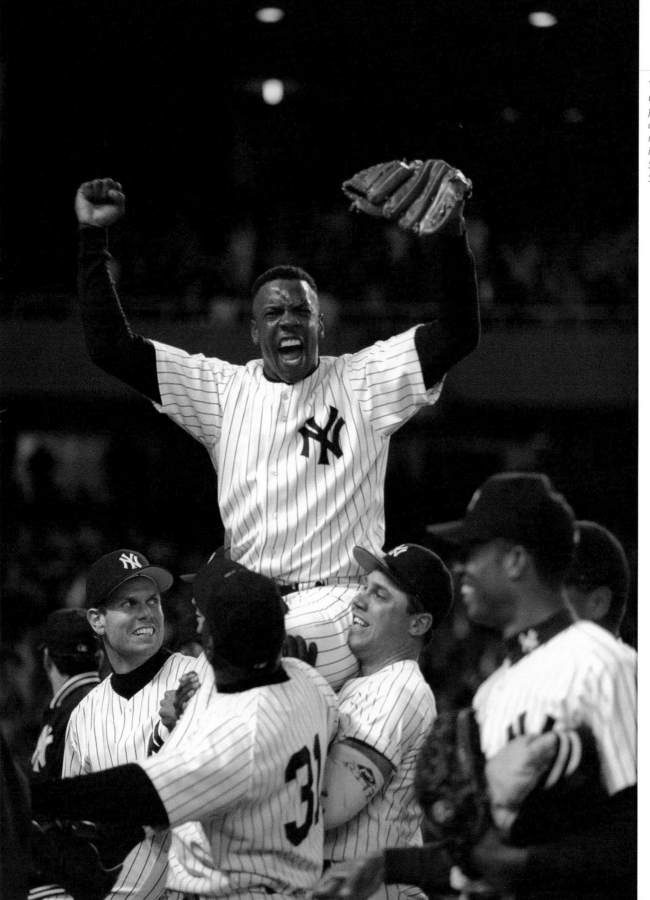

Yankees pitcher Dwight Gooden is carried off the field by his teammates after pitching the first no-hitter of his career in a game against the Seattle Mariners at Yankee Stadium on May 14, 1996.

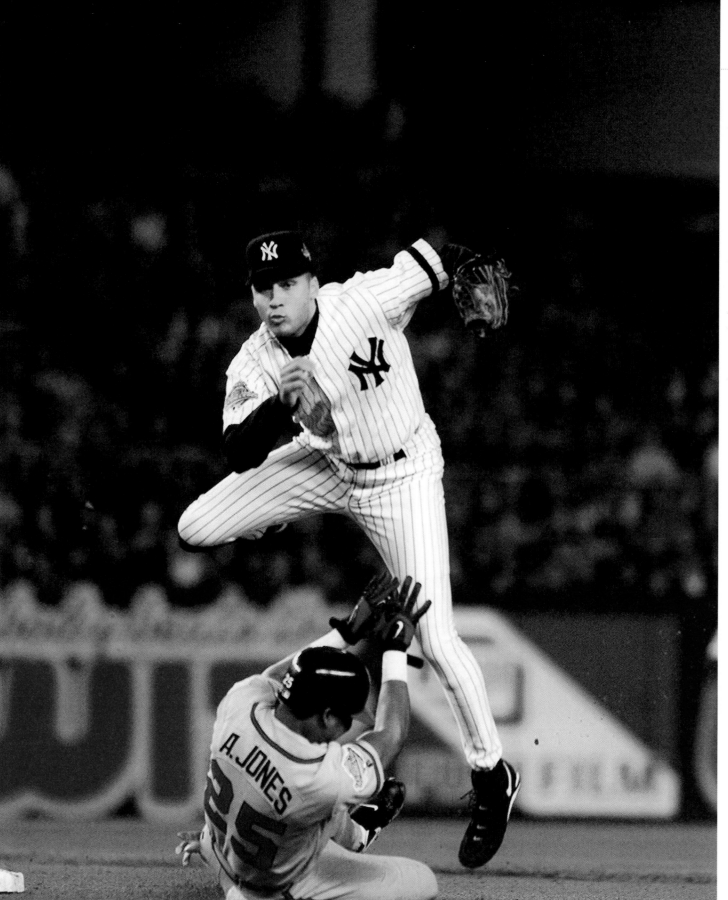

Derek Jeter jumps over the Atlanta Braves' Andruw Jones to turn a double play in Game 2 of the 1996 World Series at Yankee Stadium.

Paul O'Neill (facing page) catches Luis Polonia's fly ball to end Game 5 of the World Series against the Braves, a 1–0 Yankees victory. After dropping the first two games to the defending Series champs at home, the Yankees swept three games in Atlanta to go up one game and bring the Series back to the Bronx.

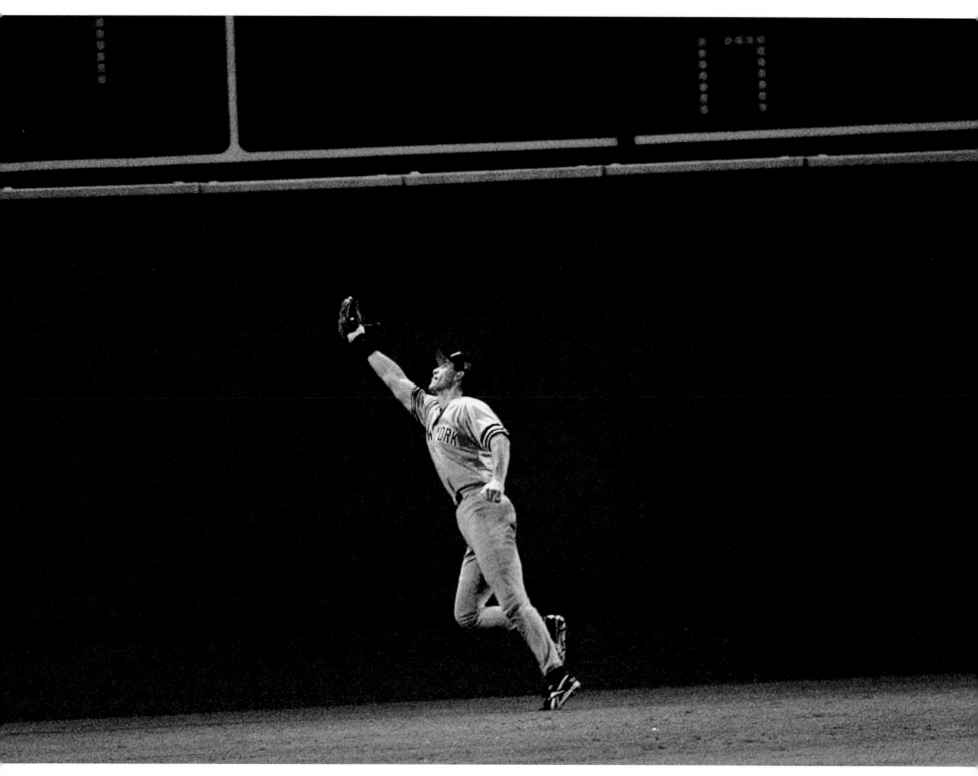

New York, Sunday, October 27, 1996

YANKS WIN IS GLORY-US

Believe It! We're No. 1 as World Series Champs

by James Rutenberg and Paul Schwartzman

with Scott Fallon and Mike Claffey

Champions!

Adding a thunderclap to a storybook season, the Yankees last night captured their first World Series crown in 18 years, triggering a raucous New York celebration that will climax Tuesday with a ticker-tape parade through the Canyon of Heroes.

On a picture-perfect Saturday night, Yankee Stadium exploded with cheers at 10:55 after Charlie Hayes caught the final out and the Bombers dethroned the reigning champs, the Atlanta Braves, and snared their 23rd World Series triumph in their 93 years.

As Yankee pitcher John Wetteland jumped into the arms of catcher Joe Girardi to celebrate the 3–2 victory, friends and strangers from the bleachers to Bay Ridge to the chessboards in Washington Square Park hugged and slapped hands.

Yankee Wade Boggs celebrated by climbing aboard a police horse and parading around the outfield while his teammates took a victory lap to the standing ovation of the 56,375 fans.

Hundreds of people poured into Times Square as cab drivers and motorists honked their horns in celebration. Firefighters huddled around a TV in a stationhouse on East 51st Street cheered. Doormen on Park Avenue shouted out to passing pedestrians of the

Boggs waves from a police horse after the Yankees won.

Yanks' defeat of the Braves, four games to two.

And inside the Stadium, the team's hallowed ancestral home, there was Bombers bedlam.

"We're No. 1!" screamed Moses Reyes, 41, of Washington Heights, as he paraded with a makeshift coffin wrapped in a banner that read, "In Memory of the Atlanta Braves."

"You don't know how awesome this is! I'm at the center of the world!" exclaimed Matt Windman, 12, of Marlboro, New Jersey, resplendent in his Yankees pinstripe jacket and World Series cap.

"Ya-hooo!" shouted Bob Scaglion, 43, slapping hands with his eight-year-old son, Jesse.

Seated behind home plate, in a shimmering sea of blue pinstripes that included Mayor Giuliani, Marguerite Torre, the nun who is Joe Torre's sister, wept after the final out of the Yanks' win.

"Thank God! God is so good to us. I am so happy for Joe," she said, high-fiving her sister Rae.

"Whe-ew! Yes! Whe-ew! Yes!" Sister Marguerite exclaimed.

It was a fitting end to a magical season, one that saw the redemption of Dwight Gooden, the resurrection of Darryl Strawberry, and the return from surgery of David Cone.

There was high drama right to the end. As Torre managed the most important game of his 32-year career, his brother Frank was recovering from a heart transplant operation.

And there were the resilient Yanks, roaring back from two World Series defeats in New York to seize three games in Atlanta and then grab the flag in the Bronx.

"There are so many moving stories on this Yankee club," owner George Steinbrenner said in a joyous clubhouse.

All over the city, Yankee caps and jerseys could be found in every neighborhood, on almost every corner.

Giuliani promised "the biggest victory parade ever"—and fans said the Bombers deserved it.

Geraud Ebert, 43, listened to the game on a palm-sized transistor radio while he played speed chess with Jerry Casper in Washington Square Park.

"The energy in the city is just like it was back in '86 when the Mets won," he said between moves. "It's unbelievable how many people have just become Yankee fans."

Of course, the epicenter of Yankee madness was at the Stadium, where fans were dancing in the aisles.

"We burned Atlanta once, now we've burned 'em again," said Mark Magliocchetti, 21, of Nanuet, New York.

Governor Pataki departed the Stadium grabbing fans' hands and shouting, "Fantastic! It doesn't get any better than this."

After the final out, throngs milled outside the gates, many of them drinking, hooting, and howling, "Let's go, Yankees!"

"This just shows this is the best city on Earth," said Gary Swidler, 26, of Manhattan, lighting a victory cigar.

Yankees right fielder Paul O'Neill tops the Yankees pileup at the end of Game 6 of the 1996 World Series. The 3–2 win over the Atlanta Braves gave the Yanks their 23rd world championship, and their first since 1978.

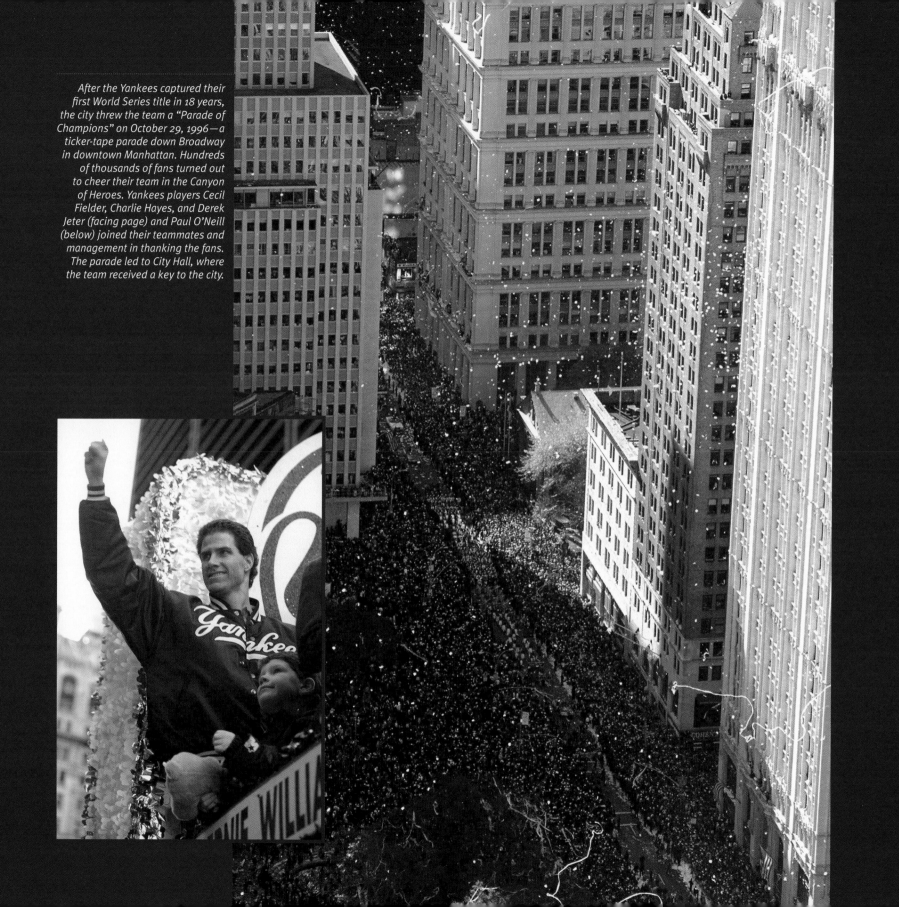

After the Yankees captured their first World Series title in 18 years, the city threw the team a "Parade of Champions" on October 29, 1996—a ticker-tape parade down Broadway in downtown Manhattan. Hundreds of thousands of fans turned out to cheer their team in the Canyon of Heroes. Yankees players Cecil Fielder, Charlie Hayes, and Derek Jeter (facing page) and Paul O'Neill (below) joined their teammates and management in thanking the fans. The parade led to City Hall, where the team received a key to the city.

Yankees right-handed starter Orlando Hernández kneels on the mound during a game against the Montreal Expos at Yankee Stadium on July 21, 1998. "El Duque," who defected from Cuba in 1997, posted a 12–4 record and 3.13 ERA in 1998, his first year in the majors. Yankees fans Shannon Grimes (left, facing page) and Liz Piselli, both from Long Island, wear their hearts on their cheeks as they watch the Yankees play the Tampa Bay Devil Rays in September 1998.

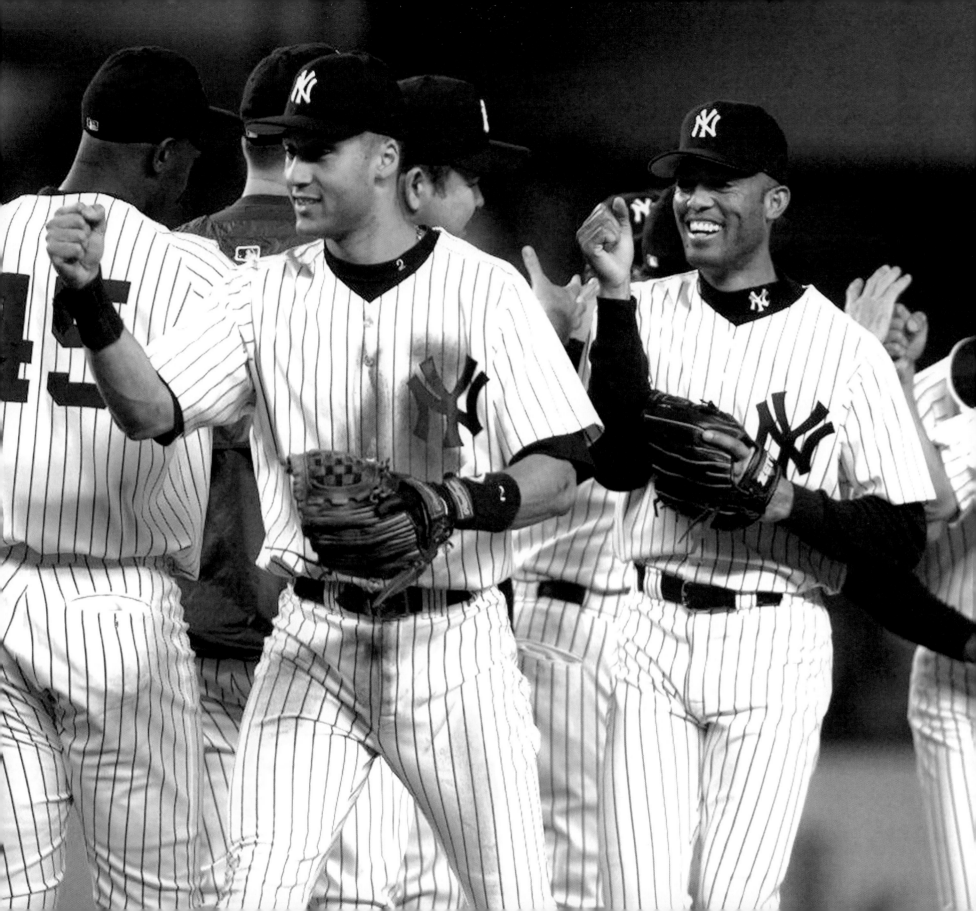

Derek Jeter and Mariano Rivera (facing page) celebrate the Yankees' 112th win of the season, a 6–1 victory over Tampa Bay at Yankee Stadium on September 25, 1998. The Yanks, who would finish with 114 wins, broke the mark of 111 by the 1954 Cleveland Indians. Sal Barca (above) makes pizza while his brother, Ronnie, and his nephew, Ronnie Jr., watch at Catania's, their pizzeria on Arthur Avenue in the Bronx, prior to the Yankees meeting the Rangers in the 1998 ALDS. The Barcas would have supplied the pizza for the governor of Texas had Governor Pataki lost his bet on the Yankees in the playoffs. There was, of course, no Catania's pizza in Texas.

Former Yankees shortstop, Hall of Famer, and longtime broadcaster Phil Rizzuto shakes hands with current shortstop Derek Jeter after throwing out the first pitch before Game 2 of the 1998 American League Division Series against the Texas Rangers.

Yankees coach Willie Randolph congratulates Jorge Posada as he jogs home after hitting a home run during Game 1 of the 1998 ALCS against the Cleveland Indians.

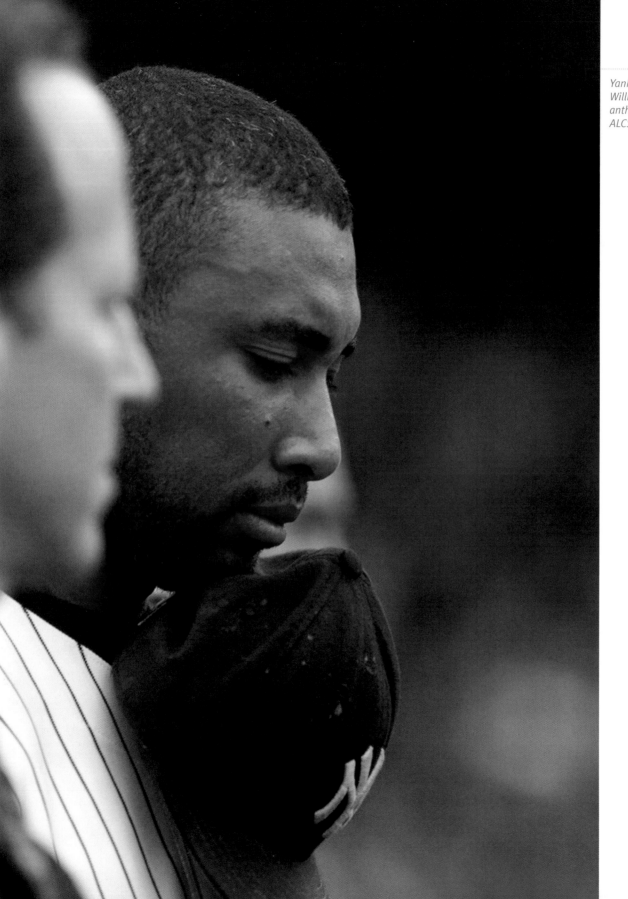

Yankees center fielder Bernie Williams listens to the national anthem before Game 2 of the 1998 ALCS against the Indians.

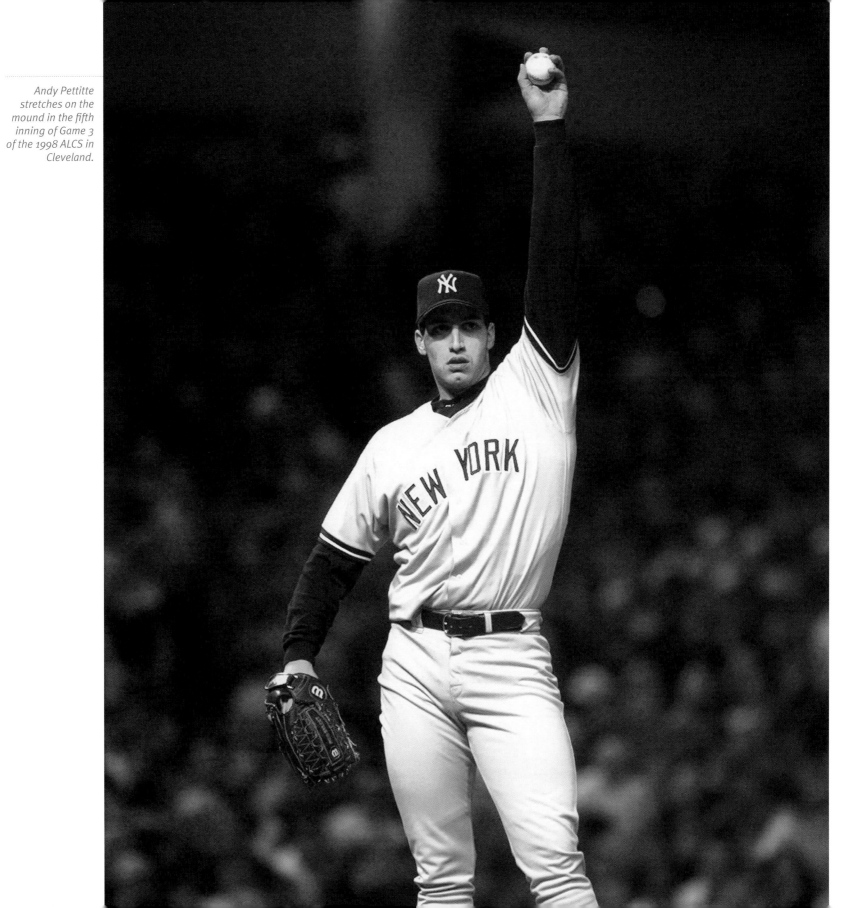

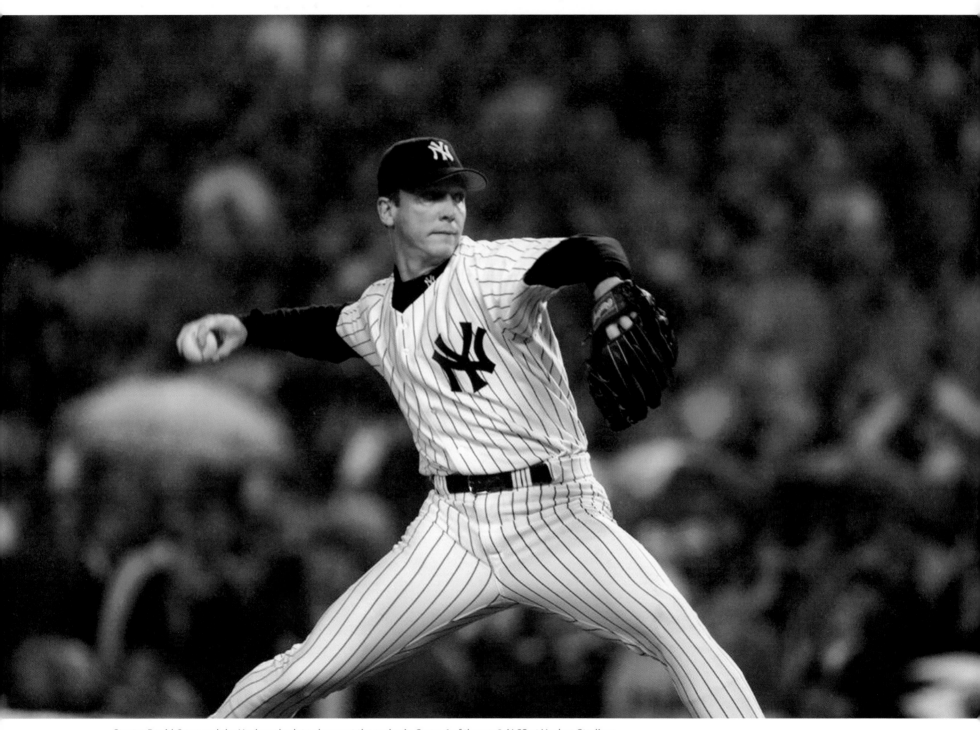

Starter David Cone and the Yankees look to close out the series in Game 6 of the 1998 ALCS at Yankee Stadium.

Closer Mariano Rivera hugs catcher Joe Girardi after the Yankees defeated the Cleveland Indians in the ALCS to advance to the World Series. In forcing six games, the Indians gave the Yankees their stiffest competition of the 1998 postseason.

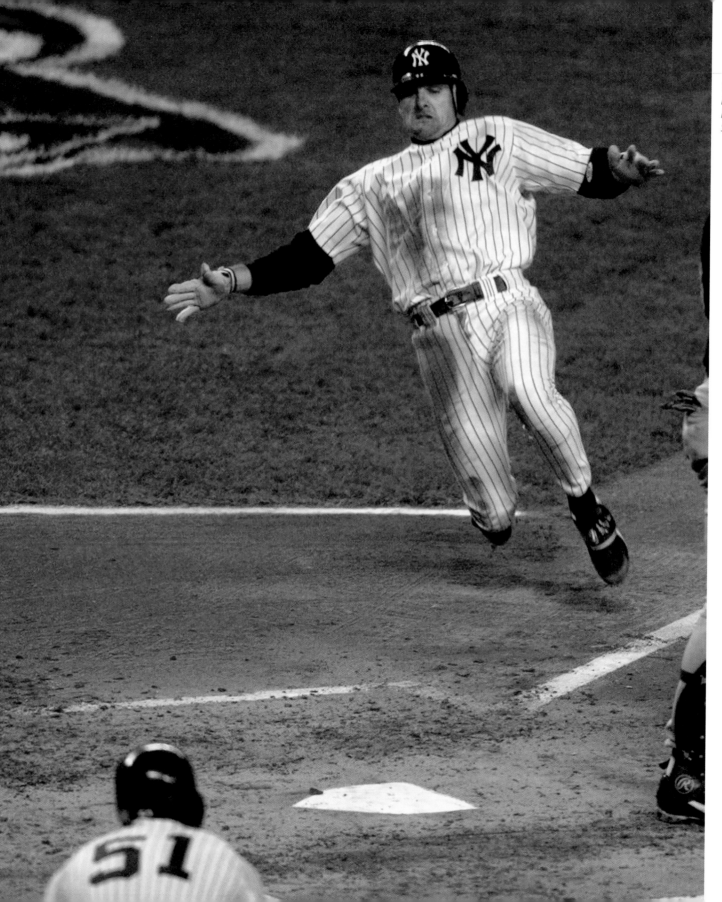

Yankees second baseman Chuck Knoblauch scores on Paul O'Neill's hit during Game 2 of the 1998 World Series against the San Diego Padres.

Mariano Rivera and the Yankees celebrate their 3–0 victory in Game 4 and a four-game sweep of the Padres in the 1998 World Series at Qualcomm Park in San Diego.

Manager Joe Torre at the Yankees spring training facility in Tampa, Florida, in February 1999. Since taking over the team in 1996, Torre had led the Yanks to three straight postseason appearances and two World Series championships.

Roger Clemens makes his home debut as a Yankee against the Tigers on April 10, 1999. He earned a win in the Yanks' 5–0 victory. Clemens, already a five-time Cy Young Award winner at the time he signed with the team, went on to win one more with the Yankees in 2001 (and another with the Astros in 2004).

Injured starter Andy Pettitte (left) talks with pitching coach and former Yankees pitcher Mel Stottlemyre in April 1999 at Yankee Stadium.

New York, Monday, July 19, 1999

CONE IS PERFECT!

41,930 Fans Watch Ace Record Feat

by Virginia Breen, Bill Egbert, and Dave Goldiner

David Cone tossed a perfect game on a perfect day at Yankee Stadium yesterday.

The rapier-sharp Cone mowed down 27 straight Montreal Expos to win, 6–0—joining the exclusive club that includes Yankees Don Larsen and David Wells—on a day the Bombers honored Yogi Berra.

A wide-eyed Cone clasped his hands against his cap, fell to his knees, and raised his arms in triumph as the final out fell into the glove of third baseman Scott Brosius.

"Maybe there is something to that Yankee aura," the 36-year-old right-hander said breathlessly after the game, which Larsen attended. "Maybe there's something to this magic, this great legend of Yankee Stadium."

Seconds after Cone was carried off the field by catcher Joe Girardi and second baseman Chuck Knoblauch, he took a call from Wells, who was traded to the Toronto Blue Jays before the season.

"Wow, I'm going to have a beer for Cone," Wells said.

The perfect game came on a day to remember for the 41,930 fans, who cheered as World Series perfect pitcher Larsen tossed out the ceremonial first ball to his old batterymate Berra.

Rain held up the game for 33 minutes in the third inning, and Yankee fans gasped when left fielder Ricky Ledee was handcuffed and barely made an awkward basket catch to save the perfect game in the ninth inning.

But the steely-eyed Cone never wavered, baffling the Expos with an array of pitches including his trademark sidearm Laredo slider.

The atmosphere inside the Stadium on a sticky midsummer day turned electric as Cone—who had tossed three one-hitters but never a no-hitter—aced untouched into the final innings.

Cone, who exudes a stubborn intensity every time he steps on the mound, needed only 88 pitches to seal the 14th—and possibly last—perfect game of the century. He didn't go to a three-ball count all day and struck out 10 batters.

"I've been to at least 100 baseball games in my life, and I have never felt a feeling like that," said Ryan Burke, 28. "It couldn't have happened on a better day."

"I wasn't nervous," said fan Carmine Ciccone, 25. "I felt like it was meant to happen."

Keith O'Donnell, 27, started dialing up his friends on his cellular phone in the bottom of the eighth inning.

"I wanted to tell them I was at David Cone's perfect game," he said.

Yankee fans exhaled as pinch-hitter Orlando Cabrera waved at a wicked slider and sent the lazy pop-up headed toward Brosius.

Then the place exploded as only Yankee Stadium can.

"I feel really lucky," said Joey DePeri, 10. "I don't think I'll ever see another perfect game."

Cheering fans poured out onto the street as hundreds of thousands of fans cheered in backyards, sports bars, and living rooms across the city.

"From the seventh inning on, everybody was standing and clapping and getting really psyched," said Amy Bachman, manager of Mickey Mantle's, where 30 Bombers devotees crowded around several television sets.

At Engine Co. 50 in the Bronx, firefighters crowded around the tube after returning from a blaze in time for the ninth inning.

"There was some serious screaming going on," said firefighter Steve DiMaggio. "Everyone was so happy for David Cone."

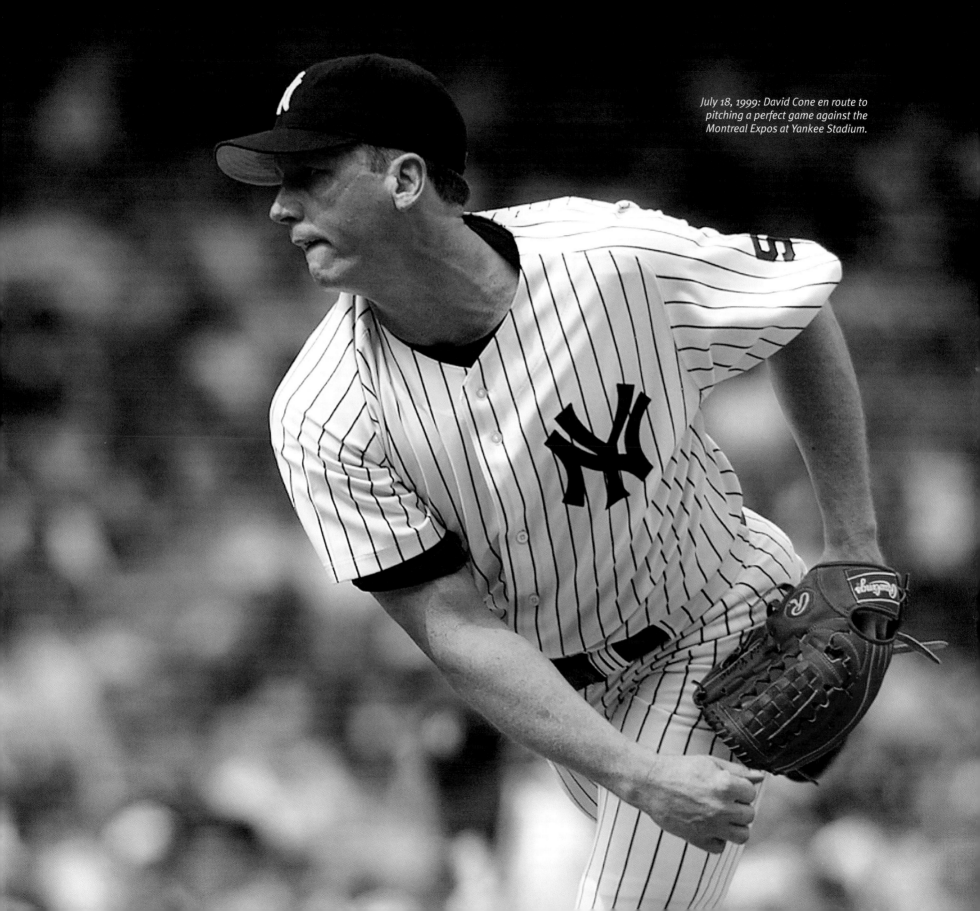

July 18, 1999: David Cone en route to pitching a perfect game against the Montreal Expos at Yankee Stadium.

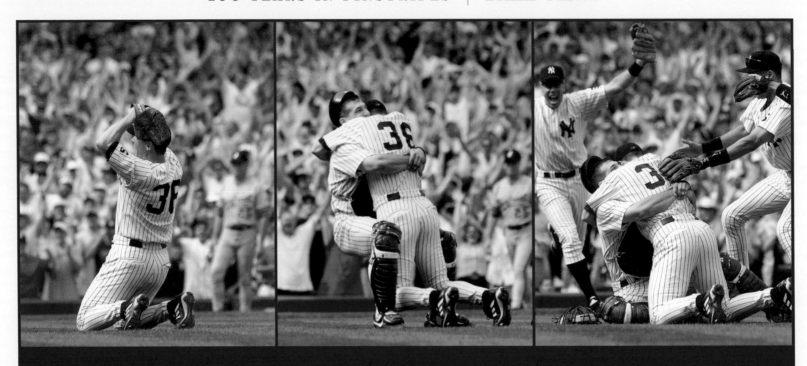

It's Wells Done, Sez Boomer

by Ralph Vacchiano and Bob Raissman

Mayor Giuliani promised David Cone the key to the city after his perfect game yesterday. Then David Wells called from Toronto and promised to show Cone the best places it'll work.

By the time Cone reached the clubhouse after the game, Wells was already on the phone in Joe Torre's office. "He welcomed me to the club," Cone said. "He said he's going to fly in and party with me tonight."

Wells tossed a perfect game for the Yankees on May 17, 1998. It was Cone who sat next to him in the dugout that game, burying his head in his jacket and apparently calming down "Boomer."

Wells, talking to reporters in Toronto, couldn't have been more thrilled for Cone. "He's overcome a lot of obstacles in his career," Wells said. "And for him to do it in New York, where he is well loved, he is the man of New York City. Wow, I'm going to have a beer for Cone." Wells also said he expects to do commercials with Cone. "Chicks dig perfect games," Wells said.

Useful advice: Don Larsen didn't tell Cone to throw a perfect game, but he did tell him what to do if he did.

After Larsen threw out the ceremonial first pitch to Yogi Berra, Cone told him he should celebrate like he did in 1956. "And actually, I got it wrong," Cone said. "I said, 'Don, you've got to go jump in Yogi's arms.' He said, 'No, it's the other way around.'"

Perfect call: The star of the broadcasting show was Bobby Murcer. In the Channel 11 production meeting, before the game, Murcer had predicted Cone would have an easy time with Montreal. Then, Murcer said, the Expos were in trouble because they arrived in New York at 4:00 AM yesterday. "They had to be tired," Murcer said. "They had to be a step behind Cone's pitches."

Of course Murcer was right. On the radio side, Michael Kay and John Sterling were into what was happening, but were hindered by an appearance in the booth by Giuliani. Sterling seemed to recognize this after the mayor left the booth. "Now it's the game, nothing but the game," he said.

At the end of the day, it was Tim McCarver who summed up the feeling of Yankee fans. "After today I don't want to leave the Stadium," McCarver told Murcer. "I just don't wanna leave."

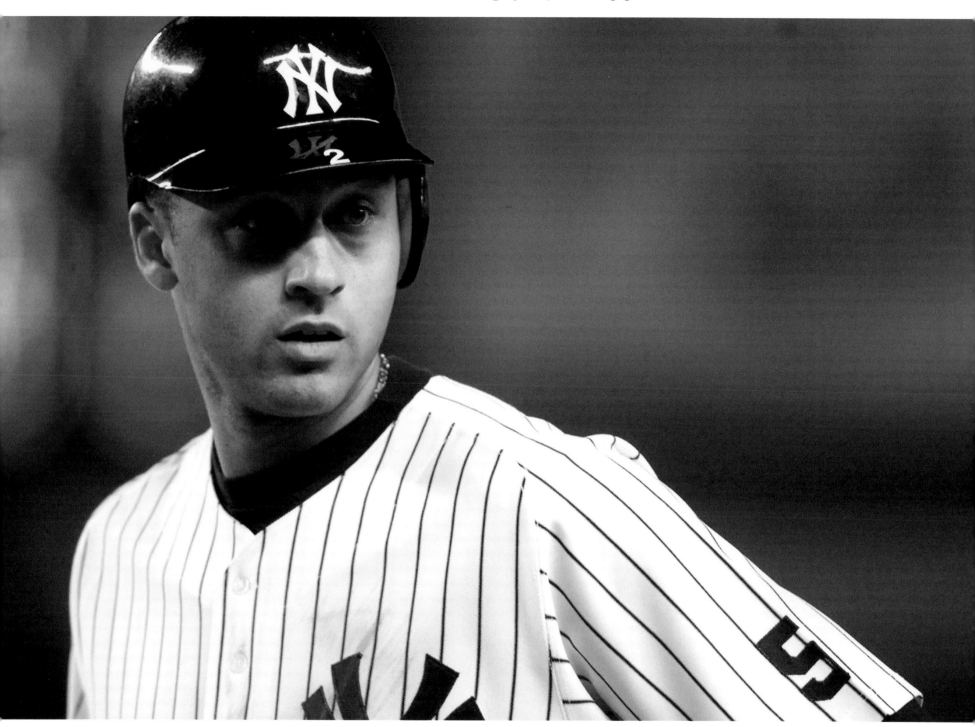

Derek Jeter on first base again during a game against the Mets in June 1999. The future Hall of Famer hit .349 that season, leading the major leagues in hits with 219.

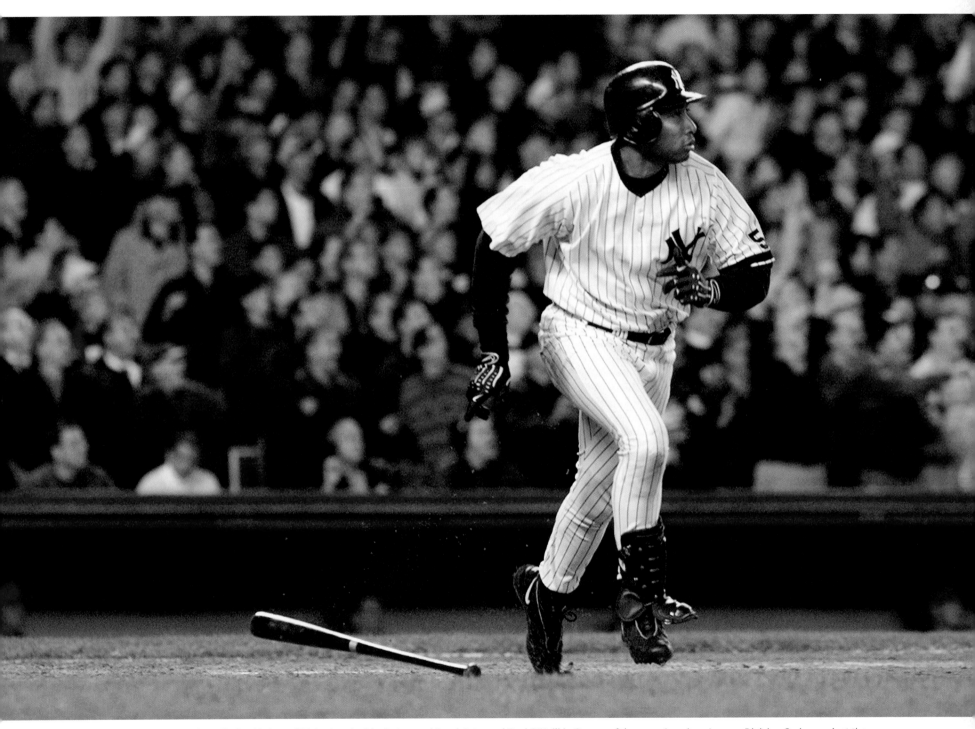

Bernie Williams takes off after hitting a fifth-inning double that scored Derek Jeter and Paul O'Neill in Game 1 of the 1999 American League Division Series against the Texas Rangers at Yankee Stadium.

Orlando Hernández looks to the sky as he starts his distinctive windup in the first inning of Game 1 of the 1999 ALDS against Texas. Later he pumps his fist after a double play ended the top of the sixth. El Duque and the Yanks crushed the Rangers 8–0.

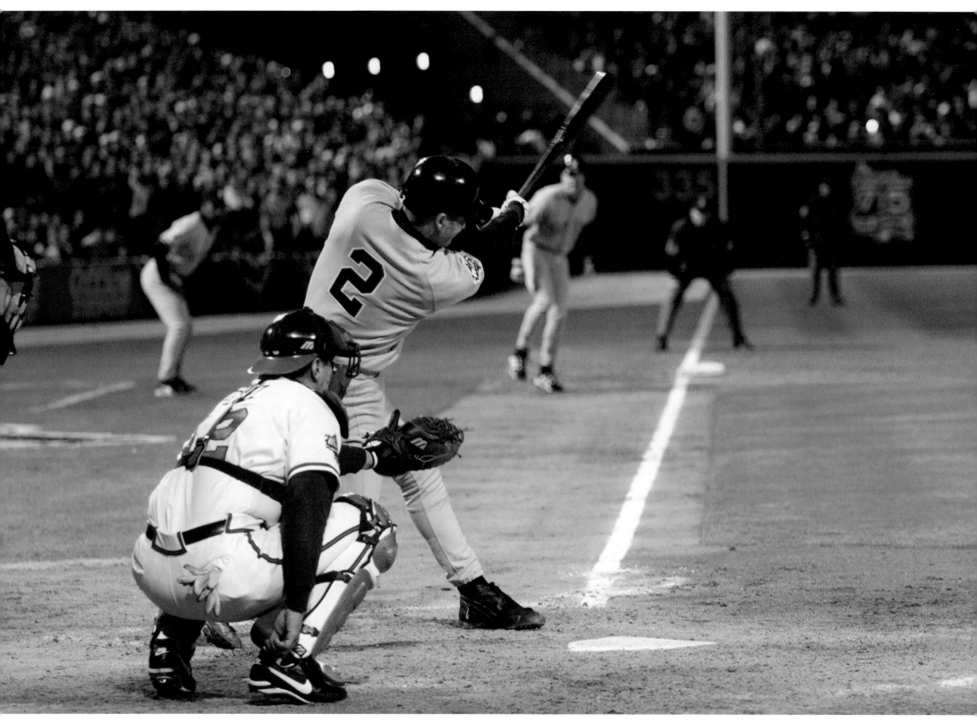

Derek Jeter singles in the eighth inning of Game 1 of the 1999 World Series to score Scott Brosius from third base. The Yankees were facing the Atlanta Braves for the second time in four years in the Series. The Bombers took the first game 4–1 at Turner Field.

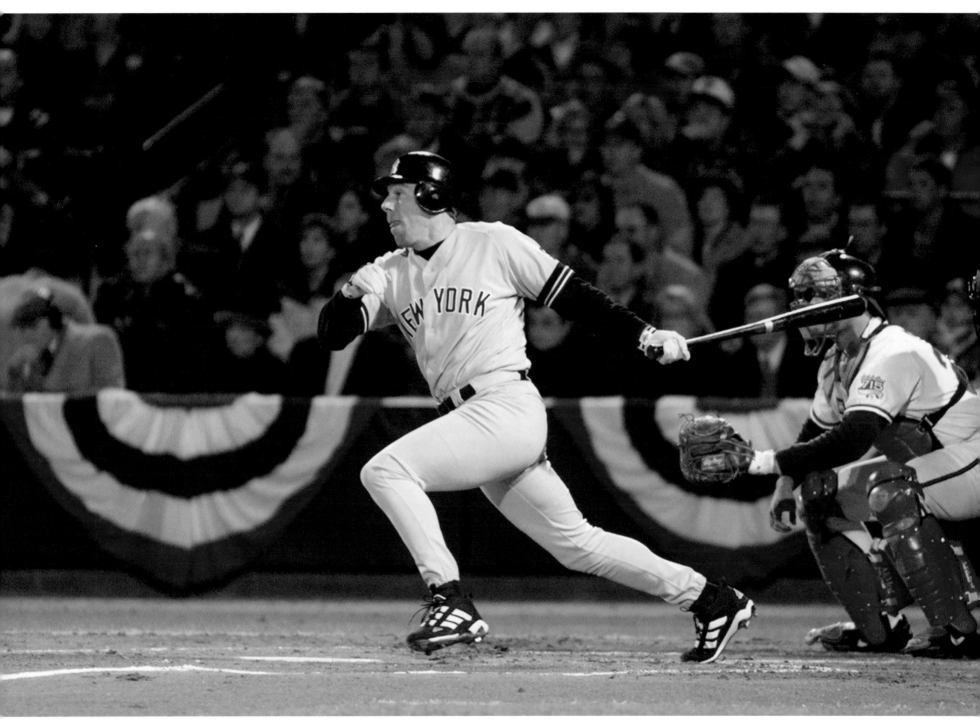

Yankees third baseman Scott Brosius singles in the first inning of Game 2 of the 1999 World Series, scoring Tino Martinez. The Yankees beat the Atlanta Braves at Turner Field, 7–2, to go up two games to none.

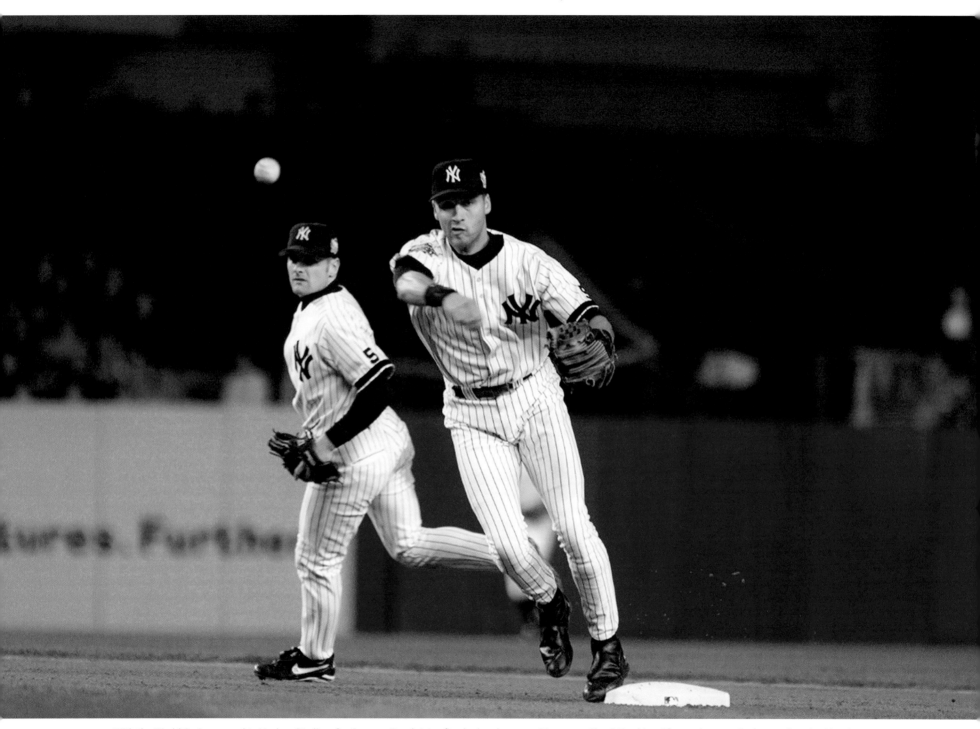

With the World Series moved to Yankee Stadium for Game 3, Derek Jeter (backed up by second baseman Chuck Knoblauch) completes an inning-ending double play against the Braves in the sixth, with Atlanta leading 5–2.

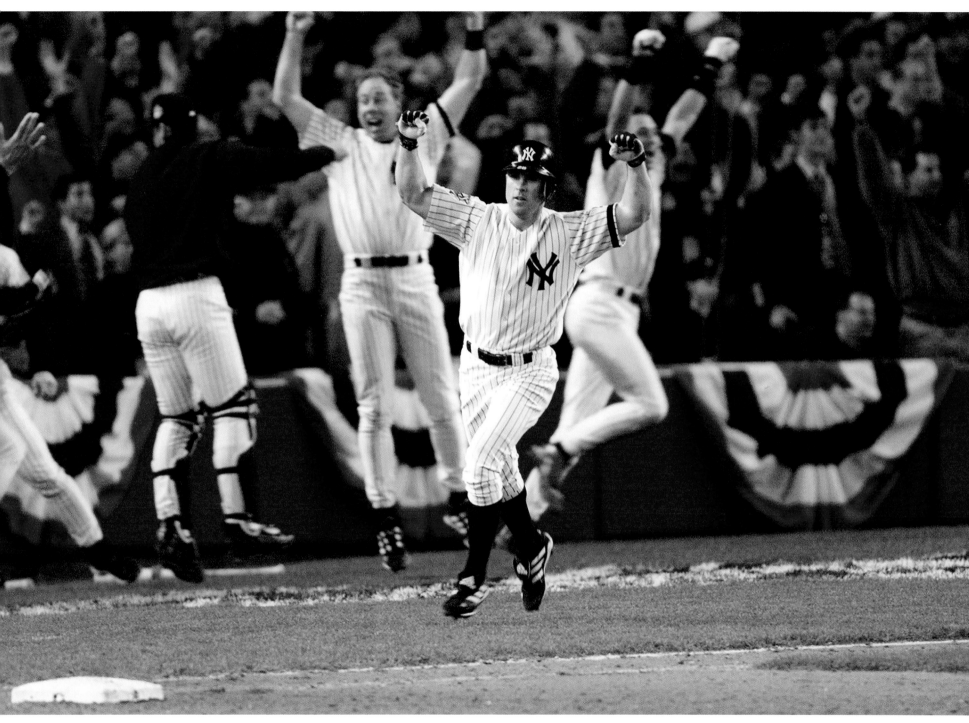

Yankees reserve outfielder Chad Curtis raises his arms after hitting the game-winning home run in the 10th inning of Game 3 of the 1999 World Series, a 6–5 victory over the Atlanta Braves at Yankee Stadium. Curtis went 2-for-4 in the game, both hits solo home runs.

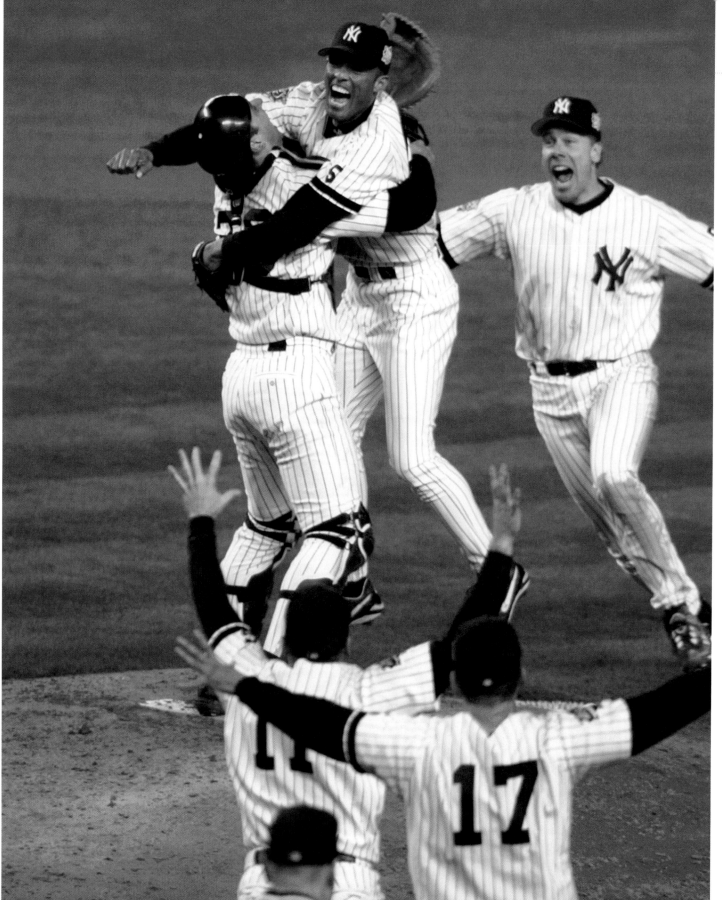

Yankees closer Mariano Rivera is embraced by catcher Jorge Posada as Scott Brosius (right) and the rest of the Yankees converge on the mound at Yankee Stadium on October 27, 1999, to celebrate their third World Series championship in four years and 25th overall. It was the Yanks' second straight four-game sweep in the Series and extended their Series winning streak to 12 games. They finish the franchise's 97th year as the undisputed team of the decade and team of the century.

The 2000s

Alex Rodriguez

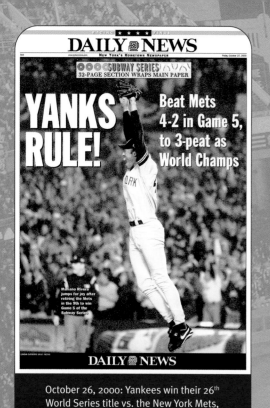

YANKS RULE!

Beat Mets 4-2 in Game 5, to 3-peat as World Champs

Mariano Rivera jumps for joy after retiring the Mets in the 9th to win Game 5 of the Subway Series.

DAILY NEWS

October 26, 2000: Yankees win their 26th World Series title vs. the New York Mets, the first Subway Series since 1956.

September 21, 2002: The Yankees defeat the Detroit Tigers 3–2 at Comerica Park to clinch their fifth straight AL East title. It is New York's sixth title in seven seasons under manager Joe Torre.

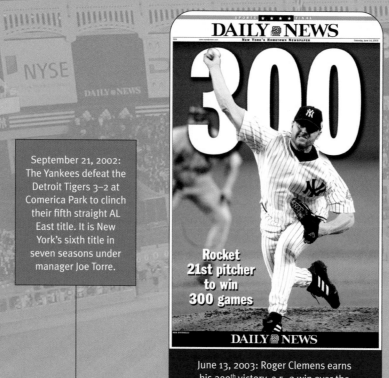

DAILY NEWS

300

Rocket 21st pitcher to win 300 games

June 13, 2003: Roger Clemens earns his 300th victory, a 5–2 win over the St. Louis Cardinals at Yankee Stadium.

February 16, 2004: The Yankees acquire 2003 AL MVP Alex Rodriguez in a trade with the Texas Rangers for Alfonso Soriano, cash, and prospect Joaquín Árias.

2000	2001	2002	2003	2004

November 4, 2001: Less than two months after 9/11, an emotional and thrilling postseason ends when the Arizona Diamondbacks beat the Yankees in Game 7 of the World Series on Luis Gonzalez's ninth-inning, game-winning single off of Mariano Rivera.

October 16, 2003: In the bottom of the 11th inning of Game 7 of the ALCS against Boston, Aaron Boone leads off with a home run, giving the Yankees their 39th pennant and sending them to the World Series.

September 30, 2004: Bernie Williams launches a walk-off home run against the Twins at Yankee Stadium, clinching the Yankees' seventh consecutive AL East crown.

October 25, 2003: Florida's Josh Beckett pitches the Marlins to a 2–0 win in Game 6 of the World Series, marking the first time since 1981 that New York has been eliminated from the postseason at Yankee Stadium.

October 20, 2004: After defeating the Twins in a four-game ALDS and taking a 3–0 lead over the Red Sox in the ALCS, the Yankees drop their fourth consecutive game, becoming the first team in baseball history to lose a best-of-seven series after winning the first three games.

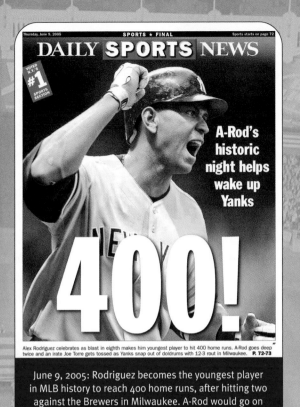

DAILY **SPORTS** NEWS

A-Rod's historic night helps wake up Yanks

400!

Alex Rodriguez celebrates as blast in eighth makes him youngest player to hit 400 home runs. A-Rod goes deep twice and an irate Joe Torre gets tossed as Yanks snap out of doldrums with 12-3 rout in Milwaukee. **P. 72-73**

June 9, 2005: Rodriguez becomes the youngest player in MLB history to reach 400 home runs, after hitting two against the Brewers in Milwaukee. A-Rod would go on to earn his second AL MVP award in 2005.

2006: The Yankees win their ninth consecutive AL East title, finishing with a record of 97–65, their sixth straight year with 95 or more victories.

August 13, 2007: Yankees Hall of Fame shortstop, seven-time World Series champion, and broadcaster for 40 years, Phil Rizzuto dies at the age of 89.

2007: Led by American League MVP Alex Rodriguez, the Yankees secured the American League wild-card with a record of 94–68, running their playoff streak to 13 consecutive seasons.

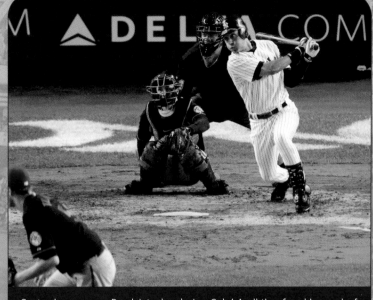

September 11, 2009: Derek Jeter breaks Lou Gehrig's all-time franchise mark of 2,721 hits with a single off Baltimore's Chris Tillman at Yankee Stadium.

2005 2006 2007 2008 2009

November 1, 2007: After Joe Torre turned down an incentive-laden contract from the Yankees in October, management hires former Yankees catcher Joe Girardi as the team's new manager.

2008: Under new manager Joe Girardi for the final season at Yankee Stadium, the Yankees' run of postseason success comes to a halt. Yankee Stadium hosted the All-Star Game in July, but the Yankees' own season was held back by injuries and inconsistency.

November 4, 2009: The Yankees win their 27th world championship, defeating the Philadelphia Phillies 7–3 in Game 6 of the World Series.

April 16, 2009: The Yankees play the first regular-season game in new Yankee Stadium, falling to Cleveland 10–2, and snapping their all-time record of 11 consecutive wins in the home opener. CC Sabathia tosses the Stadium's first official pitch, Johnny Damon records the first hit (first-inning single off Cliff Lee), and Jorge Posada hits the first home run (fifth inning off Lee).

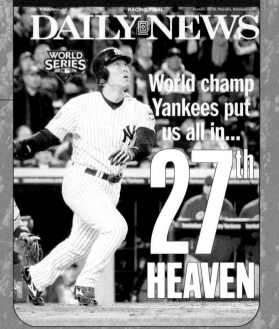

DAILY NEWS

WORLD SERIES

World champ Yankees put us all in...

27th

HEAVEN

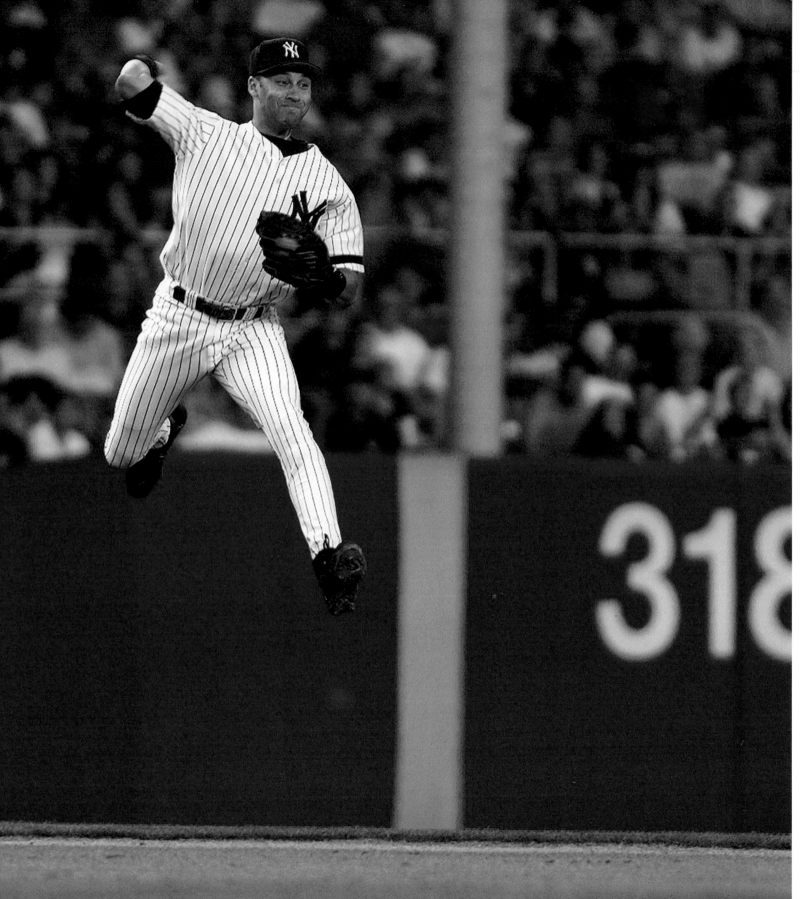

Derek Jeter makes a leaping throw to second to force the runner in the fifth inning against the Baltimore Orioles at Yankee Stadium on July 5, 2000. The Yanks, who had lost five in a row at home, avoided their longest home losing streak in 11 years with a 12–6 victory.

Bernie Williams (facing page) is congratulated by David Justice (28) after hitting his 30th home run of the season on September 24, 2000, in a game against the Detroit Tigers.

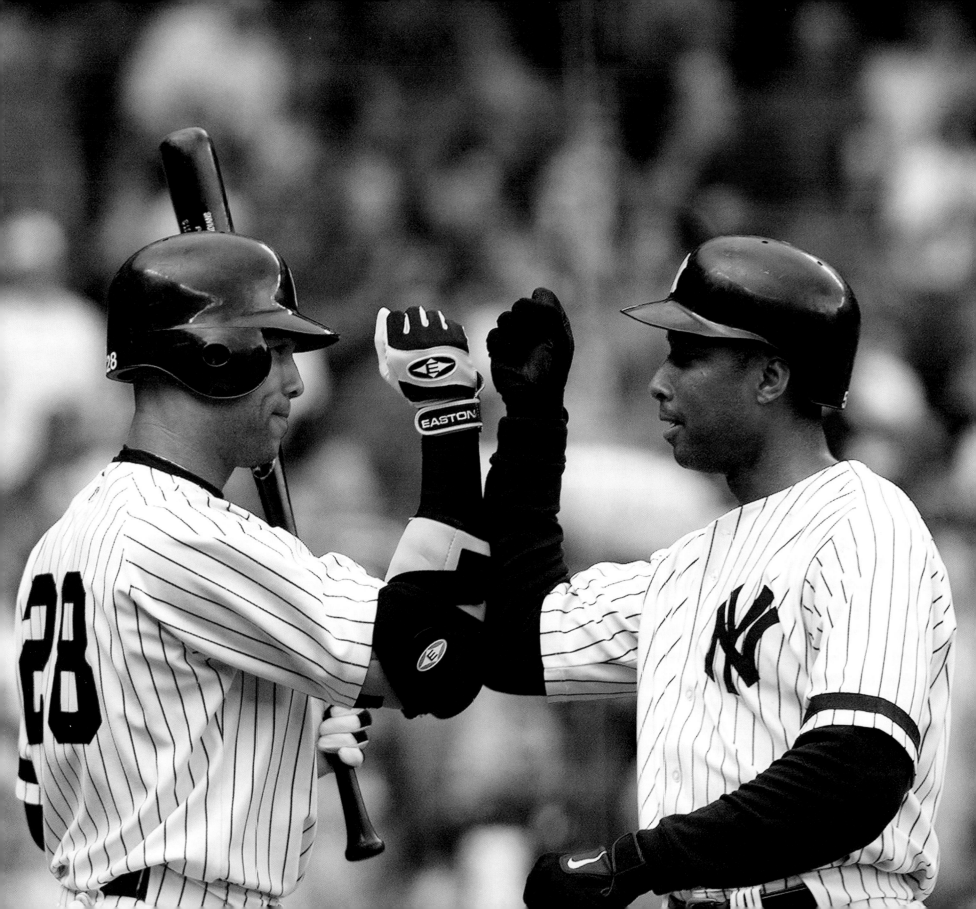

Yankees manager Joe Torre and bench coach Don Zimmer worked together to lead the Yankees from 1996 to 2003, winning six pennants and four World Series titles. They watch as their team is getting bombed by the Cleveland Indians, 15–4, at home on September 17, 2000. The Yanks finished the season with an 87–74 record, still good enough for first place in the AL East.

Roger Clemens (facing page) pumps his fist after pitching his way out of a jam in the seventh inning of Game 4 of the ALCS against the Mariners in Seattle. The Rocket struck out 15 in a one-hit, complete-game shutout over the Mariners. The 5–0 victory gave his team a 3–1 lead in the best-of-seven series, which the Yanks won in six.

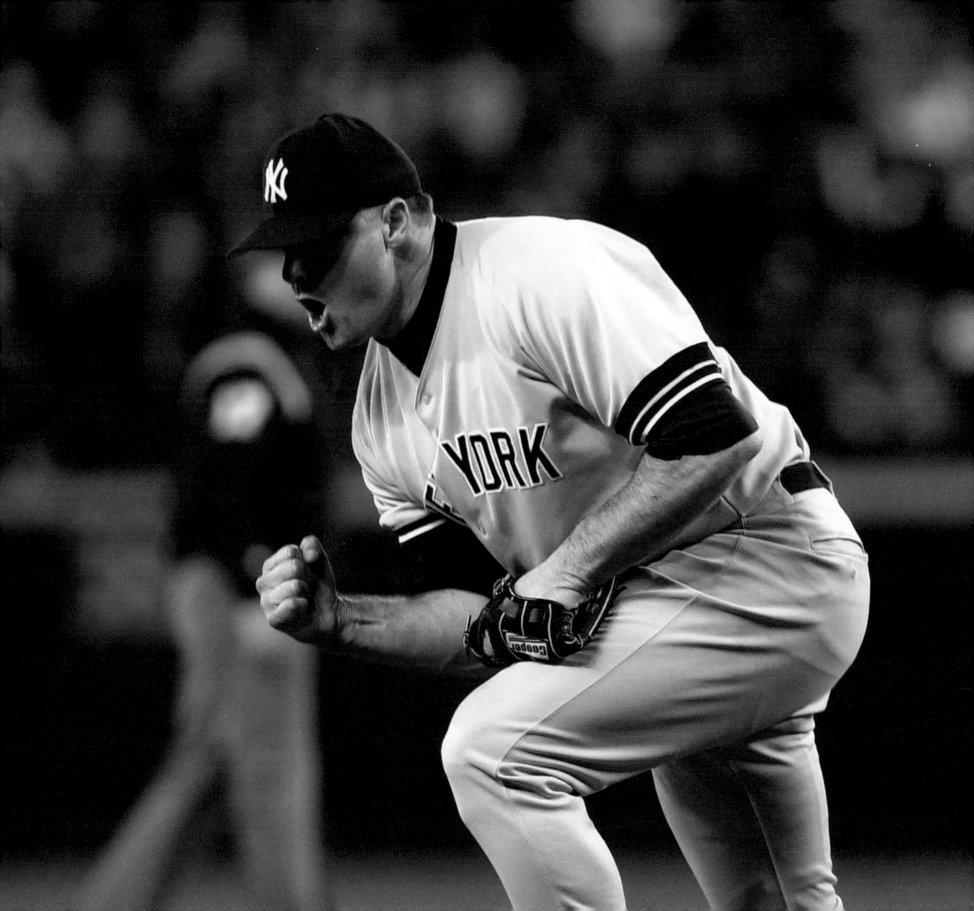

New York, Friday, October 27, 2000

YANKEES REIGN ON THREE TRAIN

Subway Ends at Usual Stop

by Thomas Hill

The Subway Series that New Yorkers could only imagine for 44 years came to a fitting end with a dream matchup last night at Shea. Mariano Rivera threw his final fastball to Mike Piazza, who hit a deep drive to center field that threatened to tie the game. Bernie Williams ended the suspense when he caught the ball near the warning track, giving the Yankees their third straight World Series championship and first against the Mets.

"We got a few more big hits than they did," Yankees left fielder David Justice said, "or they'd be celebrating."

In the end, however, the Yankees recorded a 4–2 victory in Game 5 that produced their 26th championship. The Mets pushed the Yankees throughout five tightly contested games, but in the end merely reprised the role of their NL predecessors from past generations who battled the Yankees year after year without beating them.

"We left everything out there," Mets center fielder Jay Payton said, "but I guess we got outplayed."

Powered by solo homers from Series MVP Derek Jeter and Bernie Williams, as well as a tie-breaking hit in the ninth from Luis Sojo, the Yankees became the first team since the 1972–1974 Oakland A's

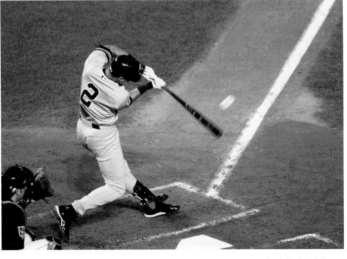

Series MVP Derek Jeter hits the first pitch of Game 4 over the left-field fence at Shea as the Yankees beat the Mets 3–2 to go up three games to one.

to win three straight World Series championships and the fourth team ever to do so. The Yankees won their fourth Series in five years despite finishing the regular season with a seven-game losing streak and then needing five games to dispatch the young Oakland A's in an AL division series.

"I'd be lying if I said this one wasn't more gratifying," Jeter said. "We struggled this year. We've had tough times. We've said before that winning isn't easy. It's something that's very difficult to do. We've had our bumps in the road. (But) we're sitting here again at the end of the year."

The Yankees offered compliments to the Mets, who broke their record of 14 consecutive World Series victories by beating them in Game 3. The Mets became the first team in three years that the Yankees did not sweep in the Series.

"This, by far, was the best team we played in the five years I've been here," Jeter said. "All five games could have gone either way. We were just able to come up with a few more runs."

During their postgame celebration, however, the Yankees acted less graciously. They mocked the Mets by singing the Baha Men's "Who Let the Dogs Out?," a theme song in recent weeks at Shea. A group of Yankees—including Roger Clemens and Justice—then

gathered in the middle of their crowded clubhouse and offered a toast to Turk Wendell, the Mets reliever who suggested before the Series that the Yankees' reign was finished.

"I think trash-talking should be left to football," Yankees reliever Jeff Nelson said. "In baseball, it's too hard to back that stuff up. Maybe they'll learn to go out and show it on the field rather than run their mouths in the paper."

After recording three one-run victories over the Mets in the first four games of the Series, the Yankees entered the ninth inning in a 2–2 tie. Mets starter Al Leiter was still going strong after limiting the Yankees to five hits in the first eight innings. He opened the ninth with back-to-back strikeouts of Tino Martinez and Paul O'Neill but could not reach the finish line.

When Leiter threw a 2-and-2 pitch to Jorge Posada, the Mets left-hander looked hopefully to home plate umpire Tim McClelland, who called it a ball. Posada walked on the next pitch.

Scott Brosius followed with a single to left that sent Posada to second. Up stepped Sojo, who swung at Leiter's 142nd and final pitch, bouncing a first-pitch single through the middle. Posada stormed around third. Payton's throw home struck Posada at the plate and bounced away, allowing Brosius to score as well.

Leiter remained winless as a starter in the postseason after 11 career starts. After Leiter's eight dominant innings, manager Bobby Valentine might have stayed with him a few batters too long. "I thought that striking out those first two guys, and the pitches he threw to Posada, made me think he had plenty," Valentine said. "I was wrong."

Almost like Jeter the previous night, Williams gave the Yankees an early boost. He led off the second by pounding a full-count fastball from Leiter into the left-field loge seats for his first World Series hit, breaking an 0-for-15 slump. Williams' third career Series homer gave the Yankees a 1–0 lead.

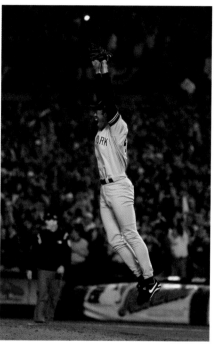

Mariano Rivera leaps in elation after a fly to center is caught by Bernie Williams for the final out of the 2000 World Series, giving the Yankees their 26th world championship.

Andy Pettitte's evening did not proceed quite so smoothly. With one out in the second, he walked Bubba Trammell. Payton followed with a single to right-center. After Kurt Abbott grounded out, moving the runners to second and third, Leiter—perhaps the worst hitter among the Mets pitchers—dragged a bunt toward first. Tino Martinez charged the ball, fielded it, and flipped to Pettitte, who bobbled it as Leiter reached the bag. Trammell scored on Pettitte's error, tying the score, 1–1.

Benny Agbayani followed by hitting a slow chopper toward third. Brosius charged and tried to barehand it but missed the ball, allowing it to roll into left for a hit. Payton charged home, giving the Mets a 2–1 advantage.

Jeter momentarily negated Pettitte's shakiness, when with one out in the sixth, he homered for the second time in two nights. He whacked a 2–0 pitch into the visitors' bullpen, tying the score, 2–2.

Mike Stanton earned the victory after pitching a scoreless eighth inning in relief of Pettitte. After the Yankees' tie-breaking rally, Rivera entered to pitch the ninth. He gained his second save of the Series and set a record with the seventh of his career.

Williams caught Piazza's final drive at exactly midnight and kneeled on the grass for a moment. When Williams rose he jubilantly embraced left fielder Clay Bellinger. They raced to the infield to join in celebration with the rest of the Yankees, who had mobbed Rivera behind the mound.

Amid the spontaneous celebration, Mets players quickly left the field. The majority of the 55,292 spectators quickly departed but a large contingent of Yankees fans remained to cheer the champions of baseball, and of the city, at least part of it.

"They were the better team," Mets reliever Dennis Cook said. "They beat us. It's never exciting until it's over. This year it's not exciting at all."

With the Twin Towers visible across New York Harbor, the Yankees Class A affiliate, the Staten Island Yankees, make their debut in their brand-new Richmond County Bank Ballpark at St. George on June 24, 2001. Two and a half months later, New Yorkers and the entire country mourn the devastation left in the wake of the terrorist attacks of September 11. A Yankees fan (facing page) flies the Stars and Stripes, while Derek Jeter honors the first responders who gave their lives on 9/11. Members of the Police and Fire Departments throw out the first pitches at a ceremony (far right, top) in Yankee Stadium honoring the victims prior to Game 1 of the ALDS. A color guard (far right, bottom) presents the flag before the start of Game 2.

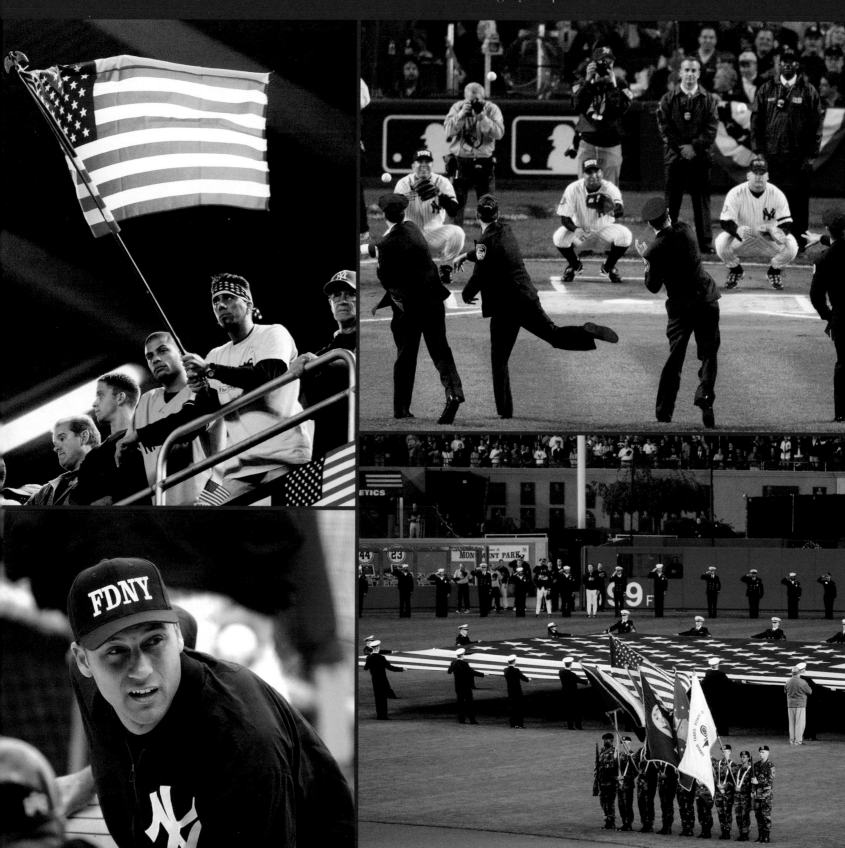

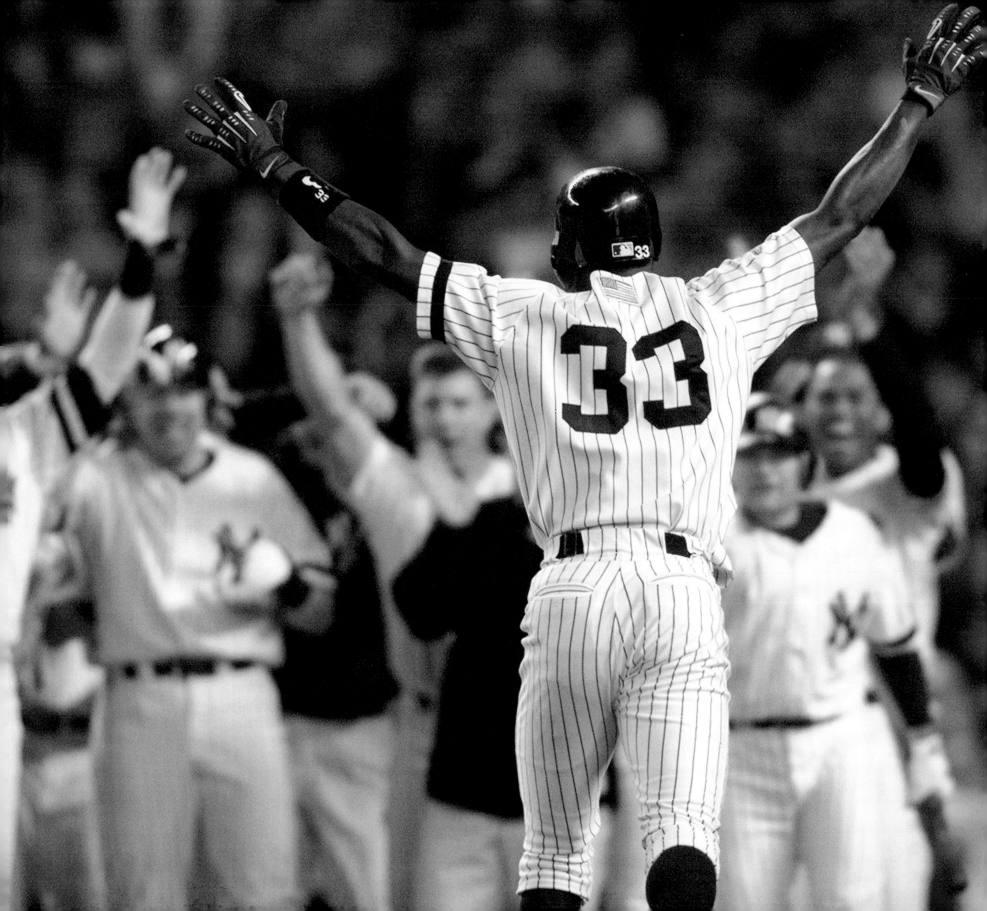

Yankees rookie second baseman Alfonso Soriano (33, facing page) is greeted by jubilant teammates as he runs home after his two-run homer lifts the Bombers to a 3–1 win over the Seattle Mariners in Game 4 of the 2001 ALCS at Yankee Stadium. The win gave the Yanks a 3–1 lead in the series.

Derek Jeter celebrates after hitting a 10th-inning, walk-off home run in Game 4 of the 2001 World Series against the Arizona Diamondbacks. The shot, hit just after midnight on November 1, earned Jeter the nickname "Mr. November." Though it was one of the most dramatic and memorable World Series ever played, the Yankees fell in seven.

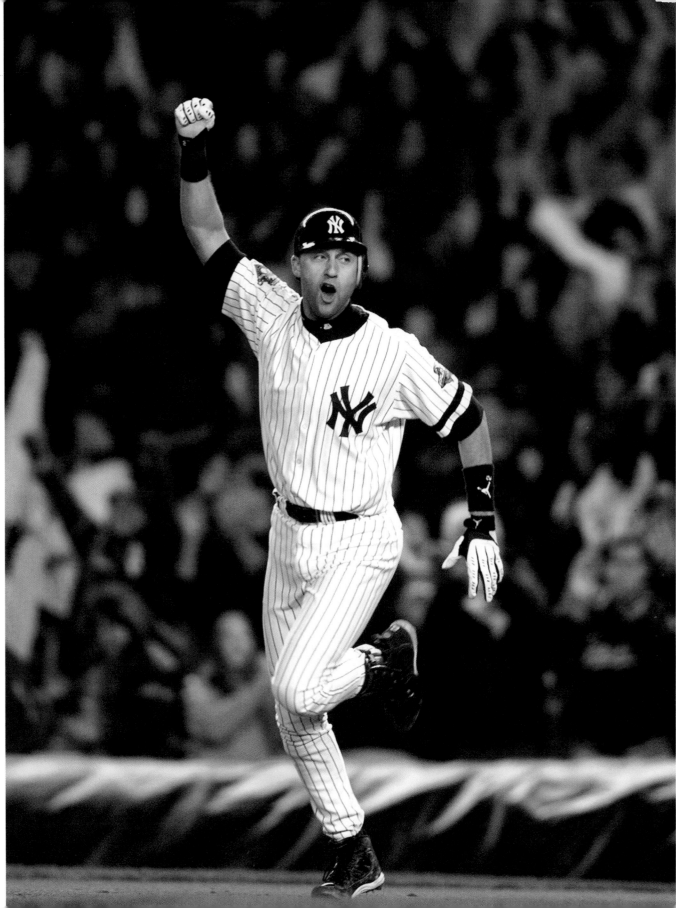

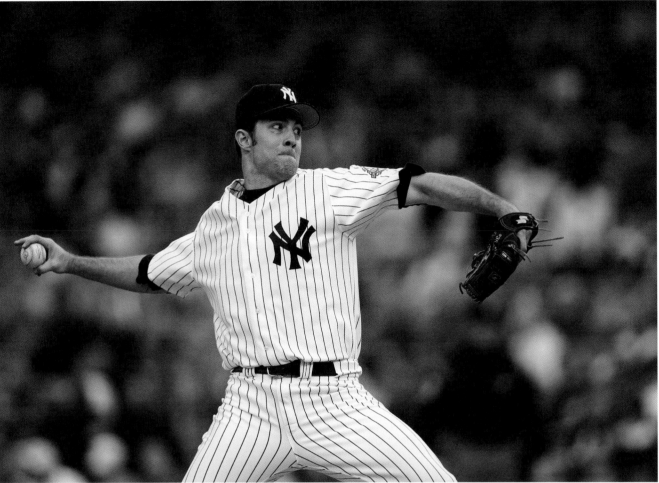

Mike Mussina pitches against the Mariners during a game on May 1, 2003. Mussina, who signed with the Yankees in 2001, was a mainstay of the pitching staff, posting double-digit wins in each of his eight seasons, including a 20-win season in 2008.

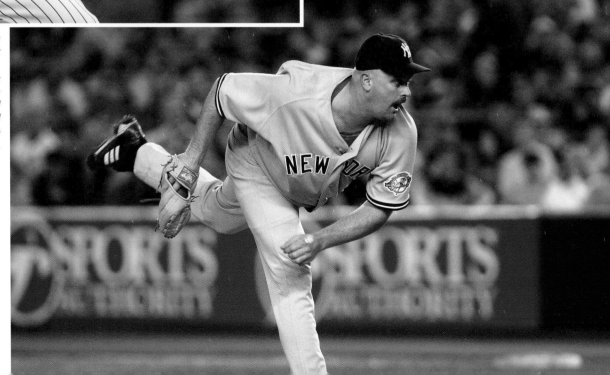

David Wells delivers a pitch in a game against the Mets at Shea Stadium on June 22, 2003. "Boomer," who pitched the Yankees' first regular-season perfect game in 1998, re-signed with the Yankees in 2002 and went 34–14 over the next two seasons with a 3.95 ERA.

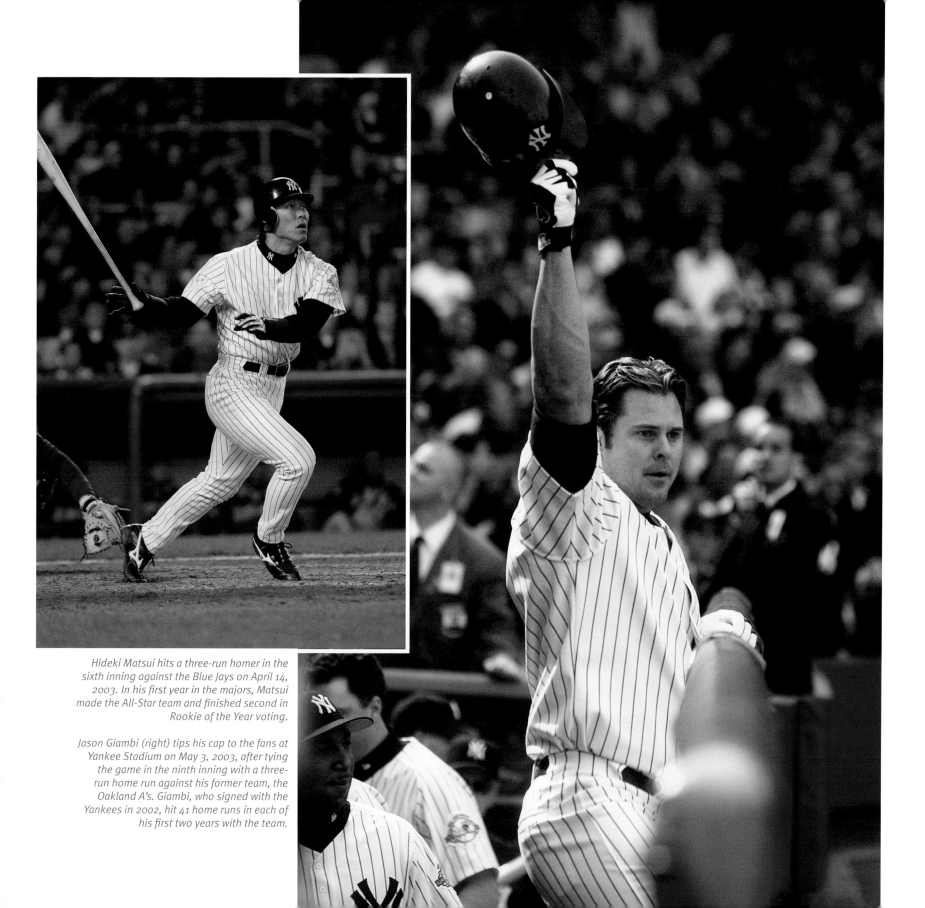

Hideki Matsui hits a three-run homer in the sixth inning against the Blue Jays on April 14, 2003. In his first year in the majors, Matsui made the All-Star team and finished second in Rookie of the Year voting.

Jason Giambi (right) tips his cap to the fans at Yankee Stadium on May 3, 2003, after tying the game in the ninth inning with a three-run home run against his former team, the Oakland A's. Giambi, who signed with the Yankees in 2002, hit 41 home runs in each of his first two years with the team.

New York, Friday, October 17, 2003

IT'S THE CURSE OF BOONEBINO

Shot in 11ᵗʰ Makes History of Sox

by Anthony McCarron

Who knew the many and varied cruelties the Curse actually contained? Now the Bambino might be piling on.

The Red Sox haven't won a World Series since 1918, and they have all winter to think about how they didn't get to the one that starts tomorrow, the one that their bitter rivals, the Yankees, will play in. Even though the Red Sox controlled Game 7 of the AL Championship Series, leading by three in the eighth, their ace on the mound.

The Yanks, meanwhile, have yet another chapter of October lore for their long, storied history. Five outs from defeat, they scored three times in the eighth against an exhausted Pedro Martinez to tie the score and won the game and a trip to the World Series on Aaron Boone's homer in the bottom of the 11ᵗʰ inning.

The Yankees beat Boston, 6–5, last night at the Stadium in a game that will rate alongside the sale of Babe Ruth and Bucky Dent's home run—don't forget about Bill Buckner—as the worst things to ever happen to Boston's darkly comic franchise. It'll rate on the Yankee ledger as one of the best.

Boone, who had entered the game as a pinch-runner in the eighth and had a bad series until his epic moment, crushed Tim Wakefield's first pitch in the 11ᵗʰ deep into the left-field stands, sending his teammates spilling onto the field from the dugout.

Mariano Rivera was the winning pitcher, throwing three scoreless innings over the ninth, 10ᵗʰ, and 11ᵗʰ. Rivera retired nine of the 11 hitters he faced. He struck out Doug Mirabelli for the final out of the 11ᵗʰ on a 96-mph fastball. After the game, he was named the MVP of the series.

Boone said he "felt like he was floating" when he hit the ball. "I knew right away I had hit it real good," Boone added.

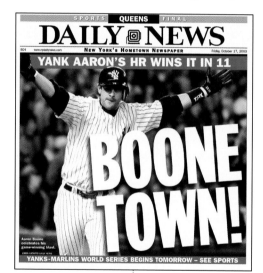

"Derek [Jeter] told me sometimes the ghosts show up here. When I joined the Yankees, this is the kind of thing I thought I could be a part of. This is the perfect story ending for everyone—extra innings in Game 7 after a comeback. It's the perfect ending."

Except for Sox fans. All over New England today, there is the familiar bitter tang of disappointment.

New Yorkers have another Yankee Fall Classic—it's the sixth time the Yankees have reached the World Series in the eight-year Joe Torre era. As a franchise, the Yankees have won 39 pennants and will try for their 27ᵗʰ title when they begin the Series against the Florida Marlins tomorrow night at the Stadium.

For Sox manager Grady Little, the derisive chant of *"19-18"* may echo in his head for the rest of his managing life. Why didn't he take out Martinez and use the bullpen that had been so effective throughout the series? Little could become as much of a rivalry symbol as Ruth or Dent, for Yankee fans, anyway.

Ruth-lover David Wells, standing amid teammates spraying champagne in the clubhouse afterward, hollered over the clubhouse din, "That Curse is still alive."

(Continued on p. 196)

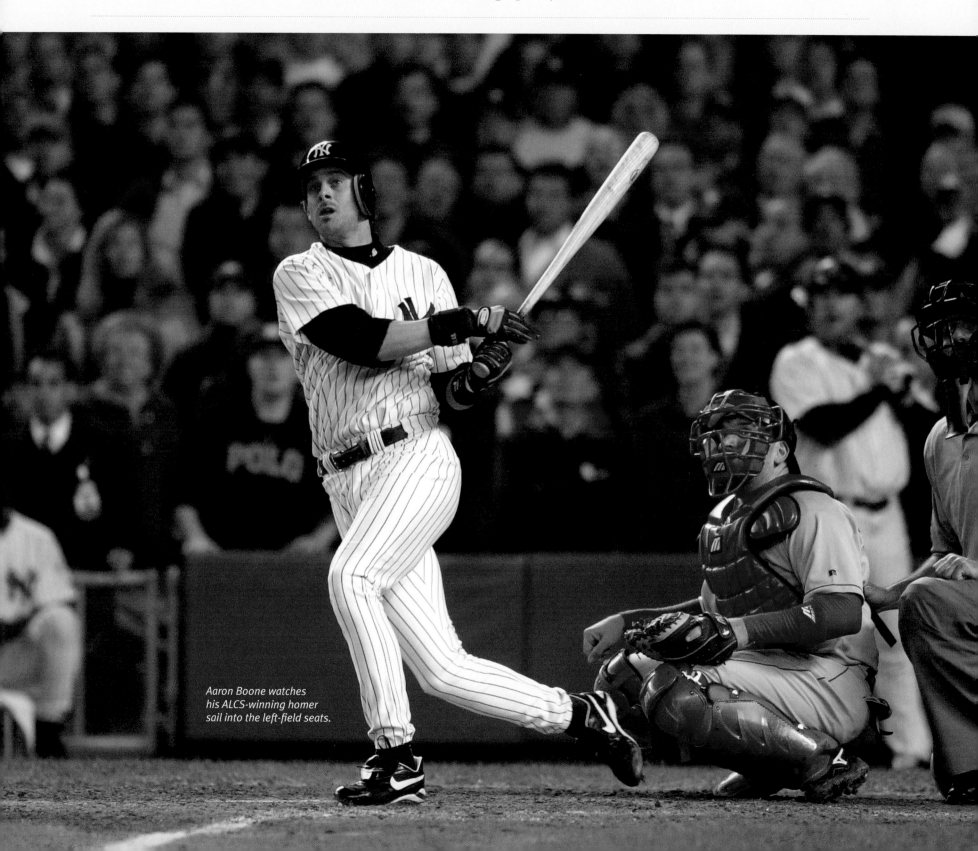

Aaron Boone watches his ALCS-winning homer sail into the left-field seats.

"I believe we've got some ghosts in this Stadium that help us out," Jeter added. "There's some magic in this place."

Considering the way these two teams went at it this season, it was only fitting that it ended in such tense, thrilling fashion. The two teams played 19 times during the regular season, and the Yankees won 10. Entering last night, they had split six more games, and in their 26th meeting last night, a record for two teams, it was decided at the last moment.

Torre called it "the sweetest taste of all for me," because of the hard-fought series and the rivalry. The Yankees and Red Sox played a record 26 games, the Yankees winning 14 and this series.

Jorge Posada's broken-bat bloop double off Martinez knocked in two runs in the eighth, completing a three-run inning that tied the score and electrified 56,279.

Jeter started the rally with a double on an 0–2 pitch from Martinez and he scored on Bernie Williams' single. Hideki Matsui followed with a double, also on an 0–2 pitch. Posada's hit finally knocked out Martinez and the Yankees loaded the bases off two Boston relievers, but Mike Timlin got out of the jam.

Jason Giambi, dropped to seventh in the order, had slugged two solo homers to help the Yankees chip away at Boston's early 4–0 lead, built on homers by Trot Nixon and Kevin Millar and helped

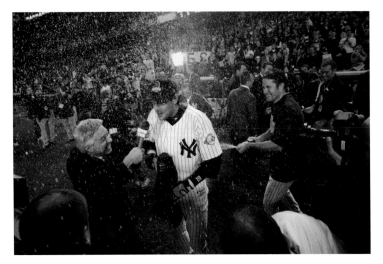

Boone (above) gets sprayed by Mike Mussina during a postgame interview. A sign (below) that seems to prophesy the end of Boston's Curse.

by an error by Enrique Wilson. Wilson started at third for Boone because Wilson hits Martinez well and Boone had been ineffective this postseason (.161 average and one RBI entering last night). But David Ortiz's homer in the eighth off David Wells made it a three-run game.

The Yanks' frantic eighth-inning rally—during which parts of the Stadium were shaking—saved Roger Clemens from ending his career on a dud. Clemens started for the Yankees, setting up a much-hyped matchup with Martinez, especially after the donnybrooks of Game 3 at Fenway.

But the Rocket could not get out of the fourth inning, walking off the field with his head down as fans gave him a loud standing ovation. He would not look up.

It seemed that would be the last time Clemens would be in pinstripes, because the Yankees could not muster much against Pedro.

It would have been a terrific night for Martinez had he not come out for the eighth. As it is, his line is tainted because of it—7 1/3 innings, 10 hits, and five runs.

Little argued that "Pedro wanted to stay in there. He wanted to get the job done just as he has many times for us all season long and he's the man we all wanted on the mound."

Ultimately, Martinez—and Little—are just another bad chapter for the Red Sox and two more punching bags in Yankee history. ▣

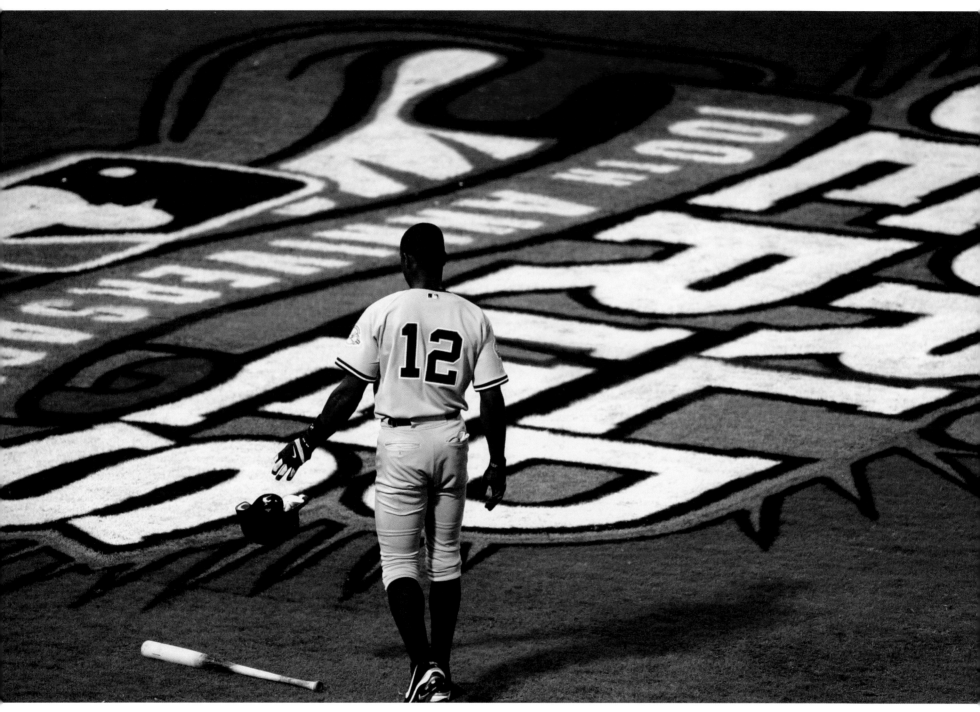

Alfonso Soriano throws down his helmet after striking out during the eighth inning of Game 5 of the 2003 World Series against the Florida Marlins at Pro Player Stadium. The Marlins beat the Yanks 6–4 to take a 3–2 lead in the Series. After a draining seven-game series against the Red Sox, the Yankees didn't have enough left to deal with Josh Beckett and the Marlins, who went on to win the Series in six games.

Alex Rodriguez works out with his new team at the New York Yankees spring training camp in Tampa, Florida, after being traded from the Texas Rangers in February 2004.

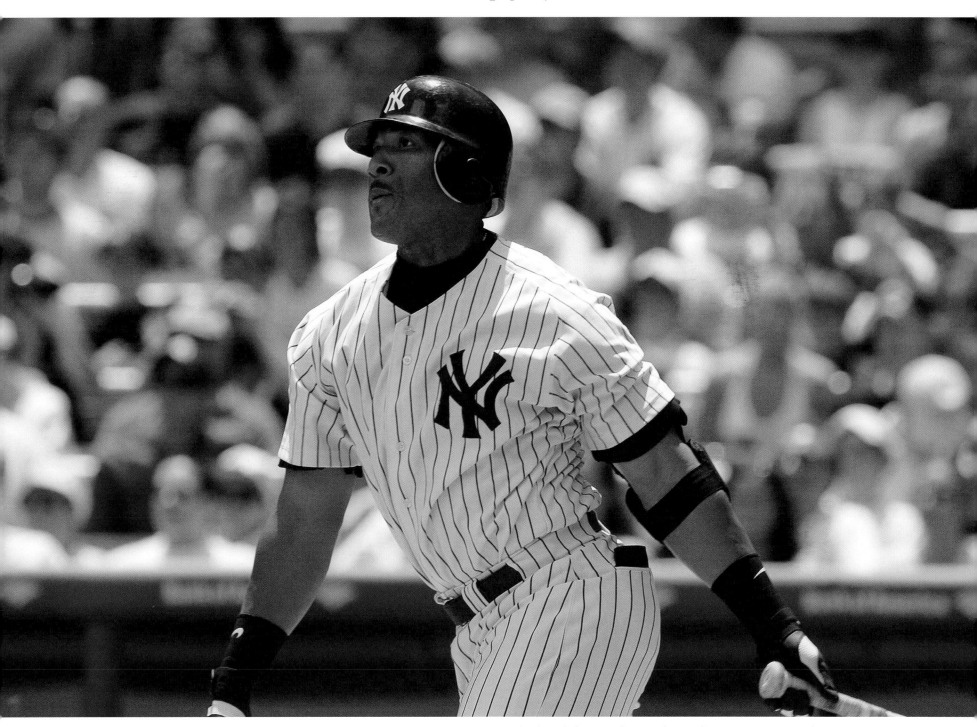

Gary Sheffield, who signed a free-agent contract with the Yankees after the 2003 season, watches his solo home run leave Yankee Stadium in an 8–1 win over the Mets in the first game of a doubleheader on June 27, 2004.

DAILY SPORTS NEWS

Yanks bury Boston, 19-8, can clinch AL pennant tonight

DEAD SOX

Derek Jeter gives Beantown an earful after scoring in first inning of Bombers' Game 3 rout of Red Sox last night. Yankees, who post second-highest score in playoff history, try to put Boston to sweep tonight. **Full coverage, Pages 54-73**

RON ANTONELLI DAILY NEWS

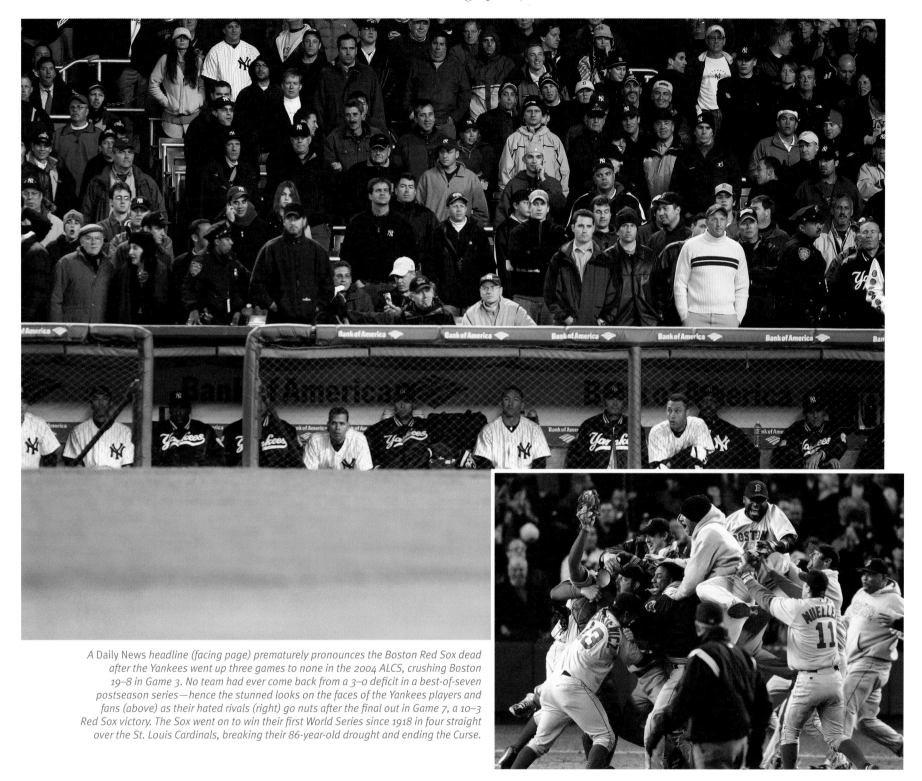

A Daily News *headline (facing page) prematurely pronounces the Boston Red Sox dead after the Yankees went up three games to none in the 2004 ALCS, crushing Boston 19–8 in Game 3. No team had ever come back from a 3–0 deficit in a best-of-seven postseason series—hence the stunned looks on the faces of the Yankees players and fans (above) as their hated rivals (right) go nuts after the final out in Game 7, a 10–3 Red Sox victory. The Sox went on to win their first World Series since 1918 in four straight over the St. Louis Cardinals, breaking their 86-year-old drought and ending the Curse.*

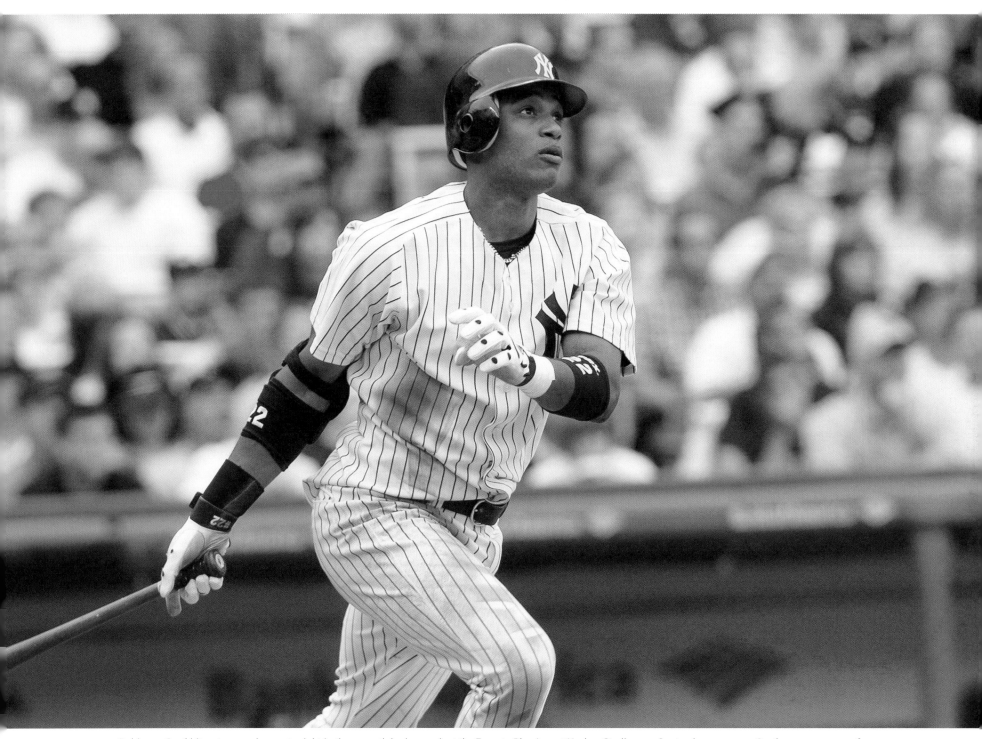

Robinson Canó hits a two-run homer to right in the seventh inning against the Toronto Blue Jays at Yankee Stadium on September 25, 2005. Canó was a runner-up for Rookie of the Year in 2005 and went on to become a five-time All-Star while batting .309 over nine seasons with the Yankees.

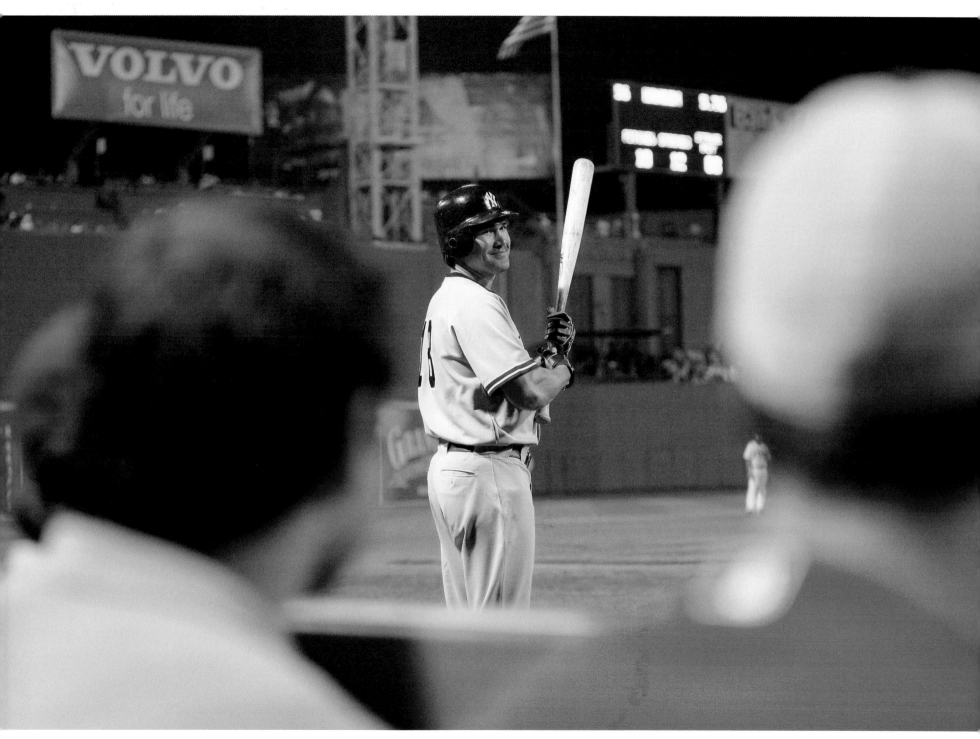

Johnny Damon, former center fielder with Boston (2002–2005), smiles at the fans at Fenway Park while on deck in the 10th inning of a game against the Red Sox on August 20, 2006, which the Yanks won 8–5. Damon signed with the Yankees after the 2005 season and roamed the outfield at Yankee Stadium for the next four years.

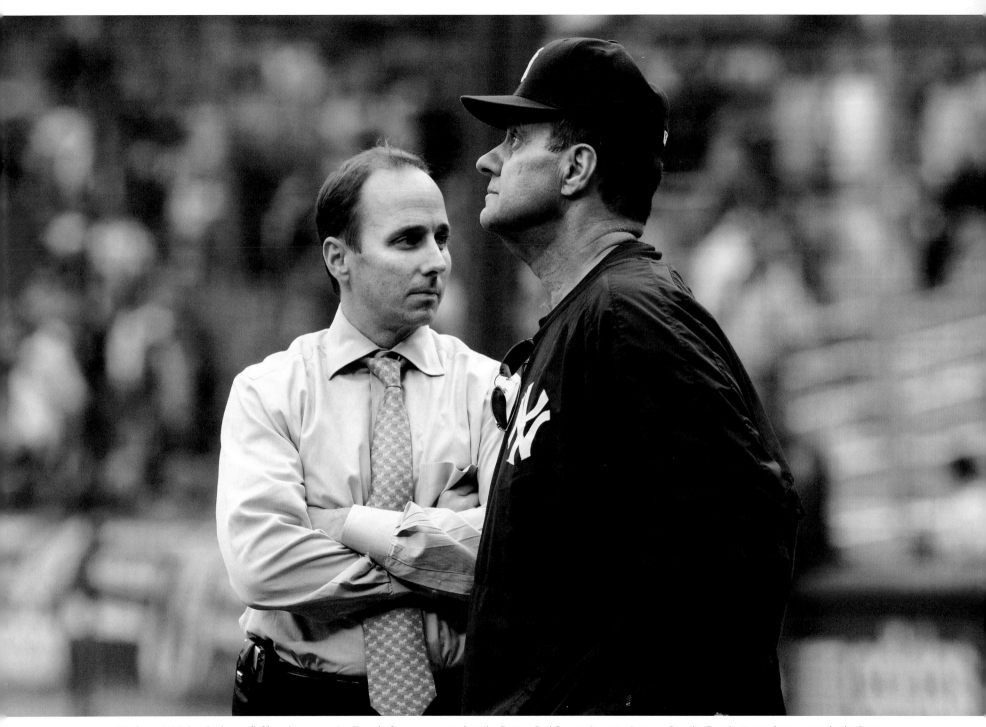

Yankees GM Brian Cashman (left) and manager Joe Torre before a game against the Boston Red Sox on August 28, 2007. Despite Torre's staggering success in the Bronx, he was seven years removed from the Yankees' last world championship, leaving the two men no longer seeing eye to eye. After an early exit in the 2007 postseason, Torre resigned rather than accept the team's contract offer.

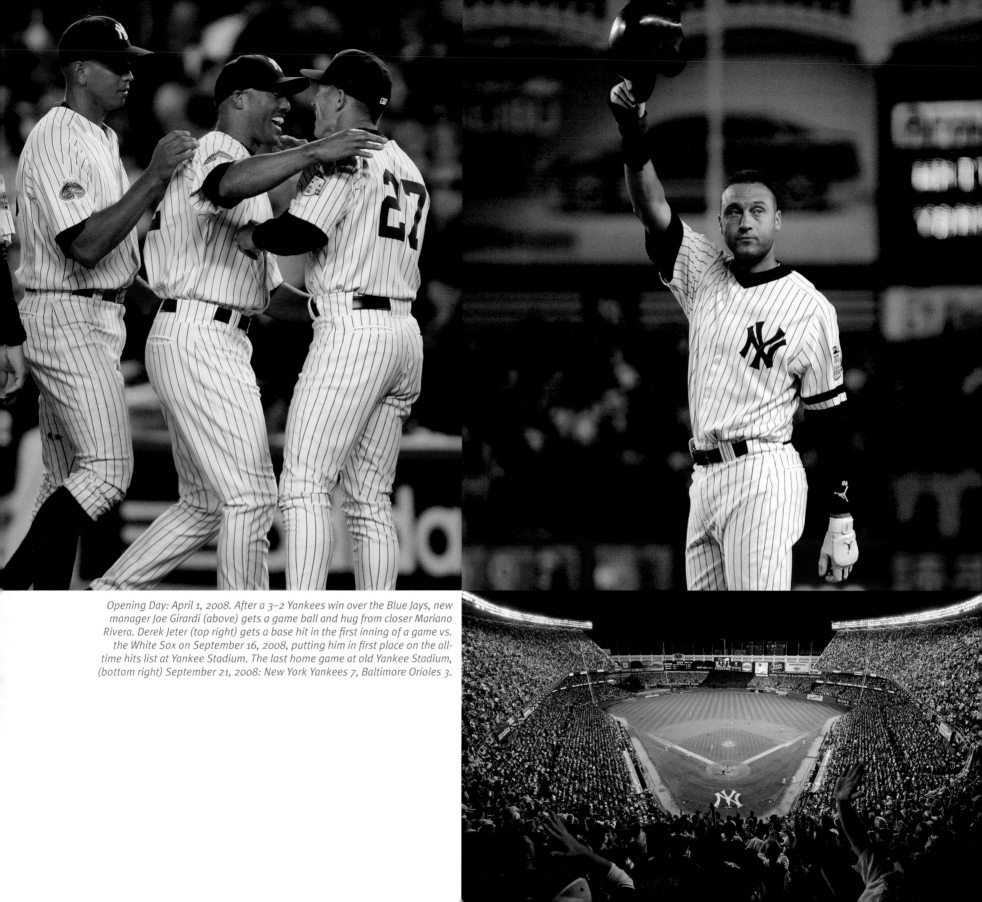

Opening Day: April 1, 2008. After a 3–2 Yankees win over the Blue Jays, new manager Joe Girardi (above) gets a game ball and hug from closer Mariano Rivera. Derek Jeter (top right) gets a base hit in the first inning of a game vs. the White Sox on September 16, 2008, putting him in first place on the all-time hits list at Yankee Stadium. The last home game at old Yankee Stadium, (bottom right) September 21, 2008: New York Yankees 7, Baltimore Orioles 3.

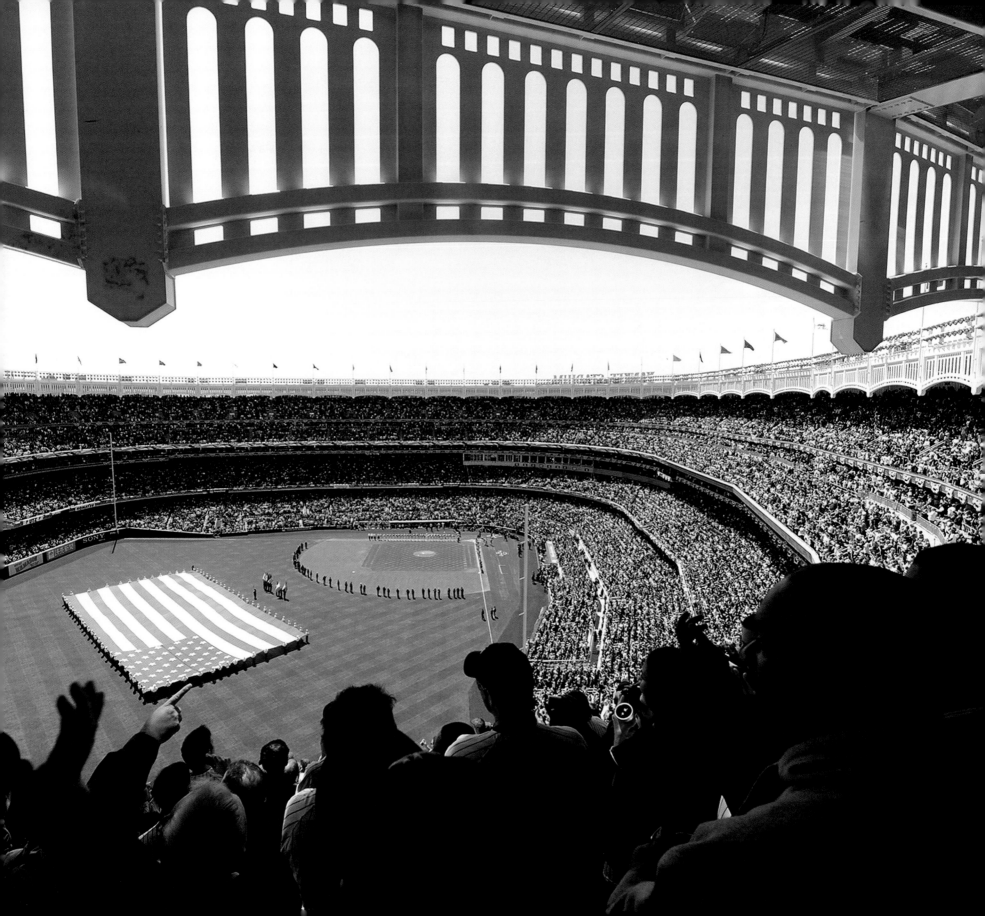

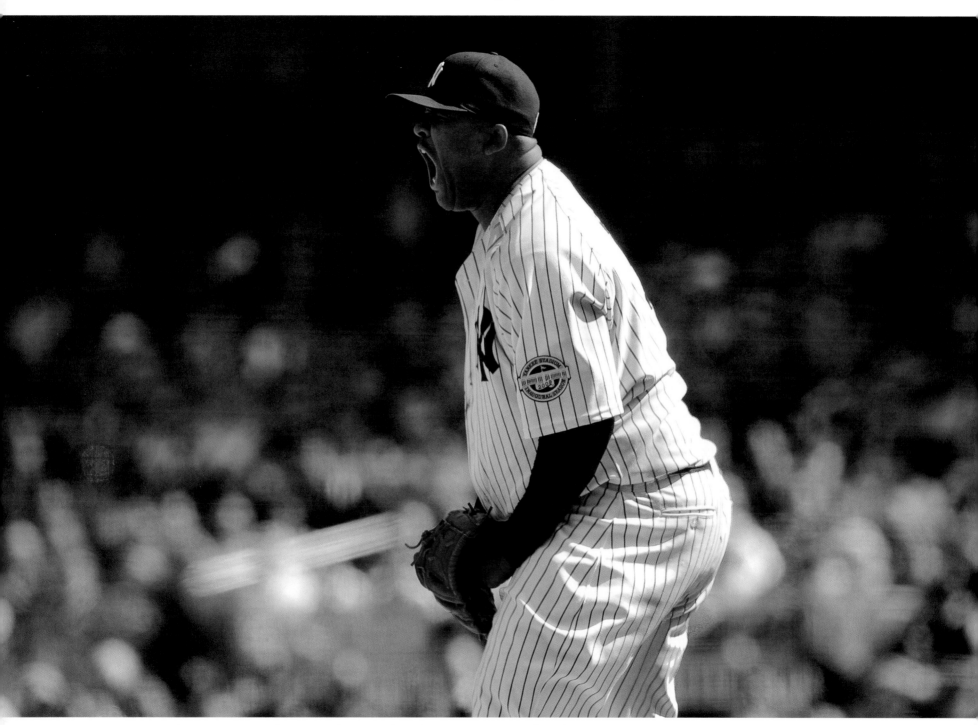

Opening Day: April 16, 2009, at new Yankee Stadium (facing page). Yankees starter CC Sabathia (above) reacts after striking out the Cleveland Indians' Jhonny Peralta to end the fifth inning during the first official game ever played at new Yankee Stadium.

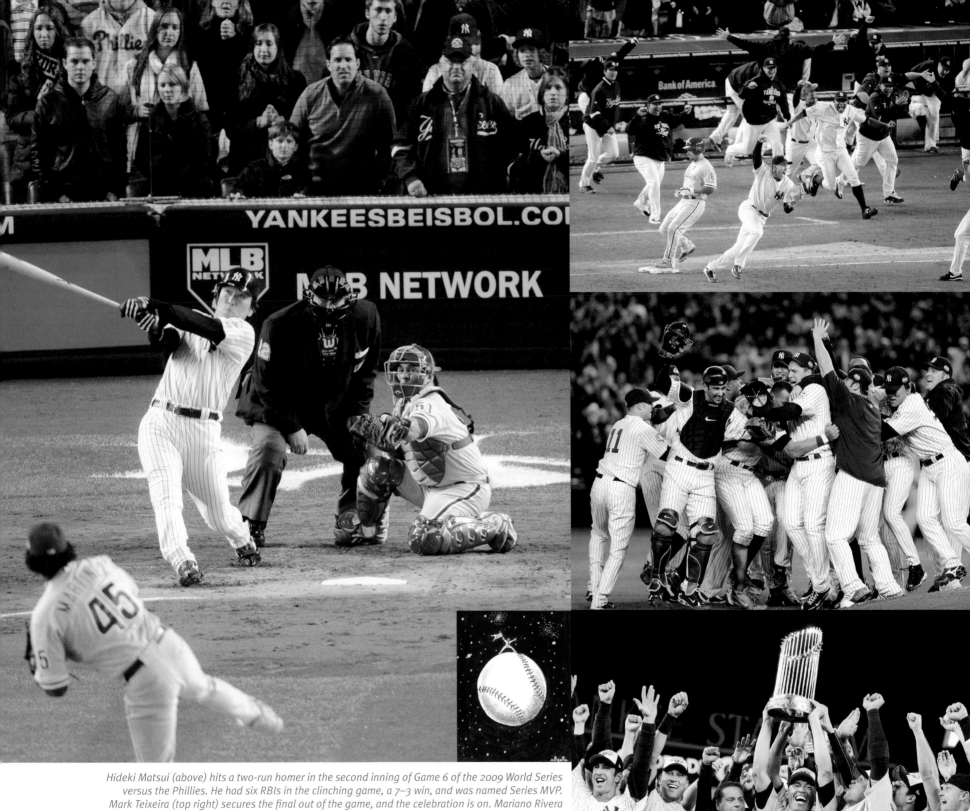

Hideki Matsui (above) hits a two-run homer in the second inning of Game 6 of the 2009 World Series versus the Phillies. He had six RBIs in the clinching game, a 7–3 win, and was named Series MVP. Mark Teixeira (top right) secures the final out of the game, and the celebration is on. Mariano Rivera (bottom right) lifts the World Series trophy, marking the 27th championship the Yankees have won.

The 2010s

100 YEARS IN PINSTRIPES | DAILY●NEWS | *The New York Yankees in Photographs*

Aaron Judge

Derek Jeter pays tribute to George Steinbrenner and Bob Sheppard before a game on July 16, 2010.

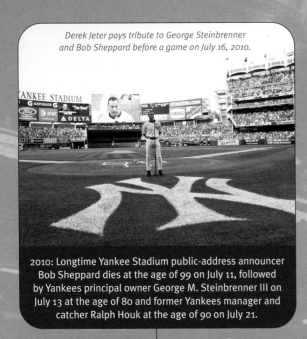

2010: Longtime Yankee Stadium public-address announcer Bob Sheppard dies at the age of 99 on July 11, followed by Yankees principal owner George M. Steinbrenner III on July 13 at the age of 80 and former Yankees manager and catcher Ralph Houk at the age of 90 on July 21.

August 4, 2010: Alex Rodriguez becomes the youngest player in MLB history to hit 600 home runs when he goes deep off the Blue Jays' Shaun Marcum.

DAILY NEWS
NEW YORK'S HOME RUN NEWSPAPER
3,000
WITH A BANG!

Jeter homers for milestone hit, goes 5-for-5 as Yankees beat Rays, 5-4

SEE PAGES 2-3 & SPORTS

July 9, 2011: Derek Jeter collects his 3,000th hit, a home run off the Tampa Bay Rays' David Price.

2011: The Yankees complete the regular season with an American League–best 97 victories, but their season ends abruptly with a first-round playoff exit, suffering a five-game defeat to the Detroit Tigers.

2013: The Yankees miss the playoffs for just the second time in the last 19 years, finishing third in their division with an 85–77 record.

2013: Mariano Rivera and Andy Pettitte retire after 19 and 15 years as Yankees, respectively.

2014: A-Rod is suspended by MLB for part of 2013 and all of the 2014 season for PED use.

2010 — 2011 — 2012 — 2013 — 2014

2010: The Yankees win 95 games and grab the AL wild-card, entering the playoffs for the 15th time in 16 years. They reach the ALCS but lose in six games to the Texas Rangers.

September 19, 2011: Mariano Rivera sets a new MLB record for saves with his 602nd against the Minnesota Twins.

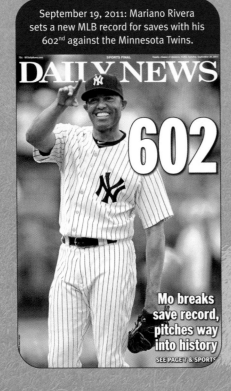

DAILY NEWS
602
Mo breaks save record, pitches way into history
SEE PAGE 7 & SPORTS

2012: The Yankees clinch the AL East for the 13th time in 17 seasons. They defeat the Orioles in the ALDS but get swept by the Tigers in the ALCS.

September 25, 2014: Derek Jeter lines a walk-off, RBI single in his final at-bat at Yankee Stadium, giving the Yankees a 6–5 win over the Orioles.

DAILY NEWS
Jeter pens storybook finish with game-winning hit in Stadium farewell
16-PAGE SOUVENIR TRIBUTE
2
PERFECT!

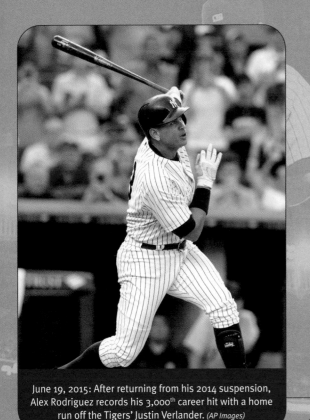

June 19, 2015: After returning from his 2014 suspension, Alex Rodriguez records his 3,000th career hit with a home run off the Tigers' Justin Verlander. *(AP Images)*

2015: The Yankees return to postseason play, falling to the Astros in the wild-card game after an 87–75 campaign that saw them finish second in the AL East.

October 1, 2015: The Yankees become the first AL club to reach 10,000 victories, a win that clinches a playoff berth.

2016: The Yankees miss the playoffs for the third time in four years, with an 84–78 record. In late July, they deal veterans Andrew Miller, Carlos Beltran, and Aroldis Chapman in order to replenish the farm system, and acquire future All-Star Gleyber Torres from the Cubs for Chapman, who re-signs with the Yankees in 2017.

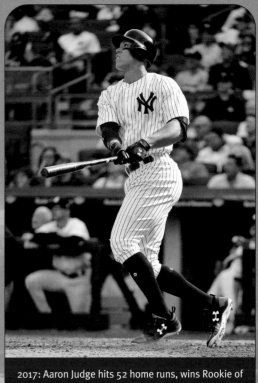

2017: Aaron Judge hits 52 home runs, wins Rookie of the Year, comes in second in MVP voting. *(AP Images)*

2015 2016 2017 2018 2019

2016: Gary Sanchez ties an MLB record by hitting 20 home runs in his first 51 career games. *(AP Images)*

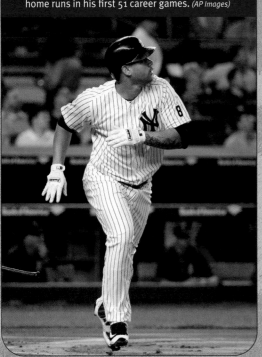

2017: The Yankees return to the playoffs, win the wild-card game, defeat the top-seeded Cleveland Indians in five games in the ALDS, then lose the ALCS in seven games to eventual World Series winner Houston Astros. *(AP Images)*

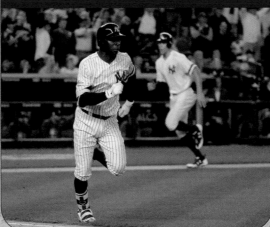

December 4, 2017: After declining to offer Joe Girardi a new contract, the Yankees hire former third baseman Aaron Boone as the team's new manager.

December 11, 2017: The Yankees acquire 2017 NL MVP Giancarlo Stanton from the Marlins for Starlin Castro and minor leaguers Jorge Guzmán and José Devers. *(AP Images)*

2019: The Yankees post a 103–59 record, their 27th consecutive winning season, the second-longest stretch in MLB history behind only the Yankees' own streak of 39 winning campaigns from 1926 to 1964. They advance to the ALCS for the second time in three years, but once again fall to the Houston Astros.

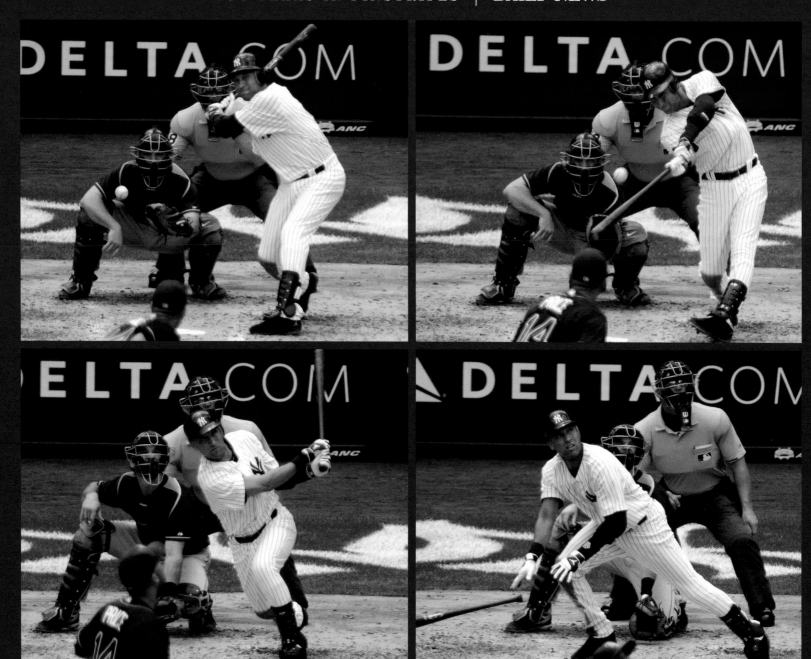

Derek Jeter smacks a home run to left field off of the Rays' David Price in his second at-bat of the game on July 9, 2011, becoming the first Yankee ever to record 3,000 hits and the 28th player in Major League Baseball history to reach that milestone.

New York, Friday, September 26, 2014

WALK-OFF INTO SUNSET

In Final Game at Stadium, Derek Delivers Game-Winning Hit

by Mark Feinsand

For one final night, No. 2 was No. 1 in the Bronx.

Fighting back emotions throughout the day, Derek Jeter delivered one last highlight for his Hall of Fame résumé, hitting a walk-off single to lift the Yankees to a 6–5 win in the final home game of his legendary career Thursday night.

As Jeter was mobbed by his teammates in between first and second base, the key players of the 1990s dynaasty, including Joe Torre, Bernie Williams, Jorge Posada, Mariano Rivera, Andy Pettitte, and Tino Martinez lined up in front of the Yankees dugout to congratulate the Captain.

"We've shared a lot of success, a lot of memories together," Jeter said. "I guess this is one last one we can share together."

After hugging each of his present and past teammates, Jeter made one last trip out to his home at shortstop, where he squatted down and said a short prayer as is his custom before games.

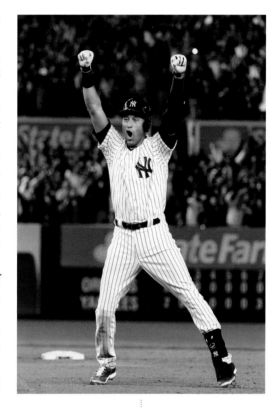

After the game, Jeter announced that it would be his final game at shortstop, although he would still serve as the Yankees' designated hitter for at least part of this weekend's series in Boston to close out his career.

"I wanted to take something special from Yankee Stadium, and the view from shortstop here, tonight is what I want to take from it," Jeter said. "Out of respect for the Red Sox, their fans, and the rivalry, I'm going to DH. I hope that people can respect my decision. I've only played shortstop for my entire career, and the last time I want to play it is tonight."

Jeter waved to the crowd of 48,613 as fans chanted his name again and again. He did a few TV and radio interviews before heading back to the field again, where he circled the diamond, tipping his cap to the fans one last time before being greeted by his family in front of the dugout.

"They're the ones that have helped me through the tough times that I've had," Jeter said of his parents. "They've played every game with me."

"I wanted to take one last view from short," Jeter said. "I was trying to take a last view in the top of the ninth and then they tied it, and I thought I would have to go back out there. I basically just said thank you because this is all I've ever wanted to do, and not too many people get an opportunity to do it. It was above and beyond anything I'd ever dreamt of. I don't even know what to say. I've lived a dream, and part of that dream is over now."

It looked like the game would have a far less exciting conclusion as the Yankees led 5–2 in the ninth thanks to Jeter's go-ahead RBI groundout in the seventh. But David Robertson allowed three runs in the ninth to tie the game, setting up the ultimate drama.

"It created another Derek Jeter moment," Robertson said. "As much as I wished I wouldn't have created it, I'm glad it happened."

(Continued on p. 214)

"I wouldn't have believed it myself," Jeter said, admitting that a game-winner in his final home at-bat had never crossed his mind. "Everyone dreams of hitting a home run in the World Series or getting a game-winning hit. I mean, I was happy with a broken bat and a run scored in the seventh inning, I was happy with that being the end. But I'll take this one."

Jose Pirela led off the bottom of the ninth with a single to left against Evan Meek, then pinch-runner Antoan Richardson moved to second on Brett Gardner's sac bunt. That brought Jeter to the plate with a chance for the storybook ending.

Jeter jumped on a first-pitch change-up, lining it to right field—where else?—to score Richardson and set off a celebration to match any postseason clincher.

"It felt like the World Series," Robertson said.

Jeter struggled to come up with words to describe what had just happened.

"I don't know what to tell you," Jeter said. "Write what you want and put my name at the bottom of it."

Rather than manufacturing a memorable ending the way he did with Rivera a year ago, Joe Girardi simply let things play out. It couldn't have worked out better.

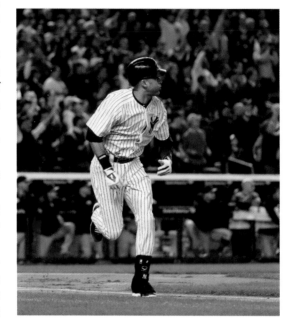

"I think it's fitting," Girardi said. "Because you think about all the big hits that he's had in his career, and all the things that he's done to help this club win championships and divisions. He's been here since the run that started in '96. I don't think there's a more fitting way for it to end."

From the moment Jeter stepped on the field for warmups, the crowd showered the pinstriped icon with affection.

A video tribute to Jeter from the fans played on the scoreboard to get the night started as the Captain and his teammates watched from the dugout.

Jeter led the Yankees onto the field at 7:05 PM, bringing about another of the many thunderous ovations. As Jeter's eyes darted around the ballpark to take in sights and sounds one last time, fans began chanting his name, prompting a quick tip of the cap from the shortstop, who appeared to be fighting back some tears.

"There were a couple of times I almost lost it," Jeter said. "First inning I was saying, 'Please don't hit it to me.' The last inning I almost lost it. Same thing. I don't know how many times in my career I've said, 'Please don't hit it to me,' but that's what was going on in my mind."

The Orioles took a 2–0 lead on two homers in the first, but Jeter answered with an RBI double off the left-center-field wall in the bottom of the inning, then scored on a fielding error to tie it up.

The game remained tied into the seventh, when Jeter reached on a fielder's choice, driving in a run on the play. A second run scored on an error, part of a three-run inning that seemed to put the Yankees in control.

Jeter began thinking about the end, doing his best to fight back his emotions. Then Robertson blew the save opportunity in the ninth, forcing him to refocus for his memorable at-bat.

"I don't know if the cameras were on me close, but there were a couple times I almost broke down," Jeter said. "I was almost thinking to myself, 'Joe, get me out of here before I do something to cost us the game.' It's funny how things change, I guess."

For all the highlights Jeter has provided over the past two decades—the Flip Play, the Dive, Mr. November, the 3,000th hit, and more—his final at-bat in Yankee Stadium will go down with them as one of the greatest moments of this era of Yankees baseball.

Jeter will have to take our word for it. At least for now.

"Maybe I can get a tape of the game and watch it," Jeter said. "It was an out-of-body experience, I guess is the best way to put it."

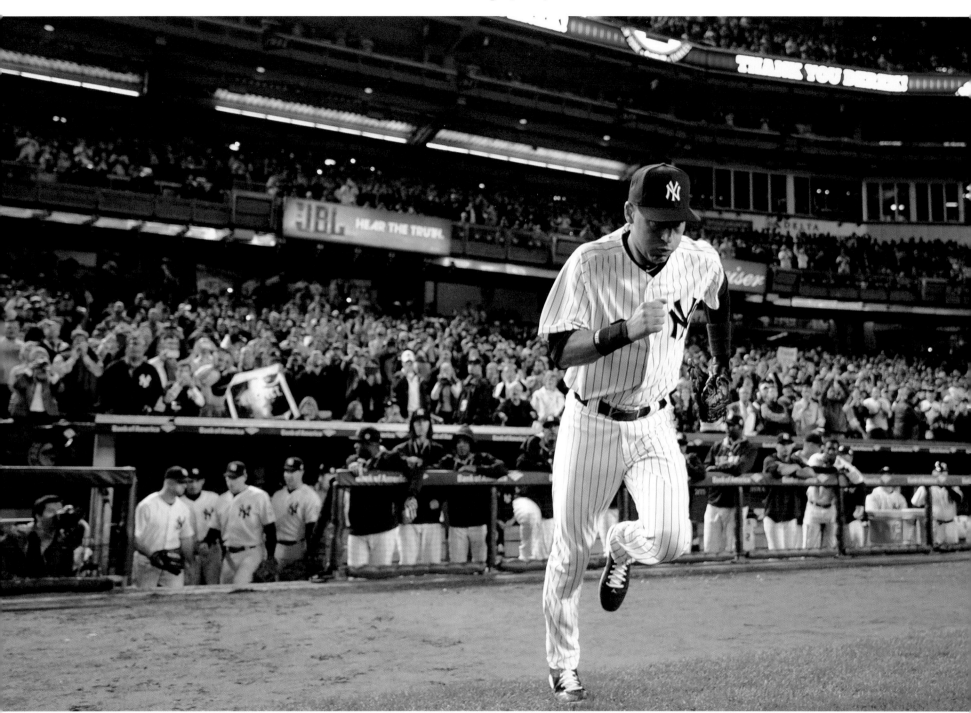

Derek Jeter takes the field at Yankee Stadium for one last time on September 25, 2014.

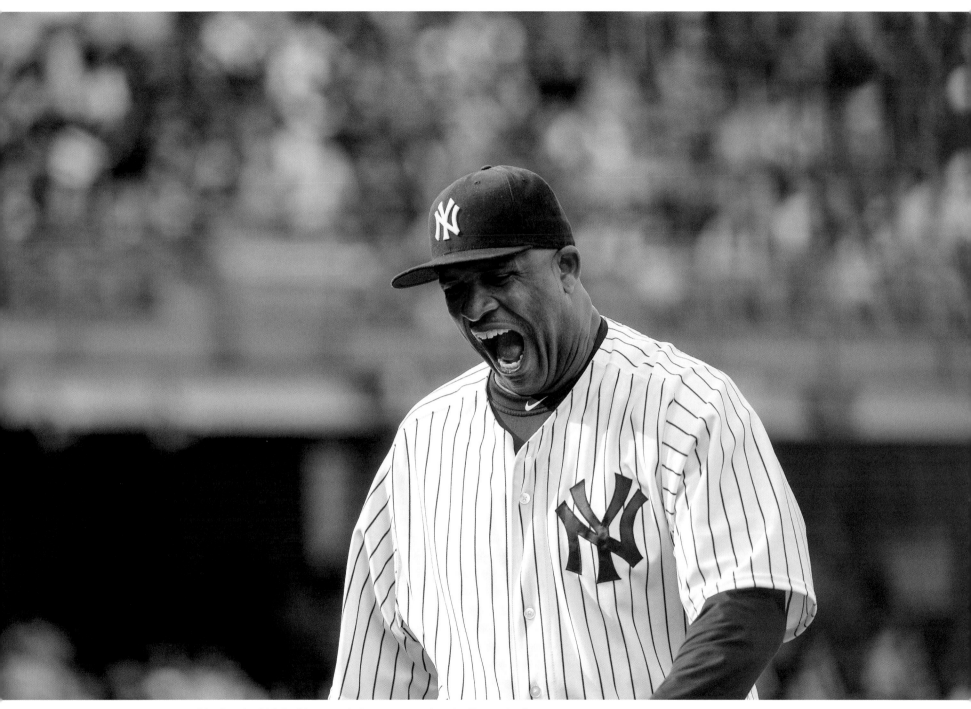

Veteran starter and fan favorite CC Sabathia reacts during a game against the Mets on April 25, 2015.

Yankees shortstop Didi Gregorius drives in catcher Brian McCann during a game against the Oakland A's at Yankee Stadium on July 7, 2015. Gregorius, in his first year with the team, would become a key part of Yankees contenders in the years to come.

217

Yankees closer Aroldis Chapman gets congratulations from catcher Gary Sanchez after Game 4 of the 2017 American League Championship Series against the Houston Astros in New York. The Yankees won 6–4 to tie the series at 2–2. Photo courtesy of AP Images

Yankees shortstop/second baseman Gleyber Torres gets high-fives from his teammates after scoring during the second game of a doubleheader versus the Baltimore Orioles on August 12, 2019, at Yankee Stadium. Torres, acquired by the Yankees in a midseason 2016 trade for Aroldis Chapman, hit 38 home runs in 2019 to go along with 90 RBIs in his second season. Photo courtesy of AP Images

Yankees left fielder Giancarlo Stanton (left) and right fielder Aaron Judge celebrate as center fielder Brett Gardner looks on after they defeated the Baltimore Orioles 7–2 on Opening Day at Yankee Stadium on March 28, 2019. Photo courtesy of AP Images